MW01055077

Texas Dives

THE TEXAS EXPERIENCE
*Books made possible by
Sarah '84 and Mark '77 Philpy*

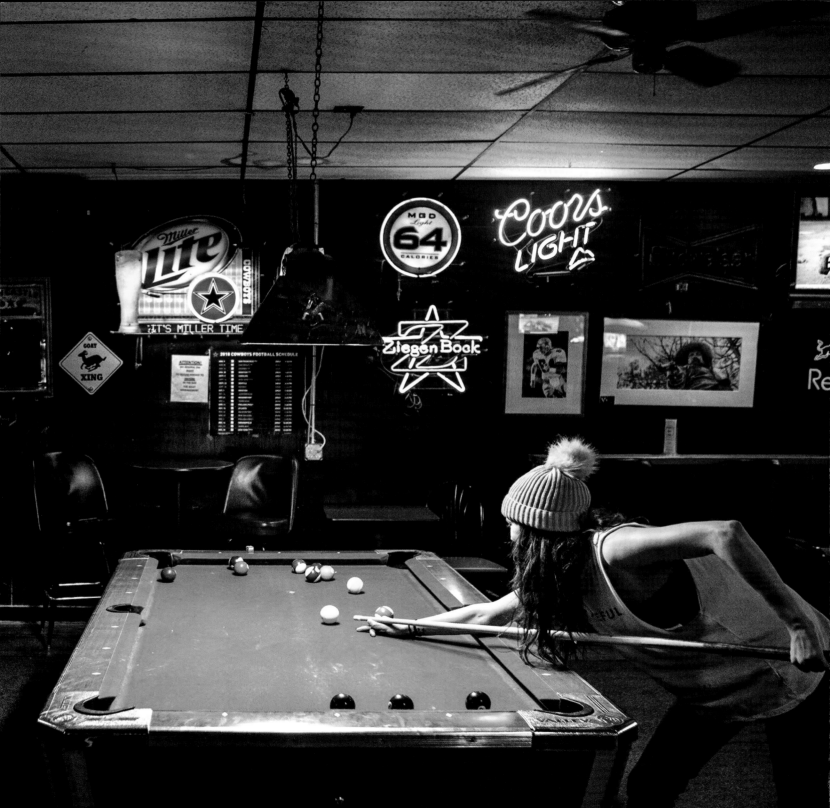

Texas Dives

Enduring Neighborhood Bars of the Lone Star State

Anthony Head

Photographs by Kirk Weddle

Foreword by Jesse Dayton

Texas A&M University Press

College Station

Copyright © 2022 by Anthony Head and Kirk Weddle
All rights reserved
First edition

This paper meets the requirements of ANSI/NISO Z39.48-1992
(Permanence of Paper).
Binding materials have been chosen for durability.
Manufactured in China through Martin Book Management

Library of Congress Cataloging-in-Publication Data
Names: Head, Anthony, 1968– author. | Weddle, Kirk, photographer
 (expression) | Dayton, Jesse, writer of foreword.
Title: Texas dives: enduring neighborhood bars of the Lone Star State /
 Anthony Head; photographs by Kirk Weddle; foreword by Jesse Dayton.
Other titles: Texas experience (Texas A & M University. Press)
Description: First edition. | College Station: Texas A&M University Press,
 [2022] | Series: The Texas experience
Identifiers: LCCN 2021041091 (print) | LCCN 2021041092 (ebook) | ISBN
 9781648430121 (cloth) | ISBN 9781648430145 (ebook)
Subjects: LCSH: Bars (Drinking establishments)—Texas. | Texas—Social life
 and customs. | BISAC: PHOTOGRAPHY / Subjects & Themes / Regional (see
 also TRAVEL / Pictorials) | TRAVEL / Pictorials (see also PHOTOGRAPHY /
 Subjects & Themes / Regional)
Classification: LCC TX950.57.T4 H43 2022 (print) | LCC TX950.57.T4
 (ebook) | DDC 647.95764—dc23
LC record available at https://lccn.loc.gov/2021041091
LC ebook record available at https://lccn.loc.gov/2021041092

This one's for the regulars.

Contents

Foreword

Dive bars. Beer joints. Taverns. Cantinas. Juke joints. Honky-tonks. These were and still are the gathering places in Texas that the local holy rollers have always warned the local flock to stay away from. They're colloquial and fiercely tribal places where the working class can drink a cold one, play pool for fifty cents, shoot the bull, and celebrate and commiserate life with old friends about a pay raise or a layoff, a divorce or a new sweetheart, or hold a tear-jerking memorial for a fallen soldier.

For some inexplicable reason some of us are drawn to that dimly lit, sacred, round stool that sits by an old wooden bar, usually across from an empathetic middle-aged woman who calls you "hon" and sells you the forty-hour-week standard: a tequila shot and an ice cold cerveza, or just a cheap shot of bourbon with a state-pride-brewed pilsner.

As a multigenerational Texan who grew up sneaking into these joints underage, two-stepping in dance halls, and drinking, playing music, and even having a few fights in these roadhouses, I've seen these historic places survive everything from hurricanes on Galveston Island, lightning storms in Lubbock, and biblical floods in Houston to being trapped once in a saloon's walk-in cooler with twenty strangers until an angry category 4 tornado blew through McKinney.

Our dive bars didn't become "dives" by just surviving the weather or by not changing the decor in forty-one years. Like people, these living, breathing entities survived marriages, lawsuits, police raids, revoked liquor licenses, health department fines, warrants, biker gang

fights, emergency calls to paramedics, $1,000 shotgun weddings, vehicles stolen from their parking lots, arson, crazy lone brawlers, graffiti, greedy landlords, crooked developers, and out-of-control drunk people.

And lately they've survived a couple of mandatory statewide shutdowns to accommodate the global pandemic—just another of the many layers of weathered forces and age-old energy that envelops these small, magical drinking establishments, each seeming to convey to its patrons: "This place has been through it all, and you're just visiting souls passing through." But while those patrons are here, they still keep trying to stir up its local color and maybe, just maybe, leave a small but lasting memory for how it was while they were there.

Onward.

—Jesse Dayton

Texas Dives

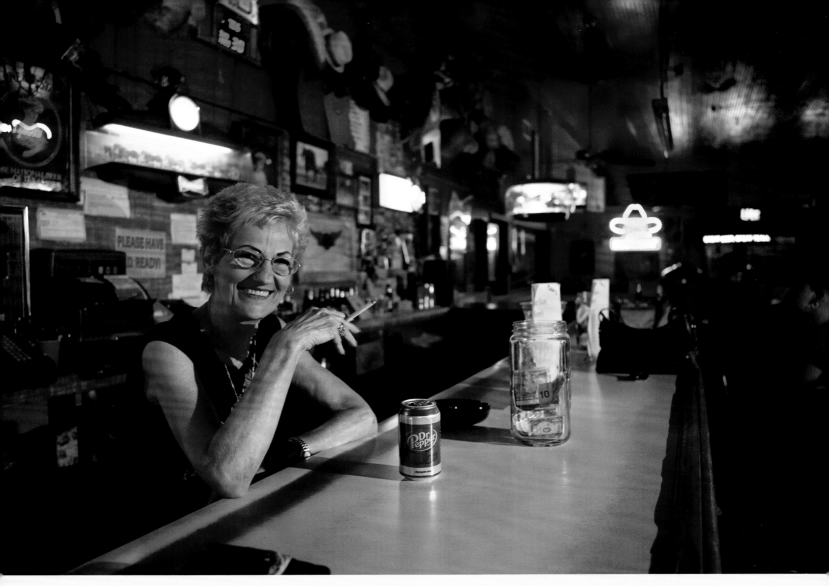

Linda McWilliams, co-owner of Mynars Bar in West, greeting us in July 2010.

Introduction

The Tao of Day Drinking

Two guys walk into a bar. One guy turns to the other and says, "We should write a book."

No joke. That's how it happened, way back in July 2010, long before the world became a very different place. One of those guys at that bar, Kirk Weddle, took photos, and the other, Anthony Head (who's writing these and most of the book's words, with Kirk's blessing, I assure you), wrote articles and feature stories for our day jobs of covering Texas' vibrant alcohol culture, mostly for magazines.

In the name of journalism, we visited the tempranillo vineyards and multigenerational wineries up near the Panhandle, checked out bubbly-interiored champagne bars in Dallas, and profiled image-making mixologists in Austin who build drinks like others craft fine home furnishings. We've made professional calls to a bunch of breweries, tasting rooms, distilleries, and restaurants with wine lists so long you simply can't read them in one sitting. We have sat at some world-famous bars.

For over a decade Kirk and I traveled thousands and thousands of miles inside Texas, attending private and high-profile events, meeting with men and women who were truly—sometimes dangerously—obsessed with the craftsmanship of their brands, and tasting our way through world-class beers, wines, and spirits, sometimes in spectacularly elegant settings, and other times in more outdoorsy locations showing off the natural elegance of the Lone Star State.

Usually, before or after work, if we had time to kill, we'd kill it in a dive bar.

Which brings the story back to that one July afternoon in 2010. After finishing up a job covering a rollout for a super-premium herbal liqueur product at a Denton pub for *The Tasting Panel*, Kirk and I were driving south on I-35. Exhausted from the traffic that formed alongside that interminable construction that has haunted motorists for years, we pulled off in the tiny town of West, about halfway between Dallas/Fort Worth and Austin. We were hoping to find something cold to drink. Mynars Bar awaited us on a hot, dusty street corner, and in we walked.

Linda, the bartender, held a cigarette lightly in her fingers as she slid over two Shiner Bocks and popped a Dr Pepper for herself. "Just passing through?" she asked.

The lights were kind of low. The place was kind of empty. Some old George Jones song was making the jukebox cry. I can remember how the smoke, the aroma of beer, and whatever the scent of history smells like were all mingled in the air at this frontier-style icehouse.

Yes, we were just passing through West that time around, but the plain truth was that the origin story for this book had just occurred. For some reason, being inside a dive always brings to mind all the other dives I've visited. They're just something I've kept track of over the years, lined up in my memory like shots of Jägermeister atop the bar. Kirk's the same way. We told Linda we'd be back some day.

* * *

Usually—and unfortunately—when the term "dive bar" comes up in polite conversation, it's shorthand for a place to be avoided. Kirk and I take the opposing view. Our book is filled with dives that should be patronized, but for clarity's sake, perhaps it's best we start by explaining what we believe a dive bar isn't. Dives are not black holes of alcoholism, despair, isolationism, and questionable motives. Those places are called dumps, and, yes, they exist. Many hotels and airports have them.

A dive is a place that gets judged unfairly from the outside world, its reputation based mostly on Hollywood typecasting of old neighborhood bars as dingy spaces filled with wastrels, miscreants, ruffians, and fools. And in most fiction, a dive isn't just in the backwater of a city; it *is* the backwater of the city. It's always located just off the edge of proper society, adrift and diluted with regret and consolation—at least some would have you believe—rather than sailing along with the same anticipation and optimism as any other sincere business. Worst of all, a dive is perceived as a place of purposelessness.

Bullshit. That's just what *they* want you to think a dive bar is. The truth: these places cater to ordinary people—third-shifters, entrepreneurs, the retired, the hard workers, and the good ol' day drinkers. Sometimes there are loving couples who visit the bar together, and sometimes they choose to come individually. There are nonconformists and people who are in between jobs. Some have done time. Others are probably going to do some time one of these days. There are legendary Hemingway-grade drinkers. There are very rich people. There are grumbling bartenders and insightful bartenders. There are joke-tellers and drunks, both amused way too much with themselves. And unlike many businesses, the owners are usually around somewhere.

We see beautiful women and handsome men in dives, same as anywhere else.

There are nondrinkers, same as anywhere else. Some of these people vote, some don't. Some were actually born nearby; others found their way to the bar probably much the same way Kirk and I found Mynars, with no other agenda than to pass the time comfortably with a drink.

On occasion, during visits to bars around the state, we may very well have met one or two wastrels, miscreants, ruffians, and fools. But that's the same as anywhere else too. A dive tends to attract a natural balance of visitors from the crossroads of America; we're guessing that's because a neighborhood bar actually is, quite naturally, a crossroads unto itself. The good places, we found anyway, weren't territorial about who their customers were; they're just interested in selling booze at a razor-thin profit margin and staying open for another day.

Some people swear the friends they've made at the bar are the best they've ever had, and that's because these are places where people get together and talk, face to face, all up front, no tricks. (Or at least they were.) Dives are where people have met, fallen in love, and gotten married. To underestimate the bonds of friendship among the regulars and staff is to miss entirely the point of a neighborhood bar.

True, we found that bars that open before lunch aren't necessarily about working hard, playing hard, achieving social status, unlocking your full potential, influencing anyone, or calling attention to yourself. Instead, the flow of life is gentler, maybe even a bit more manageable at these neighborhood staples. They're no less dynamic, by any means; they're just misjudged reminders that not everyone lives in the exact same 9-to-5 world.

By the way, if you're looking for a carpenter, electrician, or a contractor—or if you need work—inquire at your local dive.

Having visited dozens of dives, spending time getting to know the people who work and drink in them, we began to recognize that a common philosophy was present on both sides of the bar: the more you interfere with the natural laws of the universe, the worse things can get. It's one reason these places exist—to offer order and continuity from the chaotic cold universe outside the front door. But please don't say to yourself that we just made an argument for turning back the clock to any so-called "good ol' days." That'd defeat the purpose of a dive.

The only true constant a dive bar possesses is time, specifically lots of it in the past tense. Dives anchor their neighborhoods, outlasting other businesses around them by decades, usually by defying social trends in favor of offering simple familiarity. They've built up consistent patronage from longtime devoted customers, who appreciate that things don't need to change all the time to remain satisfying. Time seems to sweep a little slower across hardwood floors and Formica bar tops, which is probably why the passing years actually remain respectful to dives. There is durability to these places, opening and closing every day for years and years while aging as well as any other piece of true Americana.

* * *

How we went about finding these twelve in the first place was really catch-as-catch-can. Some, like Mynars, were return visits from earlier discoveries. We talked to

colleagues around the state, we took suggestions from friends and acquaintances of those friends. For the right kind of source (you know, like, a *real* square), our typical inquiry might go something like, "If your mother was coming to town, where wouldn't you take her?" We also Googled, we Yelped, but mostly we just walked into bars wherever we happened to be at the time, sat down, and had a drink with friends we didn't know existed yet. Alcohol is a proven social lubricant, after all.

While we both had ideas of what makes a bar a "dive," there is no legal definition to meet, and so we never concocted a working sketch of the term, then sought out such examples. We took what we got and ended up picking these twelve for the book because we thought they provided a welcoming atmosphere. While each had a singular clientele, rich with tales uniquely pegged to that particular bar, all twelve of them are places where somehow it wouldn't surprise you to see anyone, from any walk of life, come through the front door. (For all the folks at the Goat, in Dallas, let's hope Buddy Guy gets the message soon.)

Some dives serve food, others don't. Some have live music at night, others don't. While lots of dives feature karaoke, all of them, apparently, have pool tables.

We especially liked going during the earlier hours, when the rest of the world was busy doing other things, living different lives, walking right past these places as though they were invisible or purposeless. Nighttime—at just about any bar—brings louder music and louder crowds, offering fewer chances for a decent conversation.

It's also when people are out on the prowl, following the siren's song to seductions unbecoming any decent barfly, turning an innocent dive into something a bit less wholesome.

Some people swap dive bar discoveries like celebrity sightings. Some brag about their hometown dive bar like another might boast of a favorite fishing spot. We did this book after traveling thousands of miles and visiting and revisiting a lot of great bars—not nearly all of them, of course—between June 2018 and December 2019. In the end, these dozen are nothing fancy, and that's why they're so appealing.

To be clear, though, neither of us claims that these twelve bars represent the breadth and width of the subject. There are dives anchoring all sorts of neighborhoods that our admittedly haphazard sampling didn't take us to. But we've picked up quite a few recommendations for the future, whatever it may hold. *Texas Dives: The Second Round*?

And by no means are we saying these are the "best" in the state. Ranking them against one another makes about as much sense as trying to figure out the best places to live in Texas. You can have your favorite, but they're all winners.

DISCLAIMER: This book describes our experiences while visiting neighborhood bars throughout Texas and reflects our opinions relating to those experiences. Some names and identifying details of individuals mentioned in the book have been changed to protect their privacy.

Please don't drink and drive.

The Last Cantina

La Perla, Austin

On June's hottest Tuesday afternoon, La Perla remains pretty cool inside, thanks to the wall-unit AC anchoring one end of the bar and blowing enough cold air to spin tiny piñatas suspended from the low ceiling. La Perla's just as small inside as its house-like facade suggests when seen from the sidewalk. There are only six stools at the Formica-topped bar, all of them occupied by women. The adjacent room, with pool table and large-screen TV, is about the size of a living room. Cardboard cases of beer, soda, and mineral water from Mexico are stacked against one wall, and there's a (nonworking) pay phone hung on another. A few small tables are scattered about with several men seated around them, a bottle or can of beer in each man's hand.

It's pretty sparse, kind of like the place was assembled in about a day and a half and then everyone just sort of sat down and started drinking.

But it's not drowsy here. In between both rooms is a jukebox, a beautiful NSM Sapphire with real CDs inside, and Selena's "La Llamada" is playing. Even though the young singer died in 1995, her voice sounds vibrant, and also defiant as she insists, in Spanish, how she's in no mood to listen to the pleas from someone accused of cheating. ("If you call me again, I'll hang up again / I'm already tired of hearing more excuses and lies.")

On one of the barstools, a woman in her late fifties or early sixties, who is fastidiously put together in a floral print dress, sips from her bottle of Bud Light, then looks at the woman sitting next to her and announces, "We've been here since two." Her friend, who sports a more relaxed look and

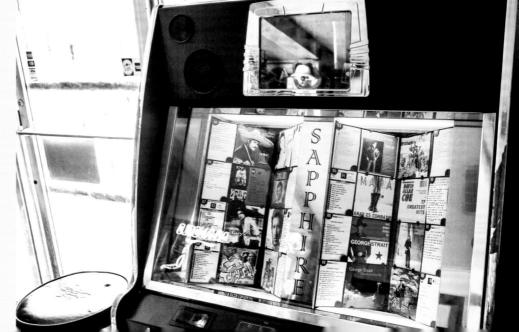

prefers denim on top and bottom, glances up from her own bottle but says nothing. She just nods along to the words of the late Tejano singer. For the record, it's now 4:45.

This is the crowd that gathers at La Perla before the after-work crowd arrives. Many of them are retired, a few are on the swing shift, and a couple of them will admit to "hiding from work." Getting here early means enjoying a more manageable bar and a little more personal space because it can get busy right after five, especially on weekdays.

Behind the bar, Fin buries cans of Modelo in the ice-filled sinks. Cases of beer are stacked in the corner with the bottles ready to be grabbed and rammed into the ice to take the place of every cold one that's sold. The beer has to be cold because that's what defines a good beer joint, and because it's so damn hot outside. Fin keeps pace with little effort. He's a pretty big guy with a wide body and shaved head. He doesn't have much room to move around, though. Right behind him, a thin board of shelving holds a television, a closed-circuit TV monitor

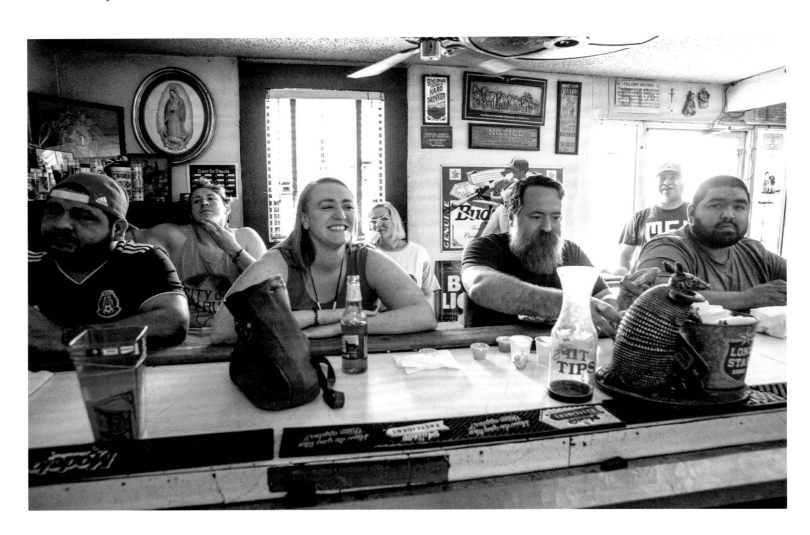

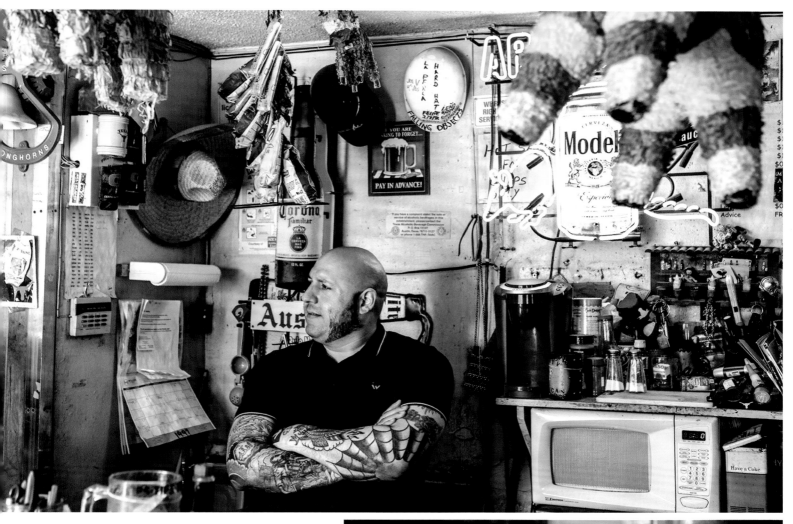

of the parking lot, the cash register, and assorted bottles of hot sauce.

Fin constantly chugs from a gallon jug of water. "Gotta stay hydrated," he says. "It's everything."

When I tell Fin that I noticed a lot of Mexican flags along the streets, he explains that Mexico is playing in the World Cup soccer tournament, taking place in Russia. The United States didn't make the cut, so enthusiasm for North America's only team in the competition is quite high in this predominantly Hispanic neighborhood, even if the odds are against Mexico winning the whole thing.

Fin smiles: He's rooting for the defending champion, Germany.

The woman dressed in denim is nodding again, though it's unclear if she's a Ger-

many fan, like Fin, or just keeping the beat to the music. Actually, most of us are nodding along to the music now like a bunch of bobbleheads. Some classic conjunto song is blasting out of the juke and its upbeat *oom-pah* groove compels human bodies to pursue the rhythm. It feels like the number of customers has doubled in the last thirty minutes, many are singing along in Spanish, and when Johnny Cash comes on next, sounding just as alive as Selena did, everyone keeps right on singing. A couple of older gentlemen motion for the women at the bar to join them for a dance on the far side of the pool table. "I fell in to a burning ring of fire/I went down, down, down/And the flames went higher," Johnny Cash sings as the ladies stay put. "And it burns, burns, burns/The ring of fire."

In walks some guy wearing a University of Texas football jersey, and someone else yells over the music, "There's goes the neighborhood," which gets repeated by others like it was a catchphrase. This new guy pulls out some folded dollar bills and is soon buying beers for the ladies and his pals. He's shaking the hand or slapping the back of everyone in the place, including those people he's never met.

"La Perla is the East Side's version of *Cheers*," Fin explains, referring to the long-lived television sitcom that took place inside a Boston bar. "Everybody's friends, everybody knows everyone. It's a neighborhood atmosphere. Been like this since long before I got here."

Originally from Corpus Christi, Fin's lived in Austin long enough to realize, upon reflection, that urban renewal or gentrifi-

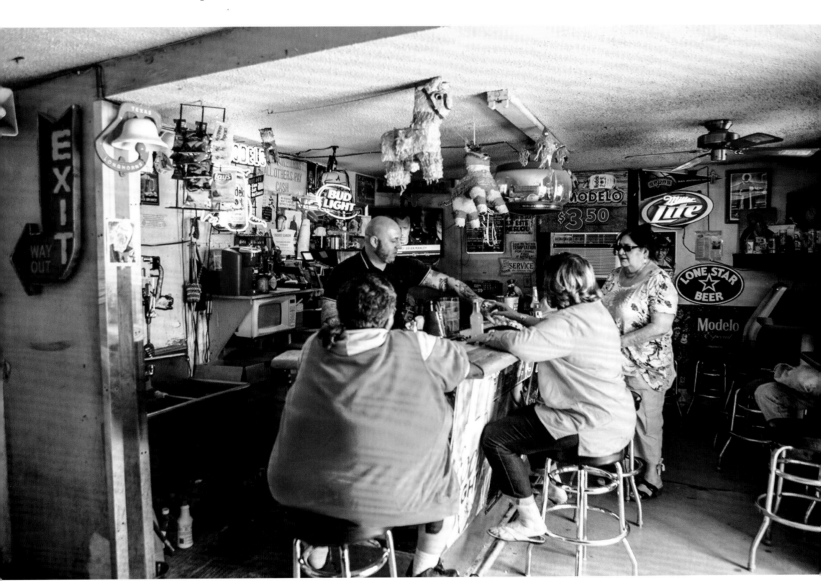

cation or whatever you want to call what's going on in the name of progress means La Perla's neighborhood ain't what it used to be.

The women on this side of the bar agree that things used to be different around here—simpler, cheaper—when the rest of the city did its best to ignore the East Side. Finally, Denim Woman says something: "And the bar is still the same, but pretty much the last of its kind." With that, she walks out of the bar and into the heat. Her friend with the careful coiffure decides to stay a while longer.

* * *

There is a rumor going around (started by me) that I am good luck for Mexico because I've been at the bar during the soccer team's first two World Cup victories, including an incredible win over Germany. (Sorry, Fin.) Much of the USA isn't paying attention, but with Mexico in it to win it, things are different at La Perla. Here there is real hope for the team, so I keep showing up.

When Mexico plays Sweden, the place is packed again. With nearly everyone wearing some shade of green (Mexico's team color) it might as well be St. Patrick' Day.

Near my table, a purebred boxer, white as the driven snow, occasionally rises from the floor to sniff below the barstools. But he mostly stays close to Eddie Costilla, his owner, who, after dropping off a couple bags of ice behind the bar, sits to talk. Eddie tells his dog, named Walter White, to lie down, an activity that suits him just fine.

Eddie begins, "I was three when my parents opened this place."

That was back in 1973. His parents, Albert and Enedina Costilla, had jobs but decided to make some extra money by get-

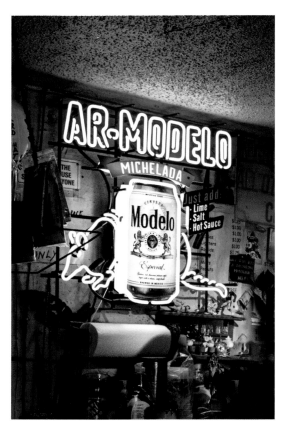

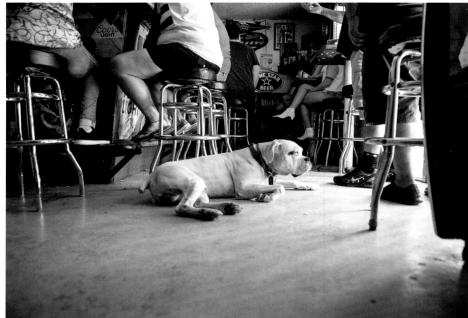

ting into the bar business. "All along Sixth Street, on both sides of I-35, there were beer joints and cantinas, some with small patios. They used to drink here and really liked the place, so they bought the building, which had been a bar named La Perla," says Eddie, who is carefully watching the game on the television over my shoulder.

His earliest memory of La Perla is of some customers stacking up boxes around the pool table so he could play. "Some of the regulars [who were also friends of the Costilla family] were involved in my babysitting—

they'd take me fishing, take me to the park, anything to get me out of my parents' hair for a while."

By the time he was ten, he was pitching in at the bar in small ways and eventually began helping his mother with the accounting. At twenty-eight he started taking over operations from his father. Now, at forty-eight, he owns the place. "In many ways I've grown up here," he says, laughing, which is something he does often.

Eddie explains that the gentrification going on throughout Austin isn't all that

new. "Eventually all the cantinas on Sixth got moved over here, across 35, and then we watched as one by one they disappeared. They were priced out of their leases, a lot of them. They were mostly beer joints like this. That's the reason people are calling this the last cantina on Sixth Street—on this side of it anyway."

The crowd groans, briefly disturbing the slumbering Walter White. Sweden has scored (and will again) while Mexico can't put together a successful attack. By the end of the game there is no joy in La Perla, for mighty Mexico goes down in flames, 0-3. With another loss they'll be out of the tourney. Whereas once we hoisted our beers

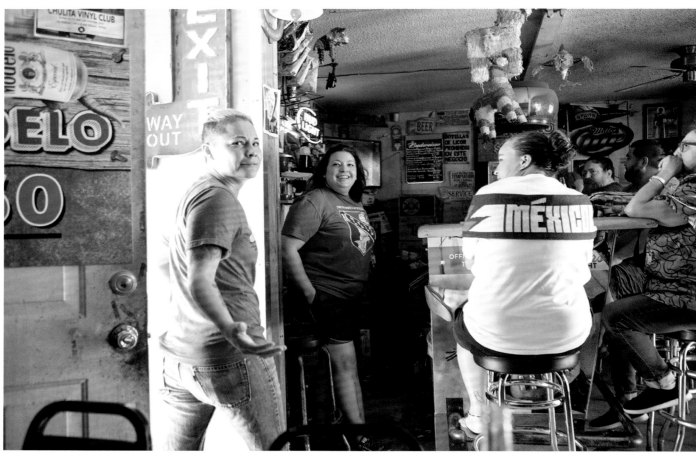

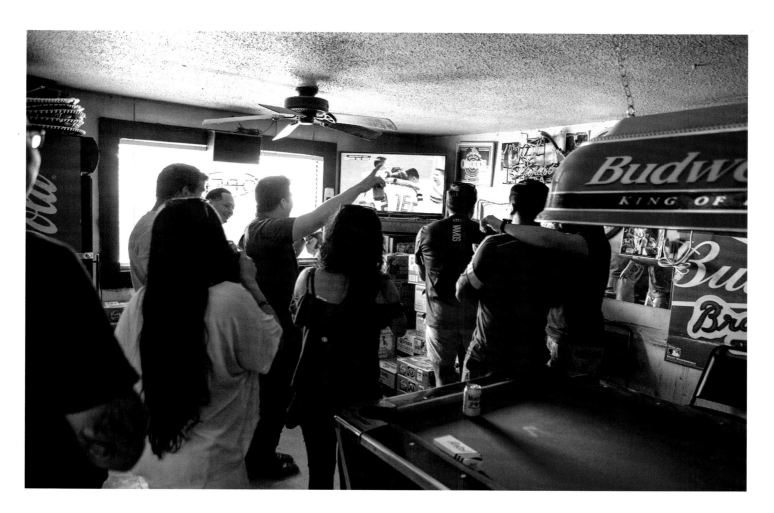

with great hope for the team's potential, there begins now a period of consolation drinking and debate on the team's future.

An older gentleman dressed in neatly pressed slacks with a green Mexico jersey tucked into them waves away all the post-game analysis. He's heard it all before. He's local and old enough to remember the days before the cantinas arrived. After listening to Eddie's stories, he leans in and says, "If that's what the neighborhood is going to be about, you have to accept it."

Eddie agrees. La Perla is trying to adjust to the changing times. "We were a cash-only bar for so long. But when people run out of cash they stop buying beer. So I put in the cash machine," he says, motioning to the ATM in the corner, just beneath an altar on the wall with votive candles, a picture of Eddie's father (now deceased), and portraits of Our Lady of Guadalupe, Jesus, and St. Martin from Peru. St. Martin "was a peacemaker," Eddie says. "When you look at his picture you'll see dogs and mice and animals gathered together. We wanted that kind of atmosphere here, and we seek his blessing. The altar's probably the bar's most important feature. It's part of the culture." But getting back to the ATM: Eddie rolls his eyes. "People didn't want to pay the service fees. Fine.

We got a credit card machine in January." Many of his regulars still insist on paying with cash, spending only the money in their pockets.

About a week later, Mexico falls to Brazil, 2-0, ending its World Cup play. It is decided that I am definitely not a good luck charm. But there is no bitterness. If that's the way it's going to be, you just have to accept it.

*　*　*

It's still hot and very bright outside. The night keeps trying to begin its shift, but the sun simply won't go down. Inside, no one's fed the jukebox for a while. The piñatas twirl with a certain lack of fiesta. The evening's crowd has filtered away, one by one, leaving the rest of their conversations for tomorrow, or next week, or the next time they're both at la cantina. Eventually, everybody clears out except for one woman at the other end of the bar and Fin, who obsessively checks his phone whenever the bar is this slow.

She's not much interested in talking, leaving me time to stare at the walls, which could maybe benefit from a fresh coat of paint. There are the de rigueur beer posters from Lone Star, Budweiser, Coors Light, some with alluring women models that seem to pull focus from the beer they're trying to sell, but that's just one guy's opinion. There's a white hardhat with names of people who've fallen inside the bar and the dates when they took their topples. (It's Fin's favorite piece.) I see Longhorn paraphernalia and photographs of friends and regulars from over the years. Most of the stuff looks pretty old.

A couple big signs declare La Perla to be "Home of the Ar-Modelo, $3.50," and I soon discover that's an honor other joints just

can't claim. When Eddie steps in with two bags of ice for the night, he explains that about six years ago some guy staggered in, kind of hung over, asking for a Michelada. (A Michelada is a savory, spicy beer drink made with lime juice and assorted seasonings like black pepper, Worcestershire sauce, and chili powder. Some use tomato juice or Clamato juice.) Eddie looks around the bar with his hands open as if to ask, What does this place look like, TGI Fridays? "I just tried to make something with what I had, Modelo Especial, some Tabasco, lime juice, and salt. The guy loved it."

Eddie started making it for others, and the Ar-Modelo became La Perla's signature drink—refreshing and racy. The bar sells a lot of them, which helps it to stay afloat while the neighborhood is reimagined with yoga studios, high-end restaurants, and bars that make their own bitters. La Perla, which has stood on the same corner for more

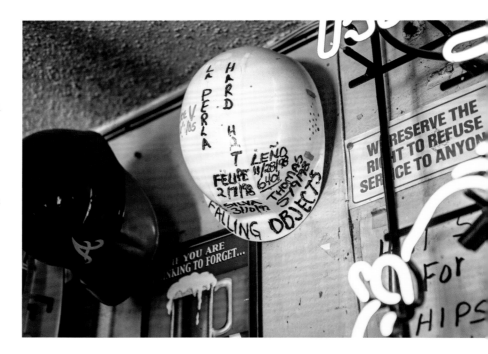

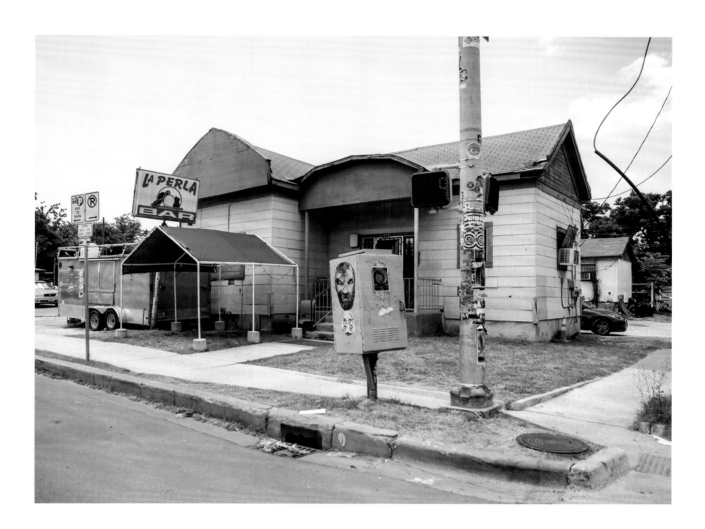

than seventy years, is kind of starting to look out of place, like a haunted house. But it does belong here, and there is a determination on both sides of the bar to hold on to what La Perla represents by holding on to La Perla itself.

It's been that way for a while too. On the wall, between the ATM/St. Martin altar and the air-conditioner, hangs a yellowed newspaper article from January 2011 about La Perla and the subject of gentrification. In the story, a bartender explains, "All the rich people are coming over here to the east side. I don't blame them if they have the money.

But I mean, one by one, they're buying out [cantinas like La Perla] . . . This is one of the last Tejano bars."

La Perla endures.

When the sky is finally dark, four customers come in. They're all probably in their late twenties. Someone plays "Shake, Rattle, and Roll" on the jukebox. Fingernails click on the bar to the beat. Heads are nodding along. They pay with plastic. The beer is ice cold.

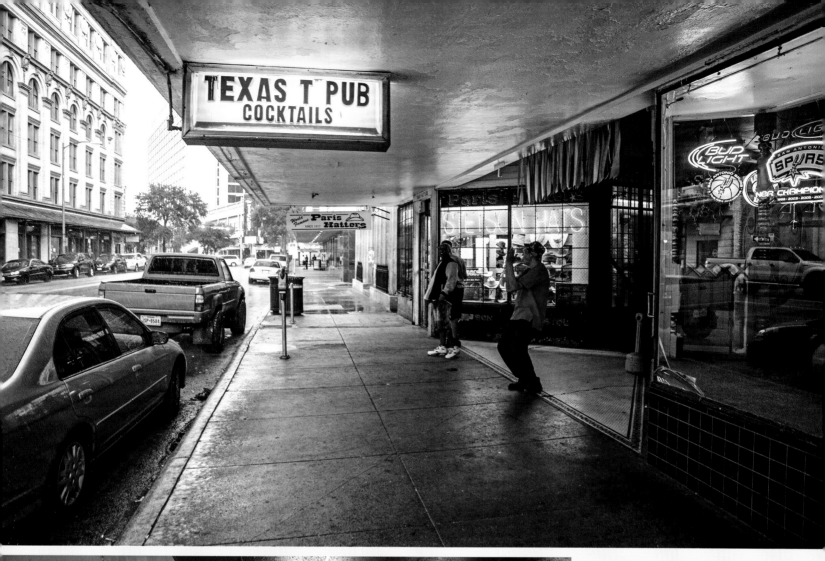
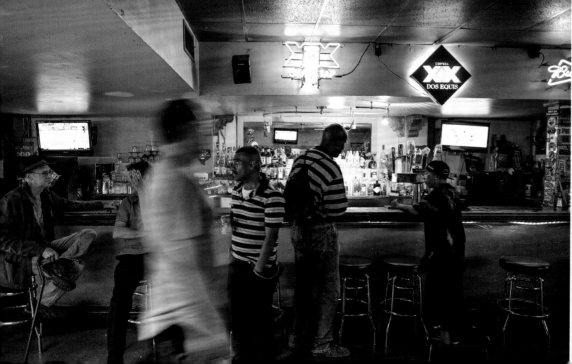

Meet Me at the T

Texas T Pub, San Antonio

We'd just finished a job at the Henry B. Gonzalez Convention Center in San Antonio and we were off the clock. It was about 11:00 a.m. Dive time. Not too far away, on Broadway, with an antique store on one side and a hatters on the other, sat the Texas T Pub. A couple seats at the bar awaited us inside. Kirk ordered Lone Star tall boys.

As our eyes adjusted to our darkened surroundings, a cat appeared. Maybe it'd been hiding under one of the pool tables or sleeping behind the bar, but suddenly it was just there, strutting around like it owned the joint. *A cat*, I thought. *What is this, a used bookstore?*

Actually, the space looked perfect for a bookstore or a shoe store: long and fairly wide. In the front there were wooden tables and neatly arranged chairs; it was bright with natural light from the storefront win-

dows. A few people were hanging around, some drinking, some engaging their screens. A couple had rough faces. One guy sat alone and never moved, never touched his drink. The front of the Texas T reminded me of the waiting area at a bus station.

Just about where the drinking tables ended and the pool tables began, the room became progressively darker. The neon and electric beer signs and the lights over the pool tables provided adequate illumination. Conversations were kept to low voices.

Kirk and I and the cat sat at the bar, pretty close to the center of the room, trying to figure out what else to do for the rest of the day. I counted three TVs, all switched on with the sound muted. Kirk pointed out a man near the back of the bar fixing his bicycle and another guy standing at the bar with a beer in one hand and a professional-grade

weed-trimmer in the other. Up front, in the sun's glare through the windows, we saw a man giving a woman a haircut. *What is this, a Fellini set?*

There was a digital jukebox on the wall, capable of playing thousands and thousands of songs, but it was silent. The only real sound in the room was the persistent clacking of Bicycle Guy ratcheting away at his gears. Mr. Weedeater eventually left, taking the subtle smell of cut grass with him. The Barber of Broadway clipped away on the woman up front until she was satisfied with the results, and then they both disappeared. We drank our beers and tried to predict how quickly we'd be returning to the T.

A couple days later I returned with my wife, Michele. She's a super-smeller, living much of her life by the information her nose gathers. Her first word when she walked in was "Piney." It hit me too. The place really smelled clean.

We sat at the bar. A young couple played pool. The cat appeared and sprawled out

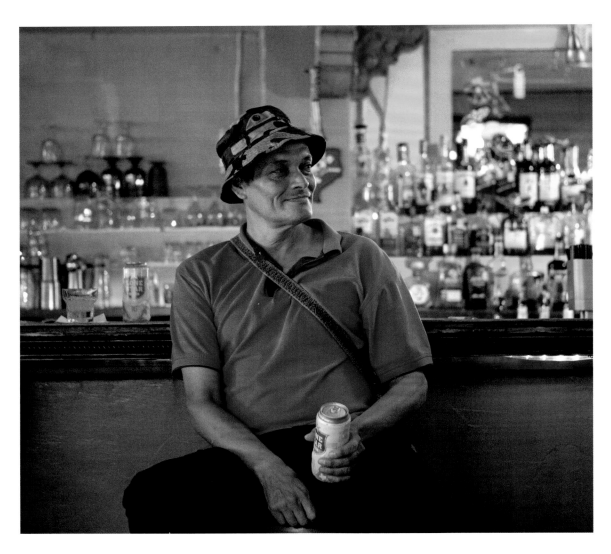

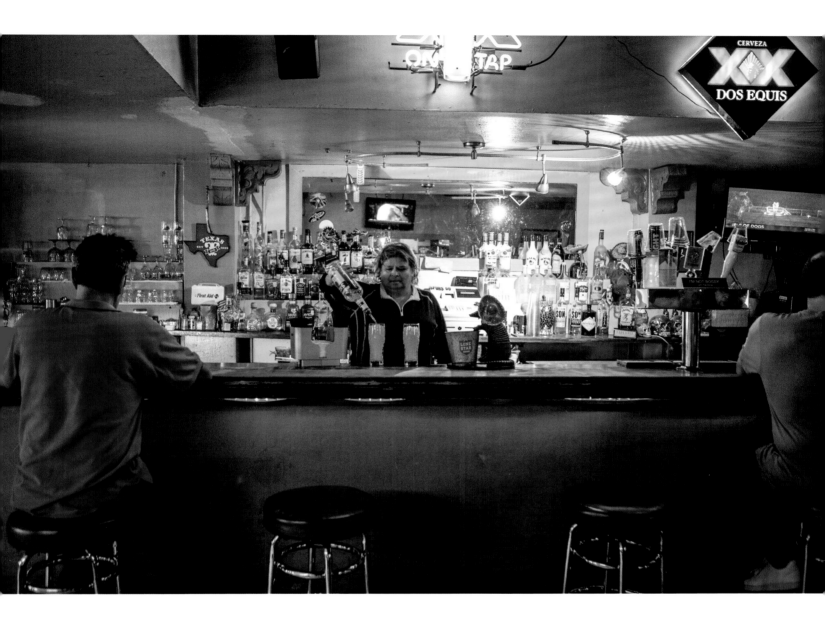

on the floor, requesting our attention or perhaps just surrendering. The speakers positioned around the bar suddenly blared a song by The Doors followed by an old familiar blues tune. Then it was back to being as quiet as a church, except for the *click, clack, plunk* of billiard balls.

Adela Fuller stood behind the bar and told us the feline's name was Kitty Cat. She also answered my next question, about how the bar got its name. "We live in Texas," she replied, "and the T is for my husband, Thomas, and my son, Tommy. It's just nice-sounding. Simple. Meet me at the T," Adela said, as if talking to a friend on the phone, getting ready to go out for the night. "I'll be at the T." She just liked the sound of it.

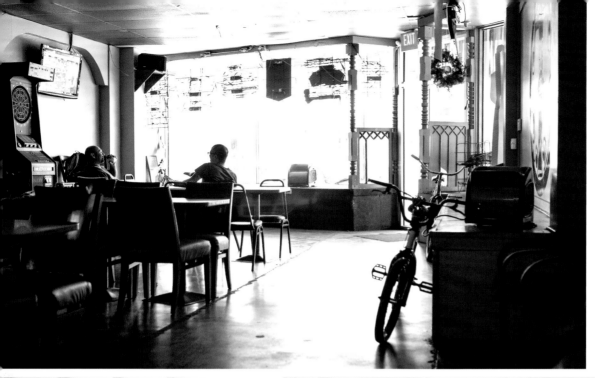
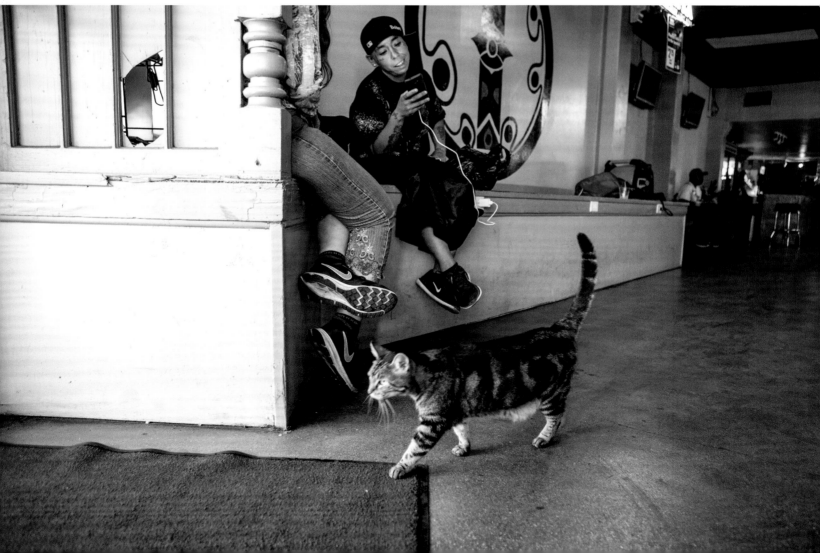

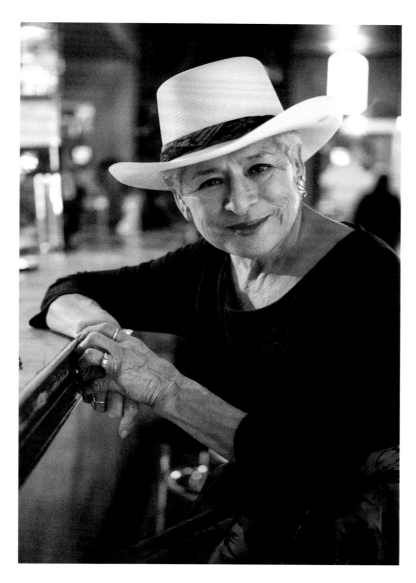

and we're going to have a party here. It's going to be something special."

The music came on again, and by the time it subsided Adela was saying something about her job: "I meet so many people, like you. Simple conversation. Good people. And—listen to what I'm going to tell you—we hang out at a bar to escape other people."

Adela is, in fact, a hardcore people person and says she comes by it naturally. "I'm a touchy person too," she admitted, rubbing my arm for emphasis. "People need people. I love people. Daily, daily, daily. Being around people—you benefit from it. It gives you great feelings." The way she stressed this point, it sounded almost like "people" was Adela's addiction. "I'll never get over talking to people. The more people-contact I have, the more energized I feel. I do volunteer work at a thrift store called Boysville. All the proceeds go to A Children's Home. It's very fulfilling."

A man with dark eyes, handsome face, and suave attitude slid up next to Adela behind the bar, hugging her softly, all in one motion, and asked us all, "How you doing?"

I introduced myself and Michele, leaning slightly in between them. This guy seemed like a serious player, and Michele had already enjoyed one Modelo and was eyeing the tequila shelf. When I ask how many years he'd been coming to the T, he flashed a knowing smile at Adela.

"Too many."

He told me he doesn't want any "publicity" so I'll just call him "Rico Suavé." He's originally from Mexico City, where I'm sure he went to school to get a degree in becoming Julio Iglesias or perhaps George Hamilton. After a few minutes, he finally admitted he's been coming to the T almost as long as it's

Adela is a slight woman, her voice soft and sweet. She often wears a pearl-white western-style hat (though she has many hats at home to choose from). It's hard to catch her when she's not smiling about something. I don't mind telling you Adela's age, sixty-nine, because she was excited about turning seventy in mid-December. "I don't feel seventy," she told us. "I feel good

been open, which is since September 1986. "We've known each other a long, long time," he said, staring into Adela's eyes. She smiled demurely. (I think they were bullshitting us, but you never can tell.) "I've met very nice people here. Some are acquaintances, some are drinking buddies."

We all chat about stuff for a while, then, apropos of nothing, Rico Suavé claims that in Mexico there is a way to let a woman know how much you appreciate her. He said to tell the woman, "When you die, you're going to go to heaven with all your shoes." Around me, the women smiled at the thought of such eternal reward. When Rico Suavé leaves, presumably to go register his magnetism with the county, I make a point of remembering that saying.

Terry Loera, the bar's manager and also Adela's younger sister, joined us, and I asked about the cast of characters I had seen on my last visit to the T. "Yeah, lots of people ride bikes. They'll stop in here for a cold one," Terry said, noting that some even leave their bikes at the bar and walk to work. Mr. Wee-deater, it turned out, "was doing some work for Adela and stopped by for a cold one."

When I asked about the guy cutting hair, Terry's expression conveyed that she was stumped. For a moment, Adele looked puzzled, but then remembered, "That would be Pedro, the barber."

"Oh yeah, a barber just moved [to the neighborhood] from California," Terry said, shrugging her shoulders as if to add, "So what's the big deal about seeing a guy cutting hair?"

"Well, nothing astonishes me," Adela said, "as long as it's not me getting drunk and acting silly." And yes, she admitted, maybe that

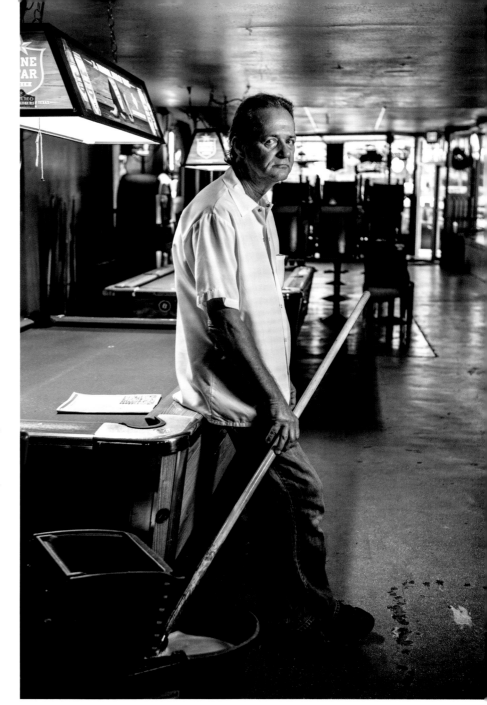

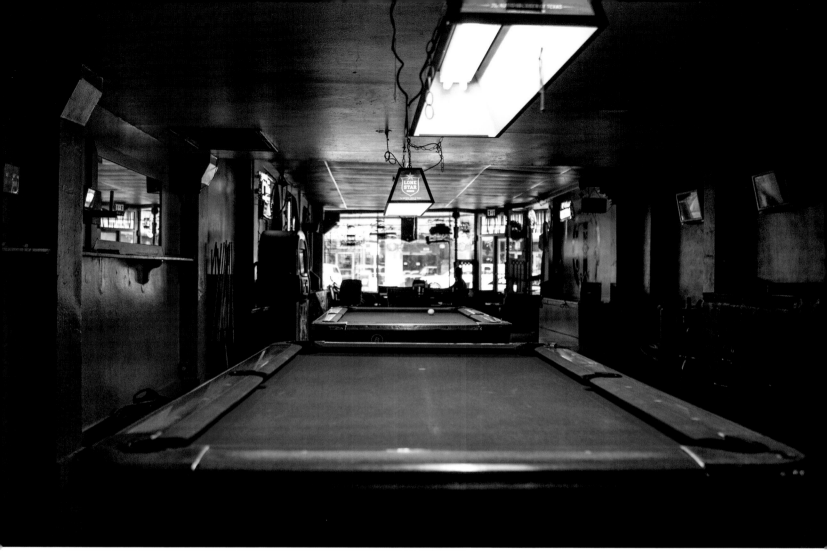

has happened a couple of times in the past when everyone was a little younger and a little sillier.

But we're all just trying to have a good time, right, Adela?

"Hell yes," she said with a twinkle.

* * *

A few days later, Kirk and I were back at the T. Terry was working. Beer for Kirk. For me, Jack on the rocks with a whisper of water. This last part, the nonstandard liquid-volume unit known as a "whisper,"

should always be left up to the bartender's discretion. Terry added a refreshing splash. (When Adela was behind the bar, she let only a drop of H_2O fall past the rim of my glass. "Silence is golden," she instructed.) Terry's worked at the T for about twenty-eight years, usually opening the place around 8:00 a.m. each morning. "It's a different crowd from day to night," she told me. "There's a lot more River Walk employees during the day. Our regulars are like the graveyard [shift] employees from the hotels, the bus drivers from the Greyhound Station getting off duty looking for a local dive that's open."

Terry seems a little less extroverted than Adela, but just as easy to talk to. When I asked about the T being known as a dive, she

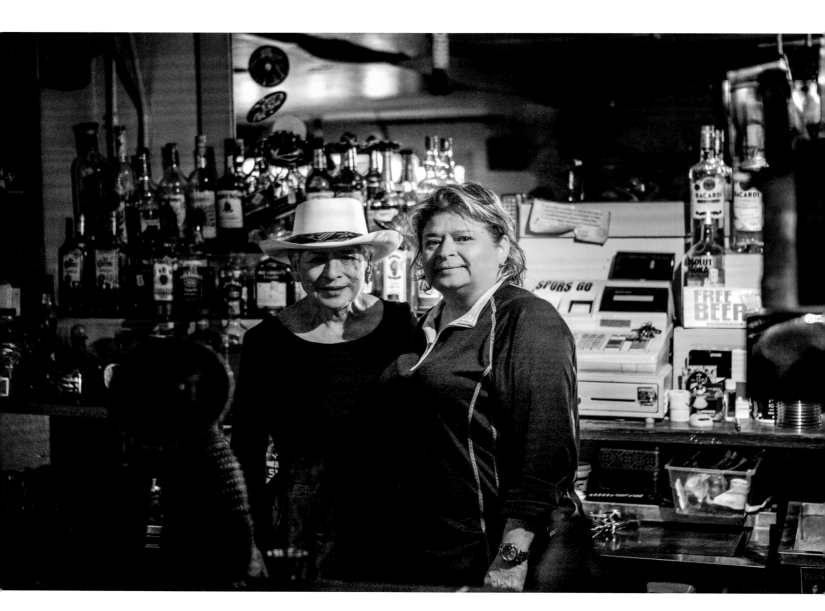

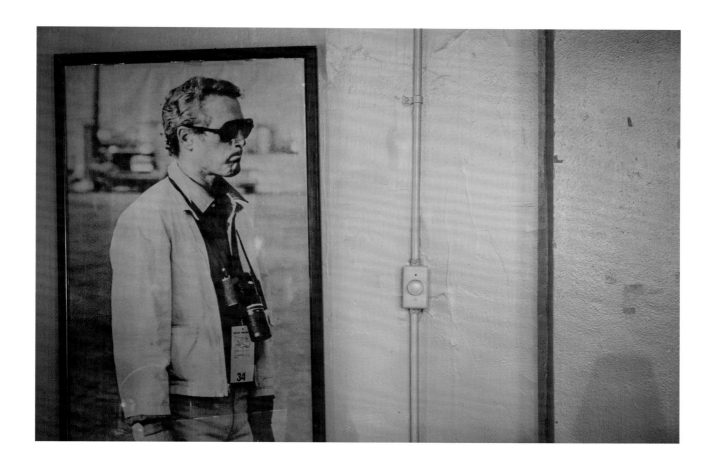

said, "We won 'Dive Bar of the Year' a couple years ago. I've never had a problem with it, but my sister," she leaned in closer, "my sister's opposed to that name."

And sure enough, Adela frowned when I asked. "I don't agree with the label. No. 'Dive' gives me the sleazy feeling." She looked around at her business, shaking her head. "It's not bad."

So later that night, as sort of a tiebreaker, I asked the guy at the bar sitting next to me if he thought the T was a dive. He wanted a definition for the term, which of course I couldn't produce. "I don't know what 'dive bar' means. I don't have an answer," he finally responded, bored with the idea.

I bought him a beer. He goes by Patrick, and he moved here from Brownsville in the eighties and started working at the Gunter Hotel. "We would come in here afterwards, bring our money," he said. "I've moved on from the Gunter but I still come back here. People like to come here for good service, and I like it because I've worked in the [hospitality] industry for thirty years, and I like to see familiar faces here."

Patrick slipped behind the bar to make some adjustment to a beer cooler and Adela patted his forearm. "Patrick helps when I need a hand," she said.

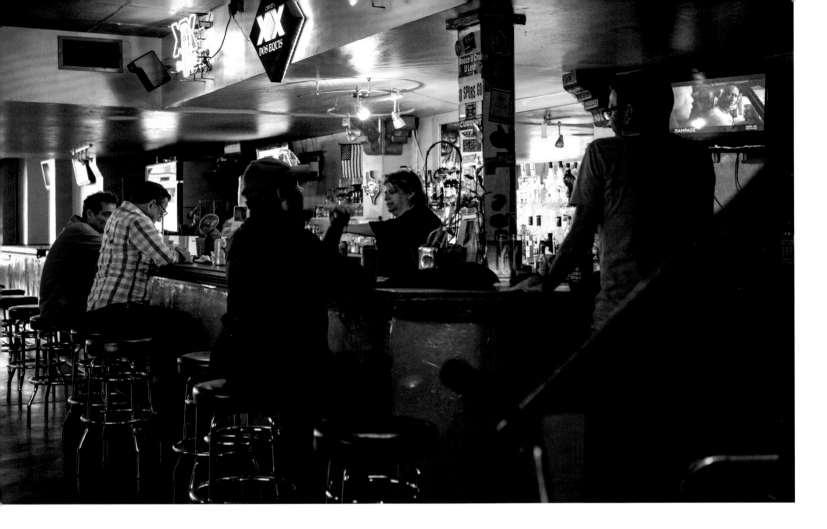

"I've worked for the best of the best in San Antonio," Patrick said, "Adela's up there. We love her. She has a touch of old-school class."

The past always means something in a bar like the Texas T. Before it even opened, some businesses in the neighborhood protested the place. Adela and her husband spent a lot of money on a lawyer and a lot of time driving to Austin trying to get the appropriate license. "They fought us, but after a year we won. I was determined," she said. "How are you going to tell me 'no?'" Although her husband has since passed away, Adela assured me (while cracking open a cold can of Bud Light for herself) that

her life as a bar owner has been "charming."

Having a neat, clean, comfortable space was obviously important. The T's walls were pleasingly unlittered with band flyers, broadsides about local politics, "roommate wanted" notices, and pleas for the return of lost cats. There is, though, a framed black-and-white poster of Paul Newman.

One morning about a week later, I talked with Michael, the custodian, and got the feeling he really cared about doing his job well. After all, he's a customer as well as the guy who keeps the T spick-and-span. He usually rolls in sometime after the place opens, when there might only be a couple

customers. "A lot of people start with the floor and do the tables last. I'm the other way around. All the stuff on the tables fall to the chairs. All the stuff on the chairs falls on the floor. You got to start with the tables," he explained.

In addition to cleaning, he'll stock the coolers, make bank runs, do whatever task needs to be done. When he knocks off in the afternoon, he gets about two hours to himself before going to his night job. Burning the candle at both ends might be tough sometimes, but having previously worked construction, he's glad of the circumstances. "At least I don't have to deal with the sun," he said.

Michael returned to his work. The floor needed to be mopped before too many more regulars arrived. "With enough elbow grease this place really can shine after a night," he said proudly.

Kitty Cat darted across the floor. It had been making its rounds and finally settled on top of a pool table. Michael looked over his shoulder at it and said, "That cat has the cleanest feet in town."

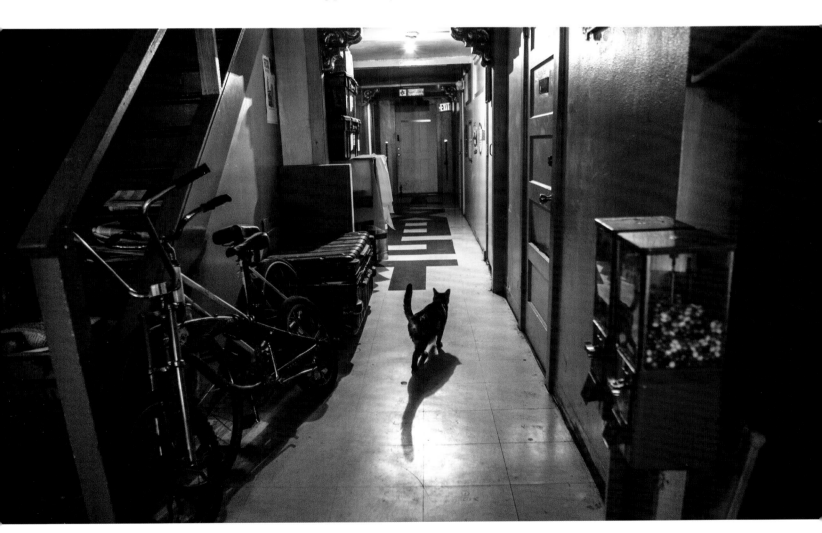

The Battle of Riley's Tavern

Riley's Tavern, Hunter

The drive ain't a pretty thing. There's too much traffic on the two-lane roads leading to Hunter, Texas, population: "50 (dispersed)" according to texasescapes.com. It's not on a lot of state maps, which kind of makes Hunter more of a concept than a place. However you define it, the country roads that stripe Hunter's once-bucolic landscape are now feeders from big ugly factories to the larger, congested traffic arteries between New Braunfels and San Marcos. Lots of eighteen-wheelers haul ass on these roads until they have to slow down for a short, curvy stretch of asphalt near FM 1102. That's where Riley's Tavern sits, and that's where things get complicated.

Kirk and I have been to Riley's many times, together and separately. We've brought our wives. I brought my kid. Flat out: It's a cool place that doesn't pretend to be anything special, which is why it's cool. For years Kirk has insisted that it reigns supreme among Texas dives, but I never thought of it that way and, despite my fondness for the place, I didn't think it belonged in this book. Still, he convinced (sometimes spelled b-u-g-g-e-d) me to go back and keep an open mind.

Which I am doing as I pull up to Riley's after a shitty drive. The radio proclaims meteorological summer is ending, but outside it's still hot as a cowboy's crotch at the rodeo. The rising dust from the road coats the cars in the parking lot. Mine will soon join them in wearing a dusty cloak. Big rigs constantly growl past Riley's front door, only stopping when another half mile of boxcars has to pass through on one of two sets of railroad tracks that bookmark the property.

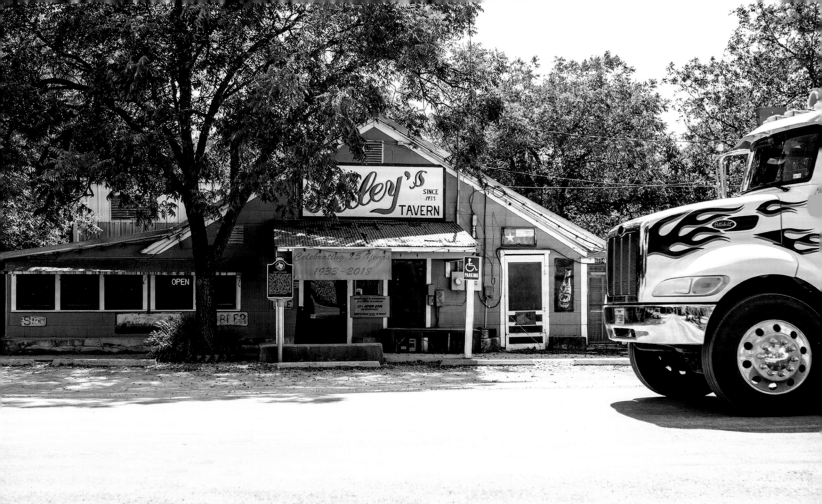
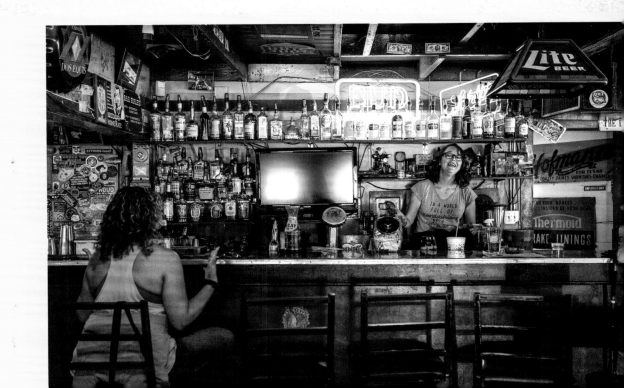

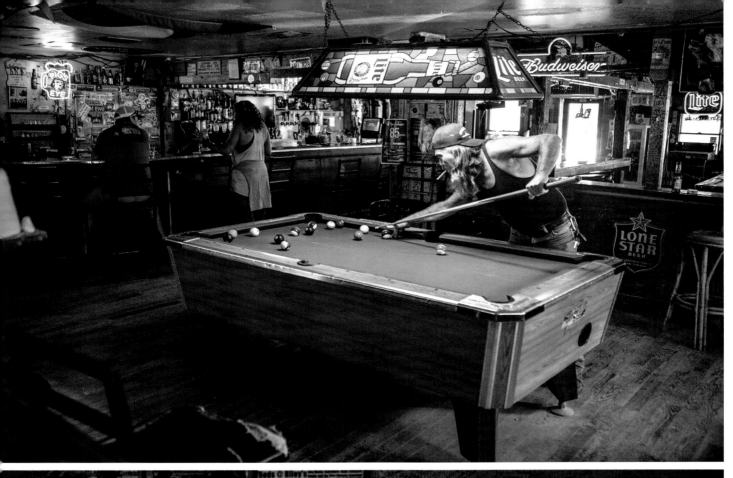
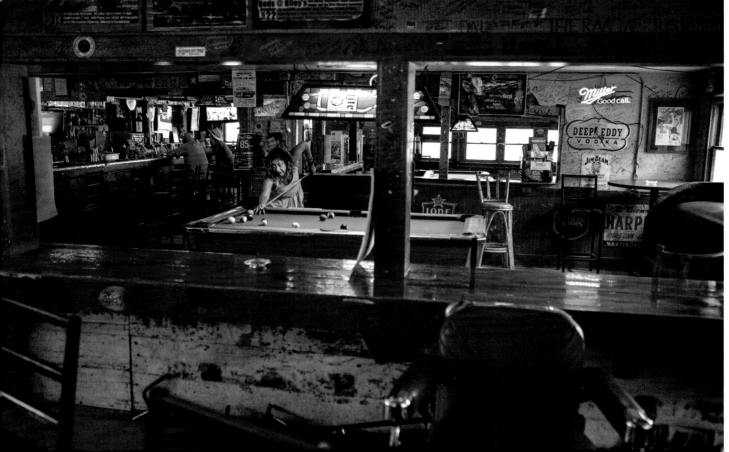

I'm primed to complain about the drive when I get to the bar, which might be a point in Kirk's favor. After all, in a dive, if you can't bitch to your bartender, why are you there? Kirk is already sitting at the bar, Lone Star in hand. What's this, though? Another familiar face? Yes, it's Piper, formerly of the excellent but forever-closed Triple Crown of San Marcos. Piper welcomes me with a Jack-rocks-water, no charge. We grouse about the roads and some other stuff you wouldn't really care about while Hank Williams sings in the background about how his bucket's got a hole in it. And yes, that seems pretty divey to me.

Kirk grabs his camera and starts snapping photos of an older couple celebrating their anniversary, leaving me to rationalize my way out of what appears to be an obvious situation: Riley's is, in fact, a dive bar. Just look around. There are exposed wood beams and the walls are some kind of green. Where there aren't beer signs or license plates or bumper stickers there are signatures, scribbles, and doodles from customers over the decades. With so many neon signs, the whole front room takes on a pink-and-yellow hue at twilight.

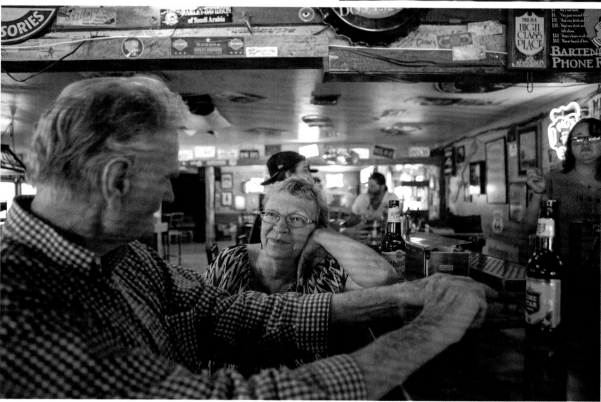

But there may not be a more compelling argument for Riley's being considered a dive than having Piper behind the bar. Piper knows her stuff, is smart and funny, but let's just say customers might interpret her demeanor at times as being, oh, I'll call it mildly mercurial. When more customers arrive, Piper asks—sourly—to nobody in particular, "Why do people keep coming in here?" Her friend Dee ("Deezul") answers for the rest of us: "Because this is a bar and we drink." Someone else says, "Hear, hear," and Piper concedes half a smile.

Deezul tells me she "plays guitar and sings some songs" and describes her style as "like a campfire guitar player." She tells me she was previously with law enforcement

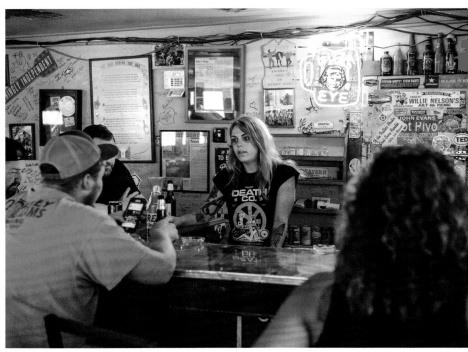

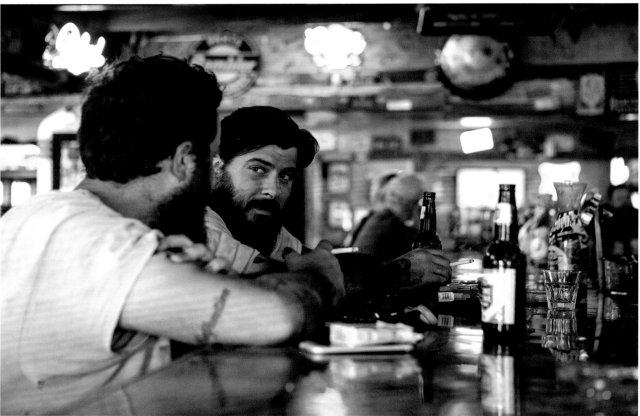

corrections, before that she was a journalist in the army. "I love Piper. She doesn't scare me," Deezul says before pulling away from the bar to play pool.

There are fifteen, maybe twenty customers; some of them would like to pay for drinks. Piper will probably never get back to the paperback book she's been trying to read all afternoon, and that's getting under her skin.

Do you know what gets under Kirk's skin? Using "portrait" and "landscape" to describe photo orientations that he insists be called "vertical" and "horizontal," respectively. So when I ask for a "portrait of the jukebox," he turns and looks (oftentimes spelled g-l-a-r-e-s) at me. "Don't ever say 'portrait' or 'landscape' again—or I'll never buy you another drink!"

He didn't actually say that last part, but his expression sure did, and he's serious about using the proper terms. "But that's what the world calls them," I plead. "Do you want me to take a poll in here?" I don't know these people, but I'm damn sure I can walk up to any one of them and talk about this asinine topic. Which is another point in Kirk's favor for the dive/no dive deliberations.

Outside, the trucks grind their low gears to a stop. A train blares its horn while pulling its freight down the line. Inside Riley's, there's a massive *clack*! It's Deezul at the pool table. She's got a sharp break. (Fair warning.) A dozen strangers chitchat, joke about shit, laugh over the state of the world, and we buy more drinks, which seems to annoy Piper, who's fighting with the cash register. Deezul asks her to make a mojito, and Piper stares at the ceiling and groans. Remember that thing about her demeanor? It's kind of

coming through again now: Why are you bothering me? Deezul changes her order to a beer and Piper smiles, taking a long drag off her cigarette.

Smoking is perfectly legal inside Riley's because it's perfectly legal in surrounding Comal County. Hell, a few stools down there's a guy with a silver ponytail dropping out the back of his baseball cap who's just smoking cigarettes, staring straight ahead, not drinking a thing. Considering how many Texas municipalities are going smoke-free in restaurants and bars, the smoke here adds a bit of an outlaw ambiance to the place and becomes another argument in Kirk's favor.

But the game's not over. For one thing the sign outside states that minors are allowed inside until 8:00 p.m. Well, hell, I don't care if they're only allowed inside for thirty minutes every time the juke plays "Whiskey River," there is no place in a dive for

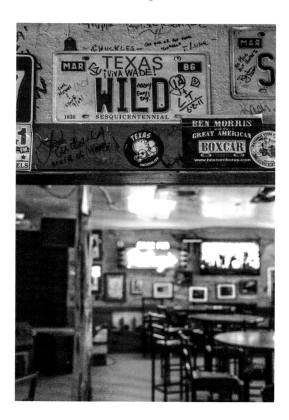

children unless they are saving their parents (the owners) money by washing glasses.

Not only that, there is a cottage in the back to rent for the night. That's not bad—in fact, it's a great idea. But it provides too much of a safety net. It's simply too good of a notion for a dive.

There's one stage in the back room and another outside as part of the spacious patio. Again, that ain't bad, but my ideal dive lets the jukebox do the heavy lifting for the entertainment—that is, if anyone wants music, and sometimes we don't. (I'm not finished with Riley's jukebox either, so hold on.)

Occasionally a woman wearing a faded tie-dye shirt pops through a door behind the bar with turkey sandwiches, brisket burritos, and whatnot for the early evening crowd. Her name is Jeska, and it turns out I used to drink with her years ago at the Triple Crown. (What can I say, Texas can be a small world sometimes.) Jeska tells me they're planning a bigger menu and the dishes will be even more polished than they already are.

Good food, like live music, pulls too much focus away from the booze and is another argument for why this isn't a dive.

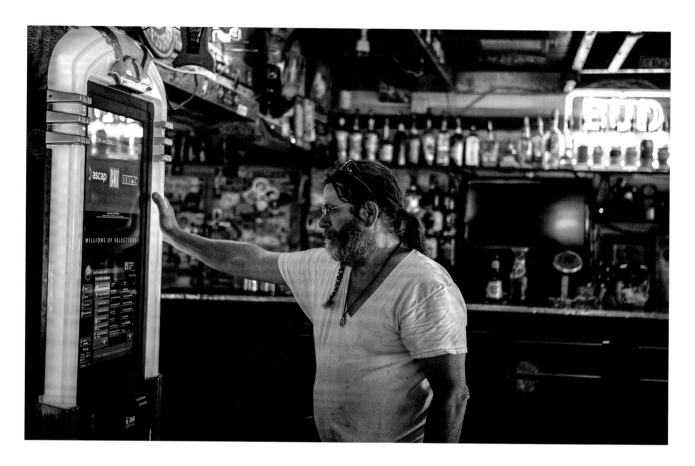

Speaking of history, Riley's is old—really old. The building's been around since the late 1800s, when it was the Galloway Saloon. It became a private house but eventually returned to the bar biz when, in 1933, Prohibition was repealed and J.C. Riley obtained the first license to sell beer in Texas. That first legal beer was served right here, and that kind of history matters. Hell, there's an official plaque from the State of Texas outside commemorating the event, which means it's only a matter of time before Riley's becomes just another stop on some bus tour of historic sites: Go inside, take a selfie, maybe buy a T-shirt, and then it's back on the bus to get to the next stop, the historic Outlet Malls of San Marcos.

Speaking of jukeboxes, Riley's has one of those modern models that streams music from the cloud instead of playing CDs (or records, for all you history buffs). REO Speedwagon's "Keep on Loving You" is playing. I actually love this song, and suddenly I find myself back in middle school, wanting to make out with Ellen Ziemer at the roller rink. Later, when Cat Steven's "Wild World" comes on, I find myself longing to make out with, like, any woman in a college dorm room. I grab Kirk and suddenly we're dancing and all the tension between us melts away.

No, that last part didn't really happen. But my point is that these streaming digital Wi-Fi nuclear-fission music genera-

tors are not an improvement on the classic jukebox. Sure, when Piper yells, "Play a sad-bastard country song now!" then her request can be granted quickly enough by typing in George Jones's "He Stopped Loving Her Today" or practically any other song in the known universe, but too many choices spoil the soul. And where is the rule written that a jukebox must be all things to all people? A well-curated juke is crucial to defining the character of a place. It's filled with well-thought-out selections because somebody had to physically load every piece of music into the machine. This is not the case at Riley's. Which is why I score another point against Kirk (who doesn't really dance that well, if you want to know the truth).

I'm reveling in my approaching victory when a guy wanders over to where I'm writing my notes, and he picks up my digital recorder. It's a slender, rectangular thing with a small stereo mic sticking out of the top. He blows into the mic. This is not the first time my recorder has been misidentified as a Breathalyzer, which is why (as I always do when this happens) I encourage him to keep blowing—"Blow, blow, blow!"— and I'm surprised when it actually measures his blood alcohol level to be 0.06. Or maybe that's the volume level—either way, the guy's under the legal limit, so we order a round.

Over the next hour or so I learn a lot about my new friend, Leo. He studied interior design at Texas State. He hates the Aggies. He's never been in jail in the United States. He was in the navy. He's been to about seventeen countries, and two of them, Gibraltar and Italy, have previously taken him into custody for one thing or another, like illegal fireworks, trash-can fires, and bar scuffles with rhesus monkeys. A third

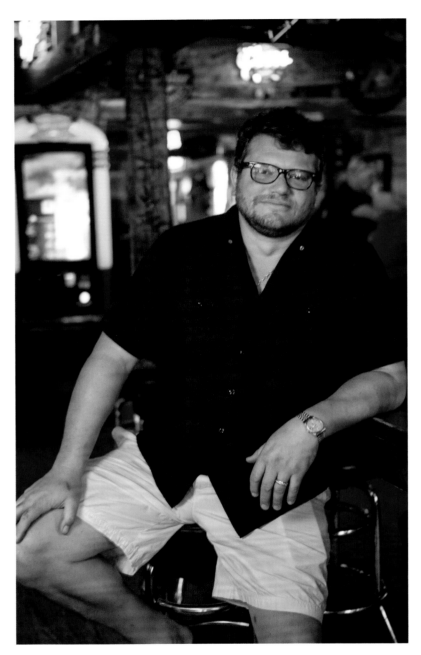

country, France, has made it clear that he's not allowed there ever again. Leo's a great drinking buddy. We talk a long time, we buy each other rounds.

The place clears out. The first band of the night will arrive soon to set up for sound check. At one point, I accidentally call Piper "Pepper" (the name of one of my dogs), and her demeanor tells me that my time at Riley's is coming to an end today. It's time to leave or, put another way, it's time to pay the Piper, which I do and then stuff a few bills in the tip jar. She flashes a smile, and I know it's not because of the cash. It's because her shift is almost over.

I stopped keeping score with Kirk sometime before Leo was done with his story about moving to Washington State to oversee a marijuana farm, so let's just say the game between Kirk and me is all tied up.

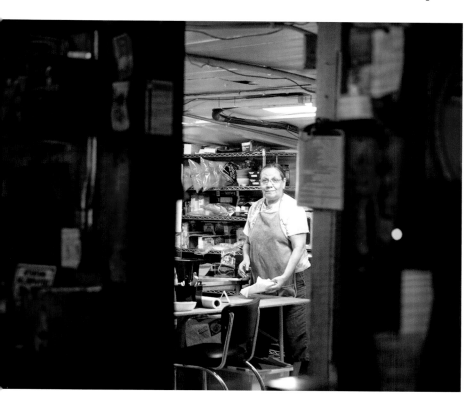

There's really no choice but to get the owner's opinion, which happens about a week later when we go back to visit Joel Hofmann. He's owned Riley's since 2004, and when I talk to him in the back room, I just come right out and ask him the big question: "Why in hell did you hire Piper?"

Joel is a pretty big guy and has a baritone voice to match the physique. At first he looks at me as if he doesn't understand the question. I don't break face. He grins. A laugh—a rich and hearty laugh—slowly rolls out of him until it fills the stage area like he's belting out a thunderous ending to a country-western song about finding redemption in the eyes of the Lord. "I don't know," he finally gets out. "I like Piper. But you don't mean that seriously, do you?" He laughs again when I reply that I kind of do, while looking over my shoulder to confirm she's not working this shift.

Actually, Joel knows I'm just having fun and that I'm happy he's hired a number of the old Triple Crown crew, especially since so many of us ex-pats regularly visit Riley's anyway. And it's a hard life owning a place like this. He bought Riley's because he figured it would be a place to make a living while playing his music. He's been singing and songwriting and getting on stage for about twenty years. "A little longer than I've had Riley's," he tells me. He calls his music "mostly traditional country."

But the bar business, like the music industry, is a tough life to grind out. "You have to sell a lot of drinks to make a living," Joel says. "When you have bands just about every night and on the weekends, you have to pay them. But about a year ago or so I had to drop cover charges because no other bar around here with music had covers. So I'm

paying the bands pretty much what I should be making in wages just to keep them playing here." He still hits the road with his band and is still putting out new music, but he's also working fulltime with his father at the family business, Hofmann Supply. He estimates that he hasn't paid himself for working at Riley's for about two years.

So when I finally ask him to categorize his bar and he answers, "It's a honky-tonk," I can't even summon the energy for a victory lap—even though I agree with him. I mean, geez, this guy is living the lyrics to a sad-bastard country song. I don't ask about his family dog for fear I might be told of its tragic demise during a hunting trip.

"So it's not a dive bar?"

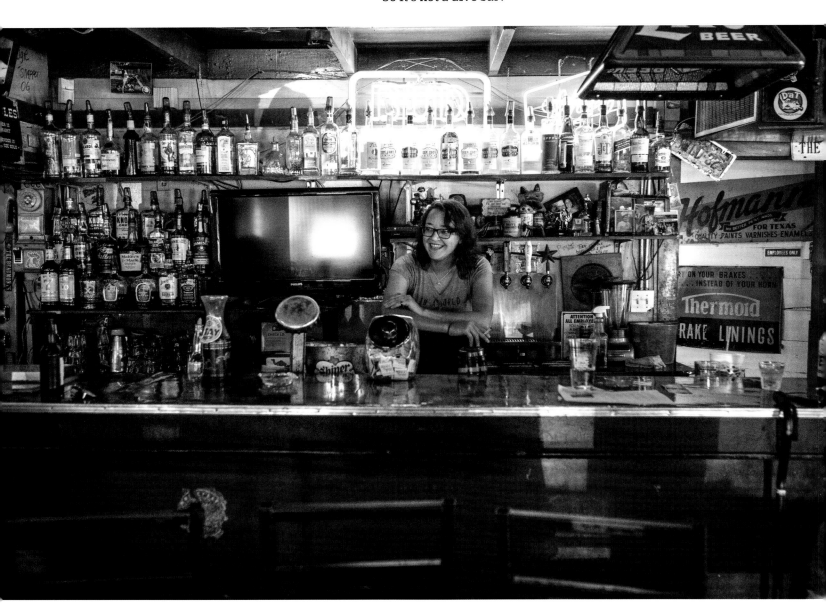

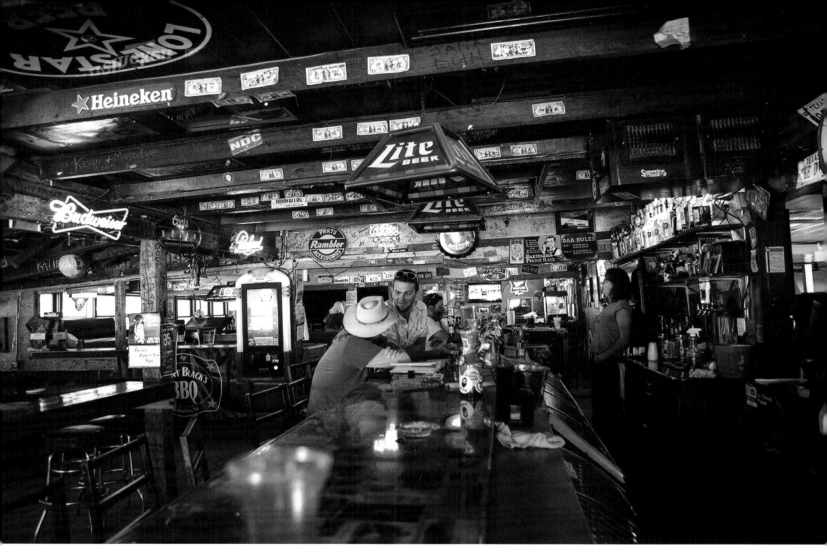

"Oh, that's fine," Joel replies, nodding like he's got no problem with the label. "Look at all the stuff on the walls. It's a funky old place. It's the people that make it what it is. You can call it a dive if you want to."

The interview ends and I'm left to face a grinning photographer.

On the muted television, there is news of Florence, the hurricane that's lashing out its watery fury on South Carolina. "Purple Rain" by Prince is playing on the juke. The rain is really coming down outside, and I'm facing a soggy walk to the loo. I don't

know how it slipped my mind, but Riley's bathrooms are in back. And "back" means outside, on the far side of the patio. While I have no knowledge of the women's facilities, I can tell you that the men's outhouse contains a trough. Kirk is still smiling when I get back. He knows he's won this game.

Look, it's hard for me to fully admit that Riley's really is a dive, but I guess if it's in this book, then it must be so.

And if you're reading this, Piper, I completely understand that someday there's gonna be hell to pay.

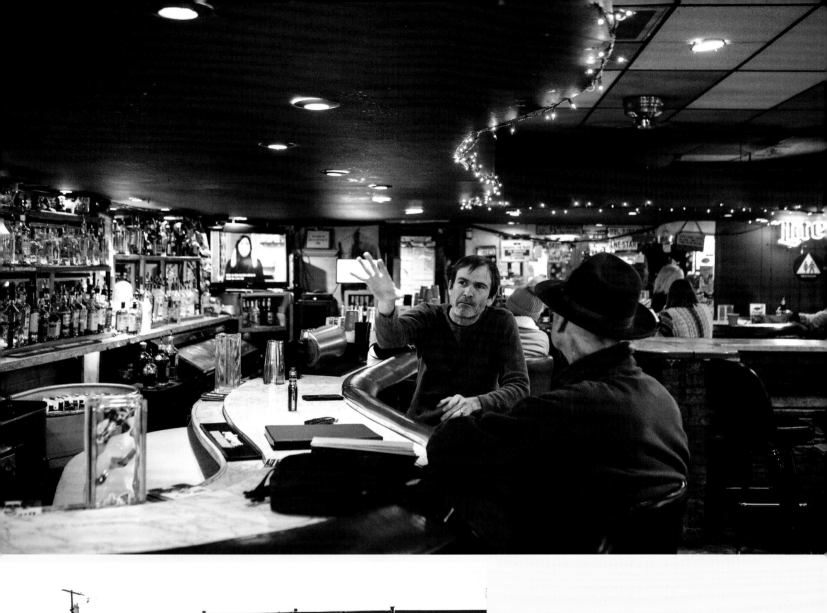

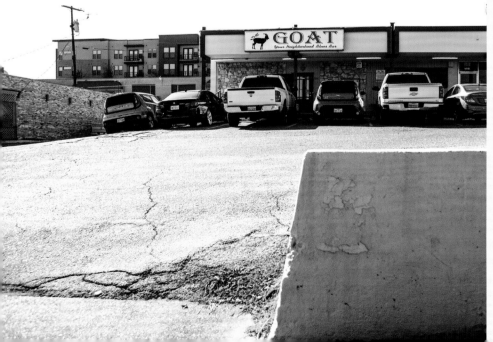

Buddy Guy, Where Are You?

The Goat, Dallas

Taking a seat at the bar is a real treat because it's a long, narrow, Formica-topped serpent of a thing that starts near the front door, curves several times like a lazy river, and after making a hard turn, stretches to its other end some forty feet away. It's an S-shaped bar, only it's a rippled S, an S with some extra groove. The edge is padded to cushion elbows and forearms, and the whole thing sits on a stone and brick foundation. The bar is a thing of beauty, one of a kind, and a good place to sit with some coffee and whiskey and wait for something special to happen.

At ten in the morning there might only be a dozen people drinking at the Goat, but they fill out the room nicely. It's not an especially large place, but in addition to that magnificent bar there's room for several tables and chairs, a pool table, and a raised stage (looks like about three inches tall), big enough for a three-piece combo. Against one wall is what appears to be a plutonium-fueled, hi-def, ultra-plasma jukebox, capable of summoning any song on the planet, and—lo and behold—near the front door, between the candy machines and the casino games, there's a working cigarette machine, sightings of which are becoming so rare that such dispensaries have become the unicorns of dive bars. Of course, plenty of places still sell smokes, but usually from behind the bar; these vending machines are getting tougher to spot and are destined to go the way of the spittoon.

It's been ten years since Dallas banned lit cigarettes in bars, so patrons head outside to blow a butt. With a little imagination, though, it's easy to still see smoke listlessly floating between the Salvador Dalí-esque

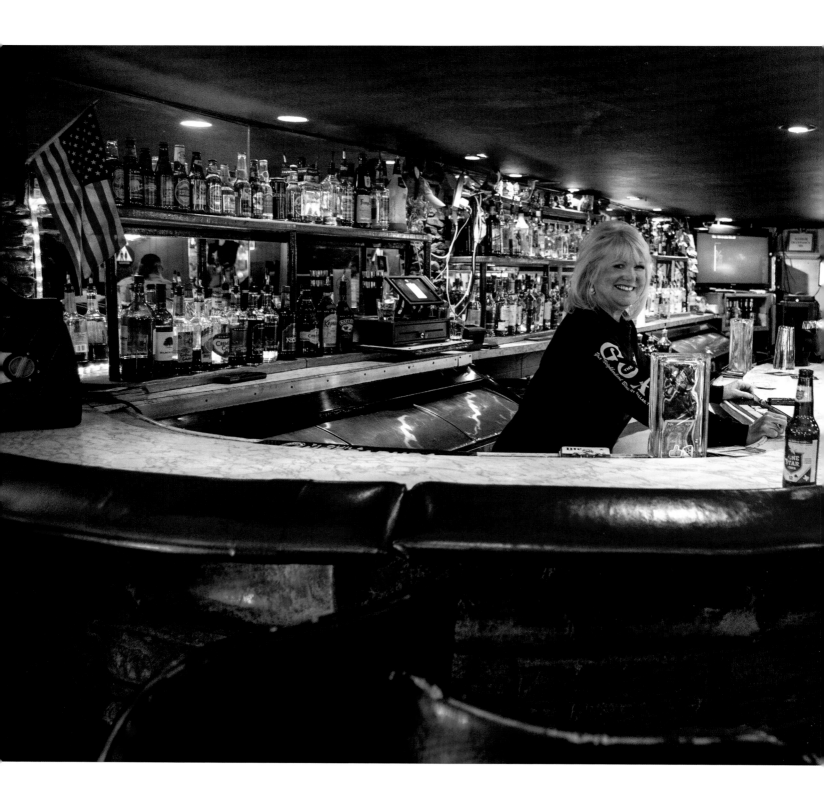

bar and the drop-down ceiling, which has its own wavy form and is accented with fuchsia-colored twinkle lights. There's just something in the Goat's character that expresses familiarity and nostalgia—the classic smoke-filled bar of yore, minus the smoke. Such a setting is ideal for daily encounters among the unacquainted.

"We once got an award from some local publication that named us the 'Best Place to Have a Conversation with a Stranger,'" says Adam Testa, who's been GM of the Goat for about a decade. Taking a seat at one of the bar's lesser curves, he hits his vape, then exhales a cloud of white mist toward the ceiling (still legal in here, I guess, and relatively passable for the real thing, if you're thinking about the aesthetics). "All walks of life hang out here," says Adam. "Everyone's talking to everyone. All pretensions seem to be dropped when you come in here. One particular time a guy came in who looked, well, to be honest he looked homeless. He sits next to a very well-dressed man, who eventually just throws down his Amex Black card and these two are buddies for the rest of the day."

Why is that? Well, Adam thinks it's because they got lucky with the neighborhood, and that's where the regulars come from. "We're on the very east end of Lakewood and to the west it's mostly residential. We're actually kind of straddling a diverse grouping of neighborhoods"—he spreads his arms to indicate the general breadth of the Goat's orbit—"and our customer base, especially in the mornings and afternoons, has got to be at least 75 percent from right around here."

At night and on weekends there are more new faces because of the music. The Goat is,

as advertised on its marquee, "Your Neighborhood Blues Bar," and it features live music, mostly Texas blues, or some nights it's blues-formatted karaoke. Depending on the action, the bar can get quite dense with people. And loud.

It's not crowded now. That glowing jukebox is playing John Lee Hooker; the music level, like the Goat itself, is comfortable, making it easy to talk to strangers. A couple women playing pool stop to grab another round of beers and vouch for the "loving" and "special" people on both sides of the bar, calling the whole group of regulars a "family." A few seats downriver, a guy drains his beer, leans over, and uses the word "simpatico" several times while describing the "chemistry of the room."

Outside on the sunny but chilly patio, Lisa, a petite woman with an "all are welcome here" smile, observes that the sur-

rounding neighborhood used to be all ranch homes. "Now they're building McMansions," she says, adding that it doesn't mean the quality and kindness of the people have changed. "It's pretty much the same. Everyone's just very kind, gracious. We all live right here in the neighborhood. We look out for each other. If someone has more than they should, we drive them home. We take care of our own."

In addition to sharing a common fondness for the Goat, most everyone here is also simpatico in avoiding the place come nightfall. It's hard trading a comfy evening on the couch for the more competitive climate that comes with such nightlife. Oh sure, maybe if somebody like Buddy Guy showed up to play, they might make the trip here after dark, but what are the odds of that happening?

"It'd be great for him to play here," says owner Bill Weiss, speaking of the aforementioned blues guitar legend. It would be too. When Buddy Guy launches into "Dust My Broom," his guitar is an incendiary agent. He can turn the nursery rhyme "Mary Had a Little Lamb" from a simple walk to school into a gritty, sonic journey to the funky side of town. Forever underrated, Buddy Guy is currently the backbone of Chicago blues.

"He taught all those guys how to play, Hendrix up to Freddy King, I've been told. Everybody copied off him. He's just never had that big hit." Bill's a fan, obviously, so in late 2018, when he heard that Buddy Guy was coming through Dallas, he put the word out to anyone who might have a connection to be sure and invite Buddy to drop by. Not only that, he had large white polka dots applied to the walls behind the Goat's stage and around the front door as a tribute to

Buddy's affinity for wearing polka-dotted shirts and decorating his guitars with polka dots. Then everyone waited for him to show up.

"We haven't seen him yet." Bill takes a sip of beer and then makes it clear that he's not delusional or anything. Buddy Guy's not keeping him up at night. After all, he's got a bar to run, something he's been doing every day since Cinco de Mayo 2004, when he bought it with his girlfriend, Sandy. "She wanted this to do. It was not at the top of my list, but it was for her."

Unfortunately, Sandy passed away from cancer, which left it up to Bill to put the Goat at the top of his list. "You learn a lot as a bar

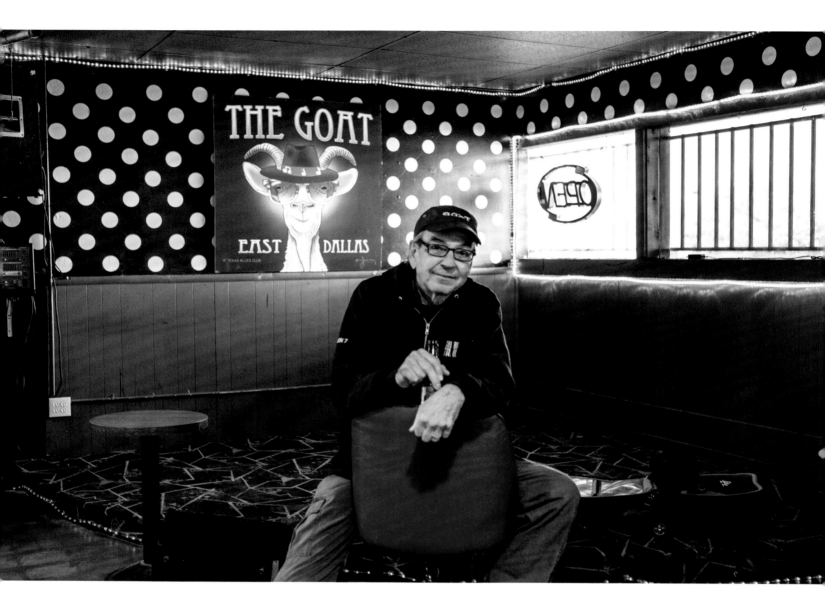

owner," he says. "You see a lot. You end up having a lot of good times. Along with it comes drama from people. There's never a dull moment here."

Some guy sitting next to Bill takes a sip of his beer and says, "We're still learning every day."

Bill likes to keep things simple, consistent, in line with traditional neighborhood joints. He says, "We have cheap drinks and we don't serve food. You go to other places and it's a bar and grill. We're a *bar*. You can bring your lunch in, that's okay. But I'm not going to be saddled with a menu. And we serve everything in glass; there aren't any plastic cups."

The other guy chimes in, "Amen to that."

"The prices stay pretty stable here. Only when the distributor's price goes up do we go up. I don't think we've ever gone up more

than fifty cents." Bill turns to the guy next to him for confirmation.

That guy nods his head. "That was quite a rumble." He's referring to the customer backlash from the last price change.

Bill says, "Yeah, we held off for years. It used to be $2 beers all day. Now it starts at $2.50. We still have the dollar beer for [Dallas] Cowboy touchdowns, though."

The guy sitting next to Bill is Jimmy, and he nods along. Most neighborhood bars have a guy like Jimmy. He is the Goat's right-hand man, the guy who starts out one day doing a little cleaning and then some maintenance, and before long his projects are what help keep the place looking and feeling the way it should. On occasion, his work stands out. It was Jimmy, in fact, who personally adorned the Goat's walls with the bold white polka dots.

"Maybe he'll drop by," Jimmy says of Buddy Guy, not all that convincingly, "but tomorrow we'll be making the patio a little more conducive to our regular outside patrons. A lot of interesting things happen on the patio. That's where the neighborhood gossip gets passed around. Movers, carpenters, electricians—they're all there." Then Jimmy stands to leave and sings, "You can get anything you want/at Alice's Restaurant—and our patio-o-o." (Before he gets out the back door, he clarifies that his take on an old Arlo Guthrie song referred only to networking on the patio. In other words, you can't get *everything* you want out there.)

* * *

About a month later, on the way to the Goat, various spots pop out along the passing streets that I'd missed on all the previous

trips, like pawn shops, liquor stores, a skate and vape shop. There's a juice bar and a bar advertising that its patrons can throw axes inside, presumably not at one another. Behind the Goat are some nice-looking apartments and across the street is a shopping center. A couple doors down there's a personal gym.

Adam's right—an eclectic clientele is bound to assemble from a place with such

elements as these. But why would anyone walk in here in the first place?

"It's a getaway," answers Brandy, who is sitting with Brad, near the end of the bar. And by "getaway" Brandy means, "People come in here because they don't want to be seen."

It was about fifteen years ago when Brandy and Brad decided they wanted to get away from the usual crowds and friends and "anyone who might be looking for us." From

all come here. I guess they come here for the anonymity," Bill says, taking a seat near us.

Kathy, who's been filling drink orders all morning, confirms Bill's conclusion. "A lot of people come in here and they don't want their friends to know. Some guys don't want their wives to know they come in here. I guess we just have that reputation." She smiles at the notion (and truly the world might stop turning if Kathy's charming smile ever left her pretty face) because it was that reputation that lured her to the Goat in the first place.

"When I first moved here, I was at a different bar, and they were telling me about places to check out. And they said the one place I didn't want to go to was the Goat. So immediately I came over here. I had to check it out. I started off as a customer, and then they hired me as a bartender."

That was just about four years ago, but this place has been a bar since the 1960s. It's had other names, like Office Lounge and Vaughntini's, and other owners, like Lota Dunham, who called it Lota's Goat. ("She loved her Pontiac GTO, nicknamed 'the goat.' She actually wanted to put the front end of it over the marquee, but the city didn't allow her," Bill says.) All the while, this funky-ass Formica-topped bar has survived; perhaps this bar is the magnetic force pulling at the neighborhood.

the outside, the Goat looked unassuming enough for them. Plus, it opened at 7:00 a.m. "But we looked to see if we recognized any of the cars in the parking lot before we first came in here," Brad says.

They've been regulars ever since, and their story isn't that unusual, at least not the part about wanting to stay off the radar for a couple hours. "Doctors, lawyers, judges, they

Without a doubt, the laws of the universe allow that anyone—anyone—could walk through the front door, even someone wearing a fancy shirt that matches these walls. But no, Buddy Guy hasn't stopped by yet.

"He does come through Dallas from time to time, but he's always booked up for a concert," Bill says with a slight nod. "Some of the musicians who play here know him a bit.

It'd be nice if he heard about us through the grapevine."

While we wait, Brad asks me, "You want to hear a good Goat story?"

Of course.

Brad and Brandy, it turns out, are a lovely, young professional couple and the kind of strangers you hope to sit next to for a couple rounds. They're relaxed but adventurous, and it comes through in their story, which is, indeed, enthralling. But it's also long and meandering, not unlike this pleasantly curvaceous bar, and Brad and Brandy tell the tale interchangeably, so it needs decoding and summarizing. Plus, it needs a bit of Purell as it unfolds. We begin with them drinking at the Goat, where they meet a guy named George. They all drink together for a while, then leave. George says some odd, inappropriate shit in the car before they hit a strip club and a couple of Asian massage parlors. That's followed by a harrowing ride crammed inside a Maserati with "a really creepy guy" at the wheel. At some point, an

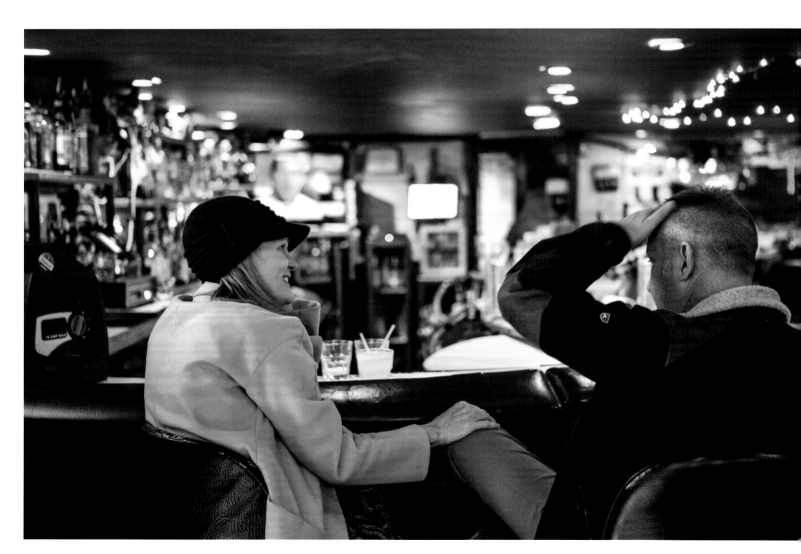

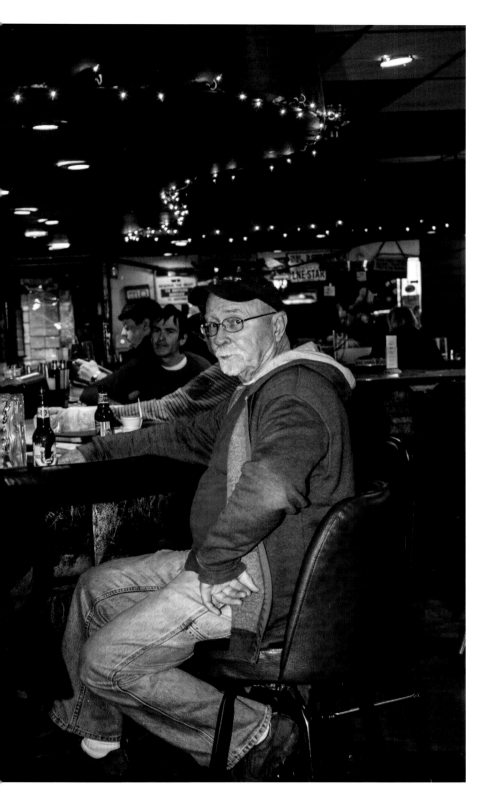

"ex-Playboy Bunny" enters the story as an Uber driver and attempts to invite herself back to Brad and Brandy's place. "She wanted to charge $1,000—just for the honor of touching her boobs." Shortly after that, this tale of Dallas depravity comes to an end—which is right where it began, with Brad and Brandy back at the Goat—the Bunny's boobs have at least been seen ("They were okay"), but there is no mention of money or whatever became of George.

It's the friggin' *Odyssey* as retold by Brad and Brandy, and it's totally unbelievable unless you know a little something about the Goat and the people who come in here. Once inside, this place becomes exactly what people want it to be. And so I believe every word.

Whether or not the possession of such an existential state of being favors the Goat enough to pull in Buddy Guy to set that little stage on fire has yet to be determined. In the meantime, this long, shapely bar remains a really good place to wait for something very special to happen.

Still Sylvia's

A Great Notion, Fort Worth

The heart of this place is Sylvia Donavan. In 1991, Sylvia arrived in Fort Worth after a successful real estate career in California. Her intention was retirement—but she really wasn't the retiring type, and so, along with a friend, she bought a bar in the Ridgmar neighborhood. It was called A Great Notion, and Sylvia wasn't that crazy about the name but still decided to keep it. Her friend passed away a couple years later, leaving Sylvia in charge—and that part suited her just fine. She was smart, capable, and the textbook definition of a "people person," the kind of woman who got along with millionaires and pot-smoking kids and everyone in between.

"Sylvia was a beautiful woman. Everybody loved her and treated her with respect. You did not cuss around her or she would get on your case," says Annette, who's tending bar at A Great Notion late one afternoon in December. Having prepared for me a White Russian, which I always drink when Christmas is coming, Annette provides a bit of a history lesson, explaining how the Notion used to be much smaller than it stands today.

Turns out, I'm sitting in part of the original bar that contains *the* original bar from 1972, when the place first opened. And somebody took the time to craft this bar with colorful stained glass on top, which is lit softly from within. The blue, yellow, pearl, and green floral design adds luminescent enjoyment to the practice of staring at bar tops, day after day, drinking and contemplating life's complexities, like how it's neither vodka nor Kahlua that makes a good White Russian: the better the cream, the better the drink.

LIGHT® PROUD SPONSORS
HORNED FROGS™

Bucket
Special
12oz
Bottles
Bud Bud Light Mich Ultra

$13 25

BUD LIGHT

ENJOY RESPONSIBLY ©2018 Anheuser-Busch, Bud Light® Beer, St. Louis, MO

OLD MAGNOLIA
The Original

Established

Bourbon Liqueur

Lite®

GREAT TASTE.
96 CALORIES.
3.2 CARBS.

GREAT TASTE. LESS FILLING.
HOW 'BOUT THEM BOYS
MILLER LITE LONGNECKS

$2.50

DURING HAPPY HOUR

Lite®

2018 COWBOYS FOOTBALL SCHEDULE

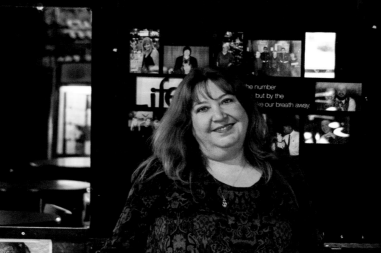

the number
but by the
take our breath away.

Brewed in
Texas.
Raised for
the Stars.

BUD LIGHT BUD LIGHT

GET Y
MARC

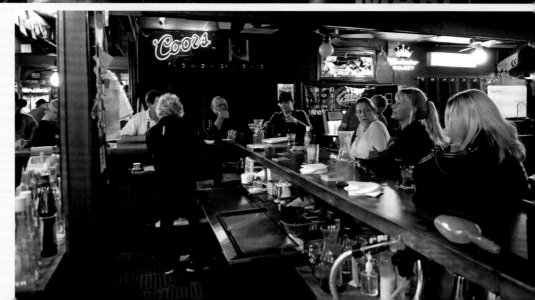

Coors

Above, the low ceiling features more colorful designs and some nice woodwork to admire. There's a brick archway behind me with mounted lanterns and a space just wide enough to put a couple tables. Then comes another archway and another small area that mostly contains electronic games of chance. It's hard to believe there was a dance floor and a place to throw darts in these diminutive spaces back in the day, back before Sylvia arrived, but I'm assured it's all true by a few of the patrons seated nearby.

"That's where all the fistfights used to take place," one of them says, with a nod and a crisp laugh that indicates he might have thrown a punch or two himself.

The bar area is decidedly different from the rest of the Notion. For one thing, the stained glass is only on one half of the length of the bar top. When the place was expanded the first time, the bar was extended—with

a similar grain of wood but no stained glass—to enclose the bartender's station, where Annette now stands and who (I have observed) will answer to the name "Pixie."

Occasionally, she disappears into the back kitchen. Food isn't a big attraction at the Notion, but you needn't go hungry if you favor club sandwiches, nachos, small pizzas, stuff like that.

"I'm not bragging, but I can fix good food," Annette tells me.

Beyond the bar, the rest of the place doesn't have quite the same architectural character or interior charm because Sylvia expanded into two adjacent spaces previously occupied by other businesses. It's ample, with a cluster of roundtops and barrel seats, a karaoke setup, a jukebox, and a pool table. The far wall is dedicated exclusively to darts, with three boards and scoring charts. The other walls have the requisite neon signs and mirrors, although a few personal touches are found as well. Perhaps the most cherished item is a framed photograph of Sylvia, mounted high on the wall, watching over her pride and joy.

Sylvia passed away at the age of eighty in 2018. By then, the Notion had grown to more than three times its original size, and day-to-day operations had been turned over to her daughter, Gail Oshier.

"Gail is one of the sweetest people," says Annette, over the sound of ice banging away in the cocktail shaker in her hands. "Her mother taught her the business and taught her well."

Sitting next to me, Ellen, a regular customer for about twenty years, calls Sylvia a great friend. "She was loved. She cared about people, her customers. I can't think of anything bad to say about her."

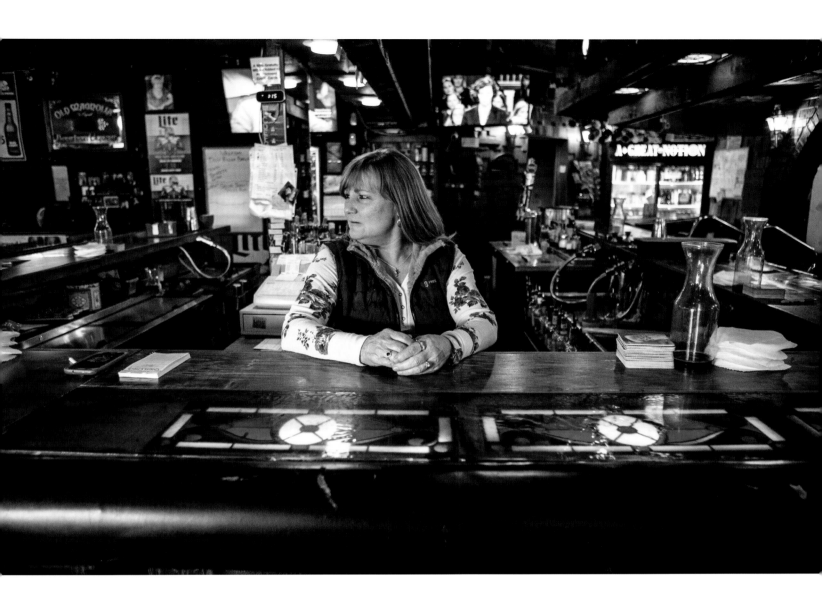

"I can't think of anything good to say about these guys." Whereas there was tenderness in Annette's voice when she spoke of her former boss and friend, now her tone is sharp and witty as she points to the customers returning from an outdoor smoke break. They reclaim their captain's chair barstools, talking all over each other, trying to get in the best rebuttal to Annette's jest. She waves them off. "Sometimes the kids

act up. There are times when it seems like everyone in here is getting ornery. They give me heck all the time. But I know how to handle them."

A fella named Clint, with long hair and a profound salt-and-pepper beard, takes a sip of his Jim Beam and Coke and leans toward me. "We always compare ourselves to *Cheers*," he says. "Everybody knows your name. Everybody's got their own idiosyn-

crasies, but we all get past it. Why? I don't know. I'm not a trained psychiatrist. Maybe it's the alcohol. Maybe it's just the mix of people. I guarantee you, if I was in trouble, there's not a person sitting at this bar right now that wouldn't come out and help me."

I understand what Clint's saying, that alcohol lubricates conversations, but what about when a stranger walks in?

"They ain't a stranger very long," answers Rusty. He and his long gray ponytail sit next to Clint. There's an ease between them that suggests they discuss matters of interest on a regular basis at the Notion.

Clint points to a young man sitting nearby. "He's a newbie, but he's becoming a regular." Then he asks him, "Why are you coming in here?"

The newbie, Zac, sips his shot and answers with a deep baritone voice that resonates like he's some lost brother of Johnny Cash. "Because I want some fucking booze." Shrugging his shoulders like he'd just said the most obvious thing in the world, he tells me, "I was living right down the street. It was the location. That's why I'm here."

Rusty chimes in, "Location will get you in

the first time, but it won't keep you coming back."

Everyone agrees there is a specialness to this place.

A hard smack of billiard balls.

Annette shakes her shaker.

The juke roars out a couple of John Mellencamp's songs.

Clint pulls out his phone and shows me a photo of Shorty's, an old neighborhood bar in Port Aransas. Apparently, some of the fellas from the Notion like to head down to Port A for SandFest, a sand castle building competition. Shorty's is their Notion away from home. "There's nothing else like Shorty's," he says, urging me to go.

There is a general state of pleasantness at A Great Notion. This may be the easiest place for striking up a conversation that I've

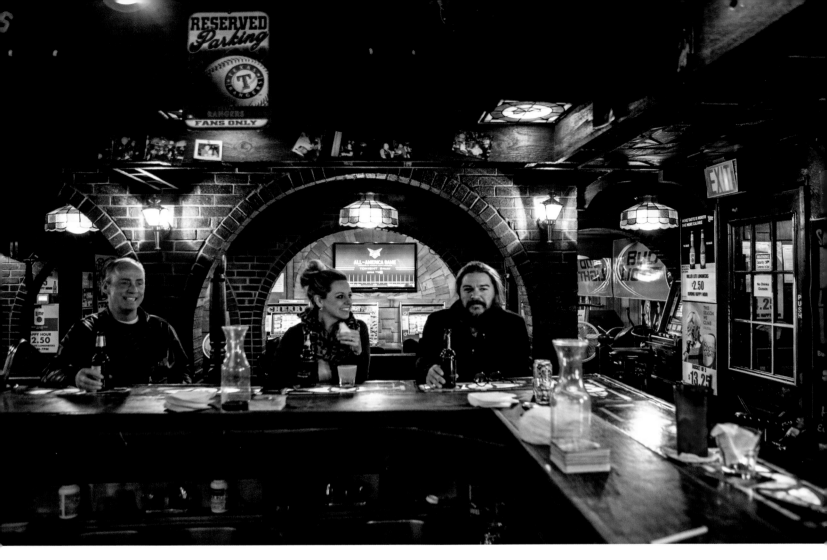

been to. For civilians who claim dives are lonely places, populated with despair and solitude, the Notion tramples their argument like a cigarette butt on the sidewalk.

At one point, everyone's raucously bantering back and forth with an older generation's humor about women's role in society. Someone tells Annette to get in the kitchen, someone reminds her to be barefoot. Annette responds with a salty "Fuck off!" and the place becomes pandemonium, with wisecracks and comebacks and cackles of laughter.

Through the front window I can see that evening is giving way to night. Happy Hour is coming to an end, but not the happiness.

* * *

It's a whole month before I catch up with Gail Oshier, who saunters in one morning with a smile.

"Don't you love that I'm hanging in there?" She's talking about still owning the Rock-Ola jukebox that I've been openly admiring while it plays one country-western song after another. "I can't even

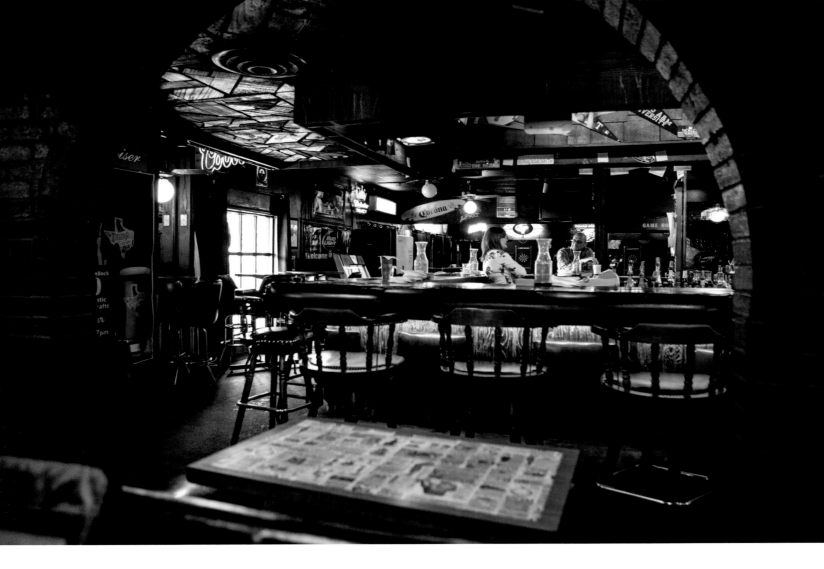

get a working dollar-bill-acceptor for it, so the damn thing's free." She laughs heartily. Gail is a serial laugher—amused at the world, smiling at nearly everything.

It's just past 11:00 a.m., shortly after the Notion opens, and we have a quorum at the bar, including Russell, who's usually one of the first to arrive. There's Brandy, who has worked here in the past but today is just drinking. ("If you hang out long enough, there's going to be a job for you here," she says with a shy smile.) And then there's Christy, cousin to Gail by marriage and a

real live wire. She says she moved nearby because she was tired of driving across town to get here—and the quorum shares a good laugh because, apparently, it's the truth.

Gail calls for a round of "Shakies," and so Cindy, behind the bar this morning, springs into action. The Shaky is famous here. It's a Kamikaze, made with vodka, triple sec, and lime juice, and it's traditionally poured in a rocks glass and stirred with ice. "I guarantee you that we do them the best," says Gail over the sound of the shaker. "We try them

everywhere we go. Ours are different. We call them Shakies because they have to be shaken a lot. The more you shake it, the better it is."

Served neat, it's delicious. Cheers.

I tell Gail I see a strong resemblance between her and her mother's photo on the wall, which makes her smile and say, "I'm very much like her, only not as tough."

Brandy says, "She was amazing. She was great."

Cindy notes, "She was Mom. She was very giving but very stern."

"Very stern," Brandy agrees.

"She was a very good business person. She gave good advice on lots of things," Cindy adds thoughtfully.

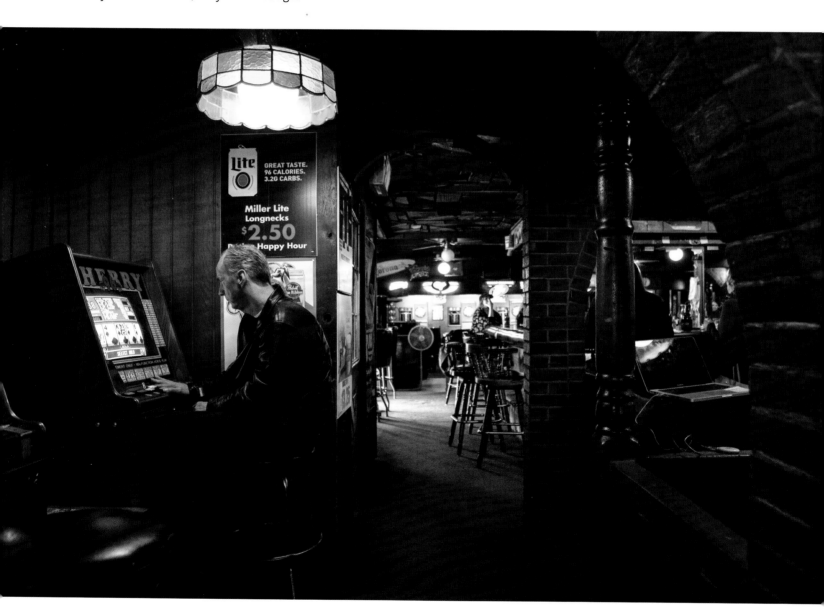

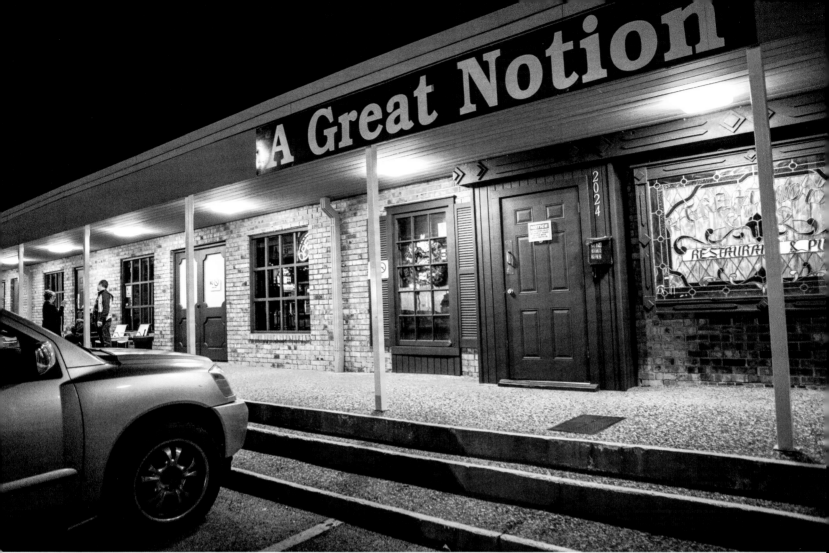
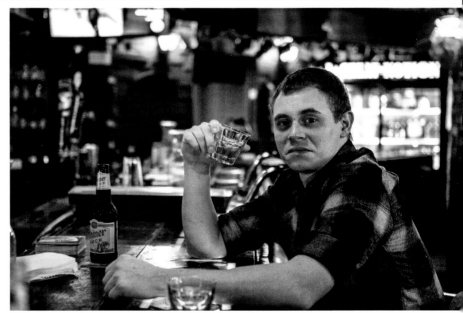

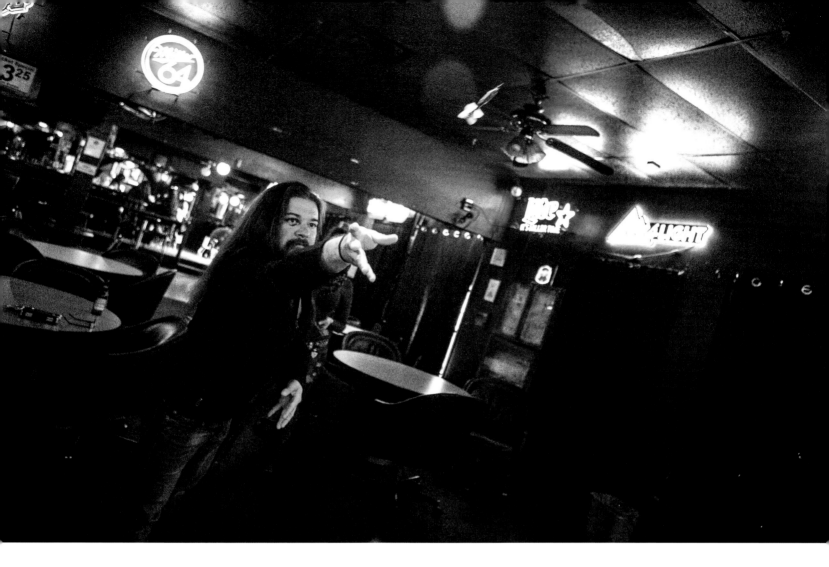

"She had kind of retired from the bar about five years ago," Gail explains to me. "We gave her the title of 'Social Director' and she'd still come up here from home to see everyone." Although Gail and her boyfriend of thirty years, Carl Linderholm, are at the helm now, it seems obvious that in many ways this is still Sylvia's place.

When it comes to the bar's unique name, Sylvia never knew the origin. Gail believes it could be a reference to the title of Ken Kesey's novel *Sometimes a Great Notion*, published in 1964, but she doesn't know that

for a fact. (Kesey's title was inspired by lines from the American folk song "Goodnight, Irene," which went "Sometimes I take a great notion/To jump into the river and drown.")

It's possible that the bar's literary name could lead someone standing outside the building to think the place is a used bookstore. After all, it's located in a shopping center, with a florist, laundromat, and hair salon nearby. Some people have called asking if the business has something to do with sewing because the word "notion" is in the name.

"I've seen cops walk in and they're surprised that it's a bar," Brandy says.

Cindy adds, "I've had lots of people say, 'I've been living here for thirty years and I never knew this place existed.'"

"I've heard that a lot," Christy agrees merrily.

"There was a moment when Sylvia wanted to change the name, but we all voted no," Gail explains. "It's so unique, no one else is going to have that name. And it starts with an 'A' so it put us at the top of the Yellow Pages."

One way or another, a few years ago an important group of paying customers eventually found their way to the Notion: karaoke singers. They're pretty serious about their sing-alongs—and loyal to the bars that welcome them and treat them right. "Business-wise, karaoke changed our lives, but it was probably the hardest decision because our regulars weren't ready for all these people coming in and singing," Gail says. "It turns out that our people can sing too."

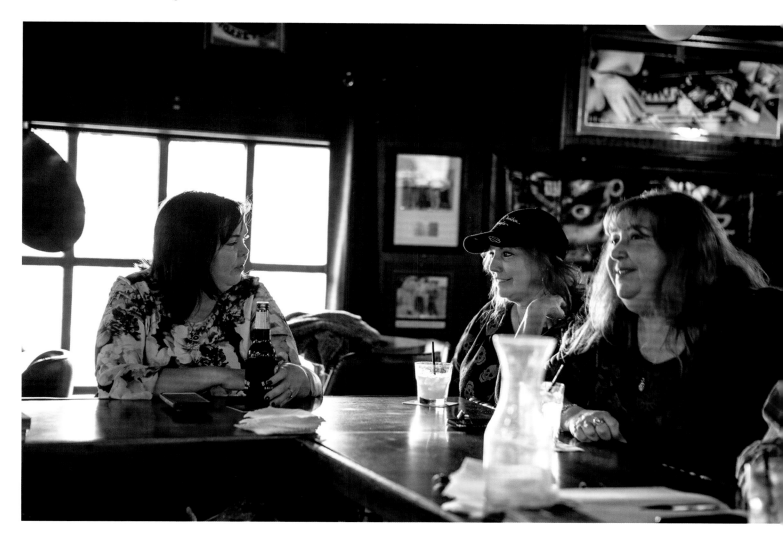

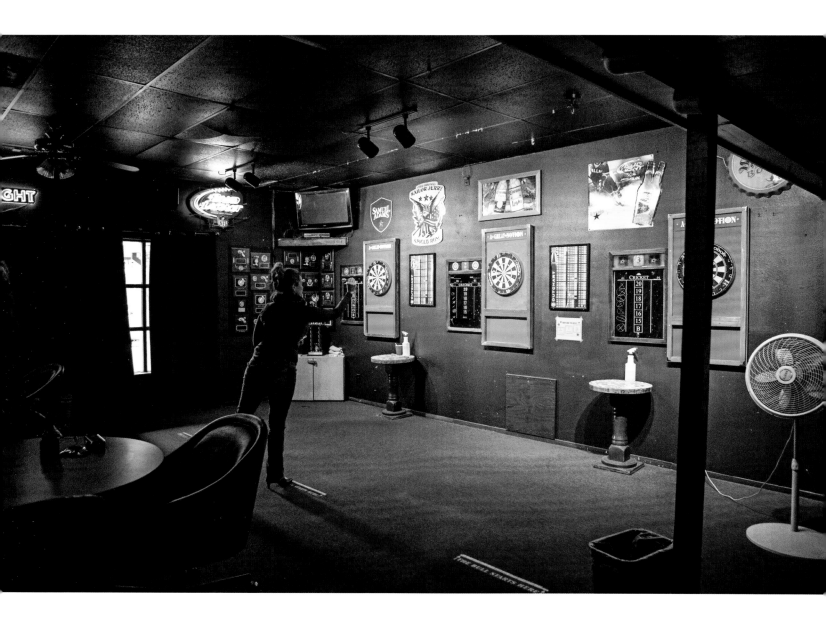

While karaoke may have saved the place, the citywide indoor-business smoking ban almost killed it—but not how you might think. When the ban went into effect in August 2018, Gail tried to clear some space out back for the smokers to go, but a neighbor complained. Code Enforcement arrived to check out the situation, and it was at that time Gail found out that the Notion was not even zoned to be a bar. "We were zoned to be a restaurant," she says with a chuckle. "I was required to have 51 percent of my sales be from food—I think I do 3 percent. I give away more food than I sell. After losing my mother in December, I really didn't need this. I thought I was going to lose the bar—*her* bar."

She went back through the records and discovered that it had always been called a

bar, despite the zoning requirements. It took some time to sort everything out. She had to first persuade the zoning commission to approve the change, which it finally did. Then she went before the city council and made her case to let the Notion keep doing what it had been doing all along—welcoming people in for drink and good conversation. And she prevailed.

"I love when people walk in here from thirty years ago and say the place looks the same, a little bigger but the same," Gail says. "My mom and I took pride in that."

Now, it may be hard to believe what happened within thirty minutes of Gail saying that, but in fact some guy came inside and mumbled in amazement, "This place looks the exact same way." A former customer, he just happened to be doing laundry nearby and thought it was time to return. It was his first visit in ten years.

The quorum celebrates this serendipity with a round of Shakies, and then we toast the future of A Great Notion.

"We've tried to improve things around here, but we don't make changes for change's sake," Gail explains. "My mom and I made sure this is the place that we want to be at for the rest of our lives. It's never going to change into a place that we'd hate."

Perhaps I can suggest one change: Rename the place "Sylvia's."

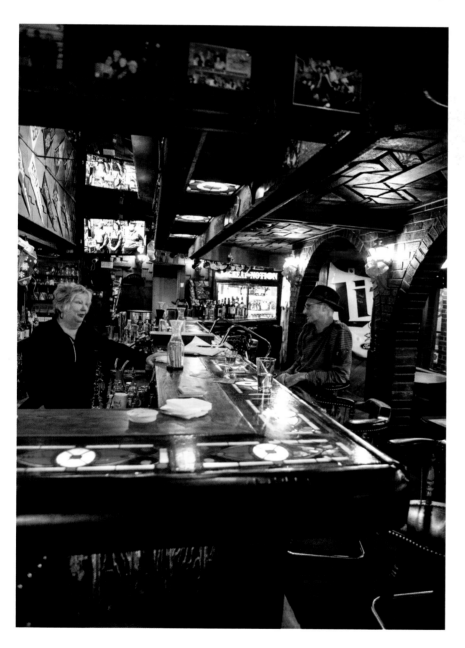

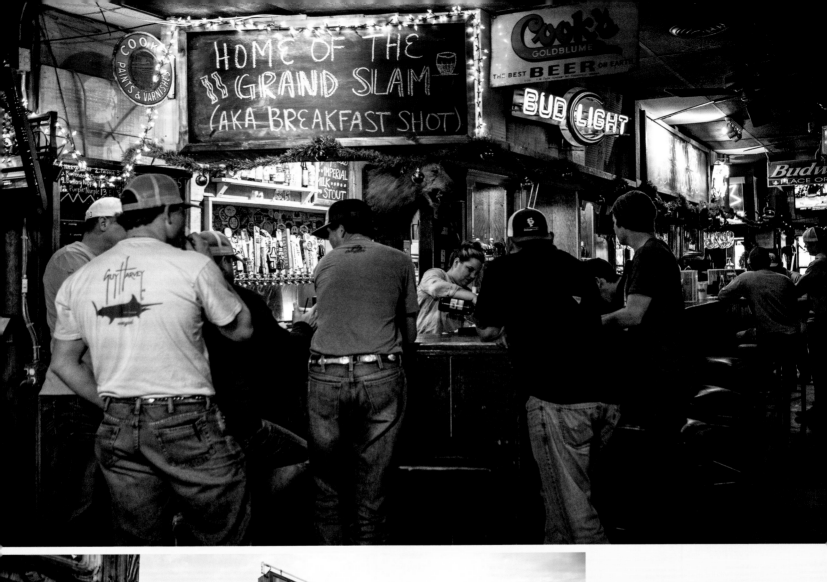
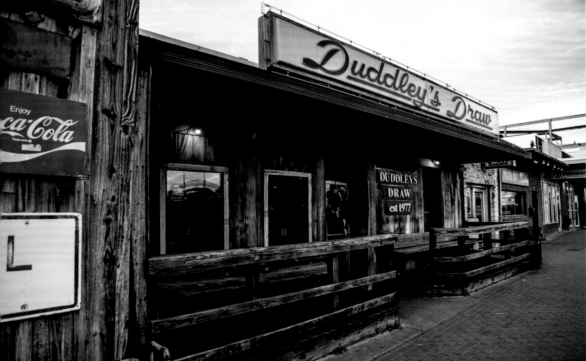

Forever Young

Duddley's Draw, College Station

Consider the cap. Specifically, the baseball cap. Not long after the ancestor of the modern baseball cap debuted in Brooklyn in 1860, the sporting accessory made the leap from the baseball diamond to the streets. It was probably sometime around the turn of the twentieth century, after the caps had multiplied and started colonizing young boys' heads by the thousands, when that original baseball cap mutated into a different organism. It's called "speciation" and in this case the cap evolved from a tool to keep the sunshine out of a player's eyes into a marketing mechanism for the teams. A generation grew up feeling solidarity with their favorite players because they, too, wore baseball caps. It was a brilliant idea, only it got out of baseball's control. Somebody—probably John Deere—convinced the country that anybody could put a logo

on some fabric and wear the dern thing just above the eyes like a billboard, and after that, it was game on. Soon, baseball caps were outperforming boaters, bowlers, and fedoras and became de rigueur headdress for cops, chefs, fighter pilots, farmers, off-duty actors, bald guys, rappers, Ron Howard (see also: bald guys), and bed-headed college students. Plus, they even infiltrated other sports, as seen atop golf caddies, stock-car pit crews, and sidelined quarterbacks. For pop culture the baseball cap (and its oily cousin, the trucker cap) became a delivery device for ironic slogans and semi-amusing musings. Today the baseball cap and its sartorial legacy clearly rank among America's top five or six greatest achievements.

I only mention this because there are seventeen people in Duddley's Draw, and fourteen of them are wearing baseball caps.

I asked, and they are not members of the bar's softball team celebrating a hard-fought victory over their College Station rival, Dixie Chicken. They're just young folks, having a few "chuggers" (32-ounce beers), getting loud, blowing off steam. I've been in a lot of bars, but this place has more baseball caps than Dick's Sporting Goods. It's not a bothersome quality, it's just hard to not see it once you see it. It's like coming across an uncommon word, like flotsam or collusion, and then hearing it on the radio or around the watercooler, or spotting it in *Texas Monthly*.

Duddley's Draw is known around College Station as a dive bar. I would only amend that a bit and call it a college dive bar. In this case, the college is Texas A&M University, and for more than four decades many of its students have made their way from the nearby campus to Duddley's, in the Northgate District, for a quick beer in between (or in lieu of) classes. Some of these students discover enough comradery here that they eventually graduate to become a Duddley's regular.

Regulars include graduate students, dropouts, professors and other faculty, and the people who keep College Station humming along. However, while the two groups—students and regulars—are not necessarily mutually exclusive, I was informed by Chloe, a bartender of two years, that they do tend to inhabit the bar at different times. Together, Chloe and I hypothesize that the group of cap-wearing youths are here in the early afternoon because school is recessed for winter break. Chloe (who is capless) looks at me sideways and, while sliding me a small tumbler of whiskey, admits to never thinking much about baseball caps.

General manager Rusty Richards invites me to take a seat at a booth and discloses that, come nightfall, the place will be swimming with baseball caps from one end of the bar to the other.

Well, he doesn't actually use those exact words, or any words to that effect. And to be totally honest, baseball caps don't come up once in our conversation. But sitting with Rusty, I find myself imagining an ocean of ball caps churning around me when he does say, "Seeing how we're a stone's throw from a school with 75,000 students, it makes sense that a lot of them are going to find us."

He goes on to explain that, over the course of the year, because of the ebb and flow of the student population around summer and holidays, it's the regulars who maintain the bar's proper character. "In college, you go out to be seen. Here, you come to enjoy yourself. To be out but not be in that spotlight. That affects who comes in here."

Rusty turns out to be one of the most affable guys I've met in this business, and I think it's because he's convinced he's got the best job in College Station. He's been at Duddley's since 2006 and says he loves every bit of his work. Part of his position requires updating a few things around the bar, but he knows there's a tightrope to be walked between doing what you can to keep new customers coming in and not scaring away his core of regulars.

"You have to change with the times," he says, "and we did rip the back section off and put in a patio. We've added more draft beers. We expanded the original bar top. Maybe the biggest thing is that we remodeled the kitchen*—we actually downsized it to be more convenient for the bar. But this place basically looks the same as it always has."

It's not that he doesn't have a lot of ideas for what he could do with the space, but since Duddley's Draw has been in the same

*Duddley's Draw received 94 points on its food safety inspection. That's a solid A. I also noticed that the woman who inspected the place while we were there was wearing a blue baseball cap.

There's some commotion in back, and I suspect it's the capped crew I noticed earlier, although I can't see them from where we sit. Duddley's is a pretty big place; while the front is a comfortable space with lots of wooden tables and chairs, the back room is even bigger with a couple pool tables, some arcade games, and a few booths. When I investigate, I see that the group has gathered around one of those carnival machines where you punch a speed bag to see how hard you can hit it while trying to keep your baseball cap on at the same time.

I'm entertained for a while until my buddy Kirk calls me to the bar—a long, wooden beauty, highly polished but with deep scars. Kirk is about to partake in a Grand Slam, also known as a Breakfast Shot.

This Duddley's original cocktail consists of a half ounce of Jameson Irish Whiskey combined with a half ounce of DeKuyper Buttershots Butterscotch Schnapps served alongside a shot glass of orange juice and a

family since opening in 1977, and since he married the daughter of the original owner (Richard Benning, who passed away in 2005), Rusty takes his job as guardian of the old ways seriously.

"What makes a good dive bar? The vibe. How people react to you. When you walk into a dive, someone is likely to offer you a seat and maybe buy you drink," Rusty says. Then he points to a rather uninteresting section of woodwork on the wall behind the bar and declares proudly, "Every dive has to have a wood sheet of paneling. And I put that one up myself."

As an aficionado of dives, I should have followed up on that last part—but to be honest, I'm distracted by what's on top of Rusty's head. Yep. A baseball cap, turned backwards. Why can't I get past this?

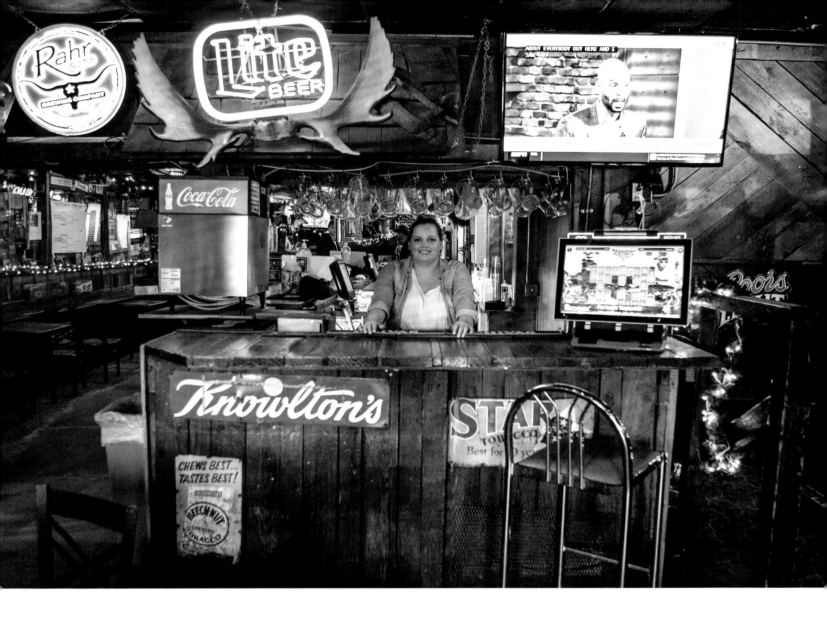

slice of bacon, crispy from the kitchen. "To your health," Kirk says, and then it's booze, juice, and bacon down the hatch. He smiles and declares it the "breakfast of champions." (I would later learn two things: Kirk's real opinion of the Breakfast Shot, and that according to Chloe, "the regulars never order it.")

* * *

It's now dive time at Duddley's: late afternoon, approaching Happy Hour. The bar fills with a different crowd. I would be remiss not to point out that they are a tad older. Some of them can remember when Duddley's opened as a beer joint on August 27, 1977, but nobody, including Rusty, knows exactly how the bar got its name.

"When this place opened up, there weren't many bars around here," says John,

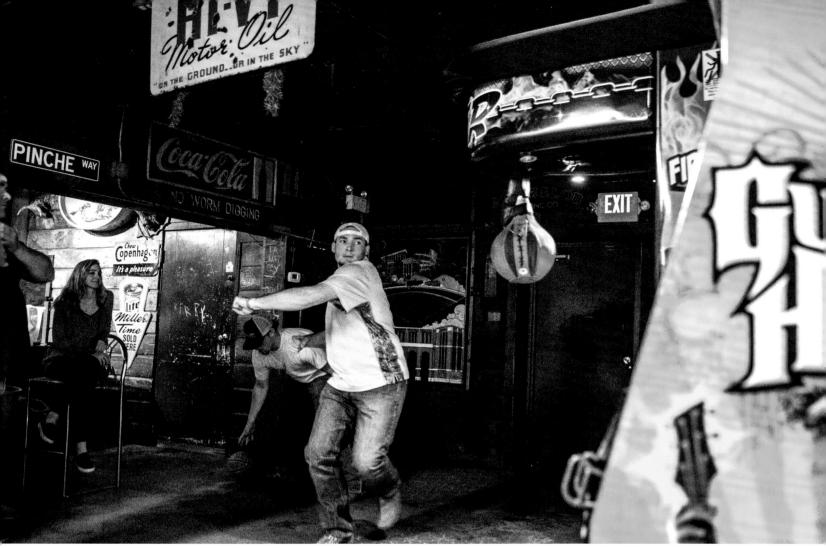

who has sidled up to where I'm sitting. "One day I'm walking around Northgate and I think, 'Duddley's looks interesting.' I walked in and said immediately, 'This will be home.' That was probably about a month after it opened."

He takes a sip from his mug of Bud Light, which he'll nurse for the next forty minutes. John was an industrial chemist and now works in intellectual property in the engineering field. He describes the dynamic here between regulars and students as "the internet before there was an internet."

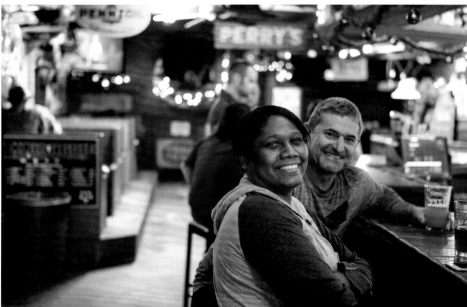

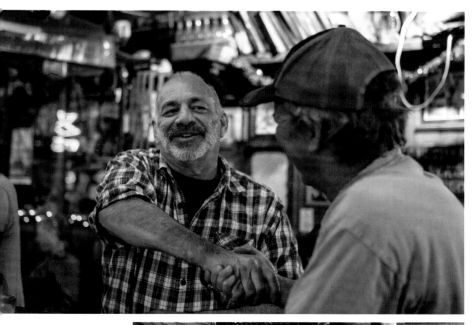

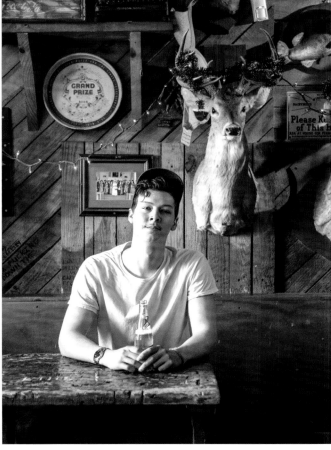

"The circles don't always overlap," says John, "but sometimes they do. And every time I'm here I learn something new from someone, young or older. I hear a good story. I meet somebody interesting. But this place"—he pauses to look around—"is a bit of a time warp. The reason I come back here is that—they say you can never go back—but this bar doesn't change. It's like walking back into a place you never left."

Such sentimentality is echoed by others, like "Sweet" Lynne, as the bar crew calls her, who stops by every day after work for a drink and to catch up with friends. "You get treated like family here, you really do. That's what keeps me coming back," she says, adding that along with the people, she likes how very little has changed over the years. "I've been coming here since 1995. When they started doing a little bit of remodeling, we got worried. We hoped that this place wasn't going to turn into a fern bar, you know, with plants everywhere. I don't like change."

The "we" in Sweet Lynne's stories include her late husband, Greg, who first started coming to Duddley's when he was an A&M student, in the 1980s, and then kept returning as a workingman. When Sweet Lynne started accompanying him, Duddley's only served beer. "I remember Richard Benning asking my opinion about getting a liquor license and I remember thinking it was a bad idea," she says, laughing pleasantly and taking another drink of her vodka and soda. Still, the bar has meant a lot to her over the years, especially when Greg died. "They had the reception for my husband's funeral here. Someone here called Greg his best friend and someone else said, 'No, he's my best friend.' Everyone considered him their best friend."

That last bit was confirmed by many people I talk to, like Russell, a local radio personality whose been coming here since 2001. "Greg was sort of our patriarch," he tells me. "Some days I just wanted to come here to see him and talk to him. He made a big impact on my life. He was at my wedding and I went to his funeral. He used to sit right there at the end of the bar every single day."

Russell points out a framed portrait on the wall near Greg's old barstool. Greg was so beloved that after he passed away someone painted this picture of him, sitting on his preferred stool, hunched over the bar, no doubt nursing a bottle of Bud, and working through some heavy issue for a friend. (At this point in our story, would it shock anyone to learn that in the portrait Greg is wearing a baseball cap?)

As for the rest of the bar's decor, it's a lot of the same old flotsam—street signs, beer posters, cheap mirrors, the usual displays of neon—easily scrounged or found in "antique" shops.

It's not all derivative, though. In addition to lots of Aggie paraphernalia, there are several animals and animal parts mounted on the walls, including a lion's head, which is bartender Chloe's favorite piece. "Years and years and years ago," she explains, "someone ran up an enormous bar tab and offered the lion's head to settle it." (Which sounds like one of those classic bar stories, the kind that doesn't need to be true to be interesting.) She says they dress the lion appropriately for special occasions, like St. Patrick's Day and Christmas, but for now, the once noble beast is blessedly free of any costume.

Most of the good stuff seems to be reserved for the glass-fronted trophy case, directly across from the bar. Here you'll

find a withering Styrofoam cup, which some professor brought in a long time ago to demonstrate—I don't know—something to do with physics maybe? I see boxes of canceled checks once used to clear bar tabs and lots of old photographs of youthful faces. There are some fossilized bones (animal, I presume) and a nearly fossilized fast-food hamburger from 2014. Scribbled notes that only make sense to whoever wrote them. Bowling pins. Little wooden curios and folk art. I think I see a stuffed prairie dog playing a guitar.

Rusty especially likes the Spuds Mac-Kenzie doll that lights up, although he's aware that most of the students who come into Duddley's these days are too young to know what a Spuds MacKenzie was.

Youth: It's what a college dive has that other dives can't always boast of. Kitchen staff, bartenders, barbacks, and ID checkers are typically mined from the classrooms. This factor helps drive the bar's future. In other words, as long as the university keeps producing a student body, Duddley's Draw

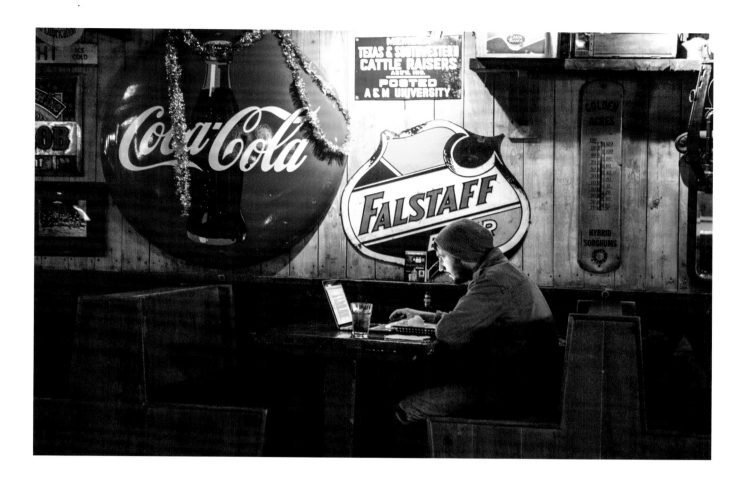

will always pull in those bodies to chug a few chuggers while carving their initials into the tabletops. That tradition started long ago, and it's awfully hard to find a wooden surface in the joint that doesn't have pocketknife signatures.

Rusty tells me that during some recent "light" construction they pulled a time capsule out of the wall. There were stickers and some student IDs inside. Based on the years of those IDs, the time capsule was probably buried in the woodwork between 1984 and 1986. "So we put in a T-shirt, a hat, and a bottle of Blanton's. It was the best bottle I could find," he says. "And then we put it back."

My eyes wander to the location of the reburied time capsule (I'm not telling where) and then down to the floor. I can see how the once-dark pattern on top has become worn down, forming a well-trodden path from one end of the bar to another, as if Father Time has spent decades shuffling his feet while carrying chuggers from the bar to the booths.

"Time doesn't really stand still in here," Sweet Lynne had told me earlier. "But it moves awful slowly. And seeing these kids all the time helps me stay young in a weird way."

Back in the Day

Mynars Bar, West

Nine years had passed since we first pulled off I-35 toward the hamlet of West. Back then, weary from the day's work, Kirk and I came across Mynars Bar, a faded brick building holding up the street corner of East Oak and North Roberts. We were thirsty. We walked into the bar.

At first glance, it looked like everything was lumbered with ancient wood, including the floor, probably original but still shining respectfully, as well as the long, straight, powerful-looking bar. High overhead, the wooden ceiling and its spinning fans helped complete the appearance of an Old West saloon—except for the dozens of dollar bills hanging from its boards like a colony of bats.

A country-western tune was playing on the corner jukebox as a right neighborly looking gentleman drank his beer at the far end of the bar. And there was a sweet aroma in the air, one that occurs naturally when just the right proportions of elements find each other—those elements being a soupçon of cigarette smoke, a preening waft of beer, and the aroma of about a century's worth of time. Admittedly, the scent is not for every-one, but for others, like me, it produces a comforting sense of nostalgia.

A small, well-kempt woman smiling at us from behind the bar took a drag off her cig-arette and asked in a voice sweet as peach pie, "Just passing through?"

"We should write a book."

That's what I said. I meant to say it to Kirk, but I think that's how I answered the woman.

Her name was Linda McWilliams, one of the bar's owners, who, after serving us a couple of Shiner Bocks—this was a beer and wine, cash-only bar—told some pretty good

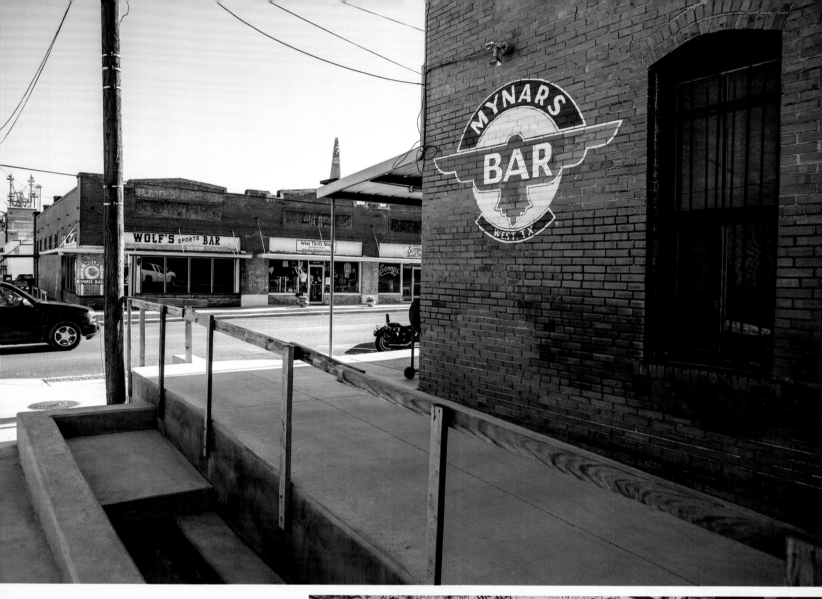

stories, like how a local cop from the 1920s and 1930s (nicknamed "High Pockets" because of his NBA-worthy height) used to warn her grandfather, who owned the place at that time, when a raid was about to happen. "That's when they were running the moonshine," said Linda of the area's once-thriving underground booze network, "and so High Pockets would warn my daddy's daddy that the agents were coming and to get rid of the moonshine. So they'd drink it."

Linda lit another cigarette and opened a Dr Pepper for herself. She told us that a flock of chickens once saved the bar, and then she explained how all that money came to attach itself to the ceiling. The other gentleman listened closely and nodded along with the stories. Appreciatively, he bought a round of beers for the whole bar, all three of us. His name was E. J.

"We really should write a book."

* * *

So now, nine years later, we open the screen door and walk into Mynars again. It's Friday afternoon. We see Linda smiling pleasantly, greeting us like no time had passed. She hadn't changed that much, and neither had the bar—same old gas pump by the front door, same old icebox at the end of the bar, packed with bottles of Shiner, Bud, and Corona. There was a familiar mélange of beer, smoke, and history being swirled around by the ceiling fans. The dollar bills up there had multiplied, though.

Standing beside Linda is her brother and Mynars co-owner, Rick Mynar, who is built solidly, is deeply tanned, and has a sincere smile.

Nearly every seat at the bar and the mismatched tables is taken. I hear a Mickey

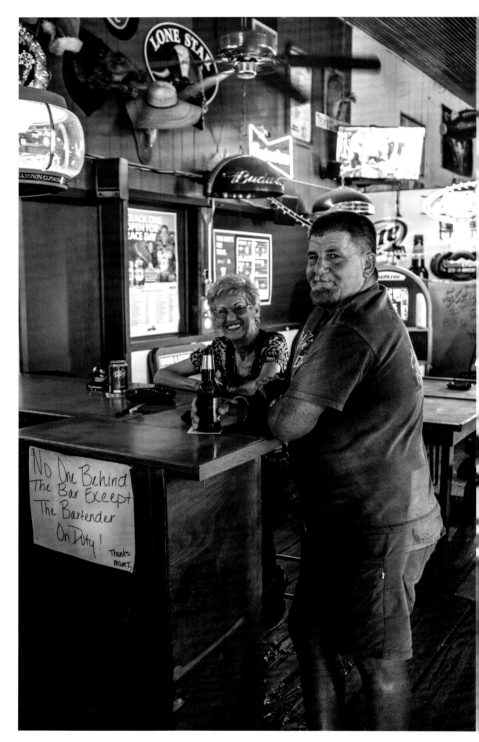

Gilley tune playing. Conversations are loud— bolstered with end-of-the-week enthusiasm and cold beer that's priced to respect a customer's intelligence. Since Kirk's already off with his camera, I suggest we three retire to someplace quieter. Rick buys me a beer and then leads us through a door at the left of the bar to the dance hall. We sit together at a four-top. Linda pulls out a pack of cigarettes and asks, "Will this offend you?"

Carry on, I implore them both.

"Back in the day," Rick begins, pointing toward the other room in order to orient me, "that part used to be a grocery store. Behind this wall, way, way back, was a mortuary. The place next door used to be a bar. Back behind the pool table, that place used to be a bar too."

Rick says that their grandparents, John and Rosie Mynar, bought the place in 1923

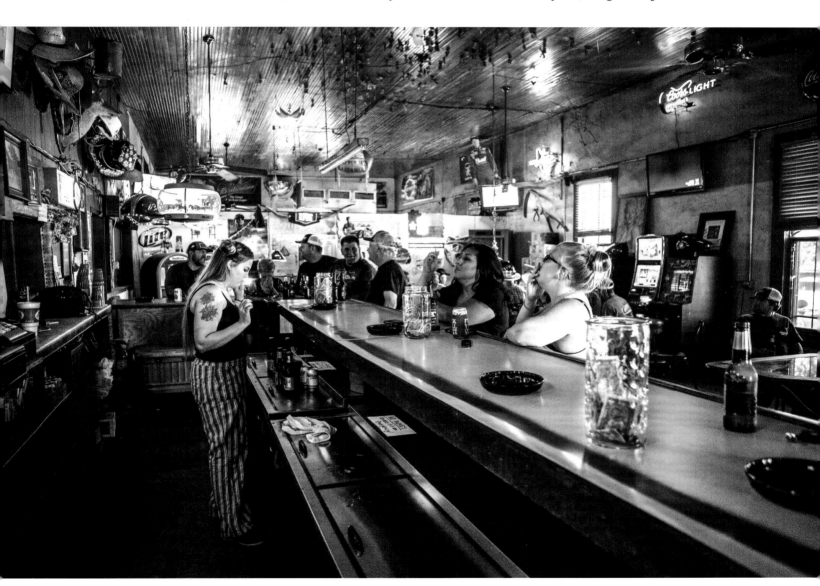

and ran it as a grocery store during the dark days of Prohibition and the Depression, back when High Pockets would give John Mynar fair warning about moonshine stings. After John passed away, it was Rosie who turned the grocery into a beer joint. But times were very tough for Rosie, especially while raising a family of twelve on her own.

"Back in the day," Rick continues, taking a quick sip of Coors Light, "when Grandma had this deal, the bar was financed by a bank in New York. She couldn't make the payments—they were just a couple dollars a month. She told them, 'I can't make it. I don't want it. Y'all can have it.' They said, 'Just pay what you can. We don't want it either.' That's how it all went down, way back when."

Linda smiles at her brother when he talks. They're a tight unit, complimentary of each other, both grateful to have real family sharing in the labors of the family business. They share another thing: They both like hearing stories of the bar every bit as much as they like telling them.

Linda leans forward and says that Rosie raised chickens and, it turns out, those

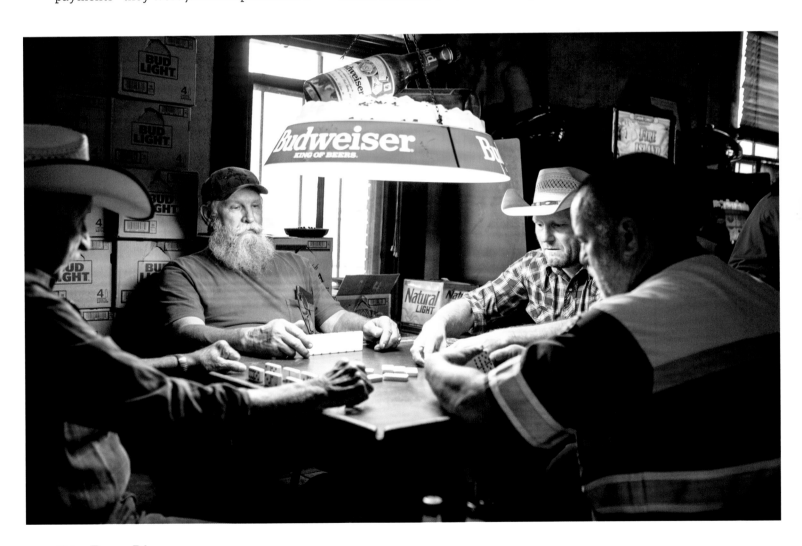

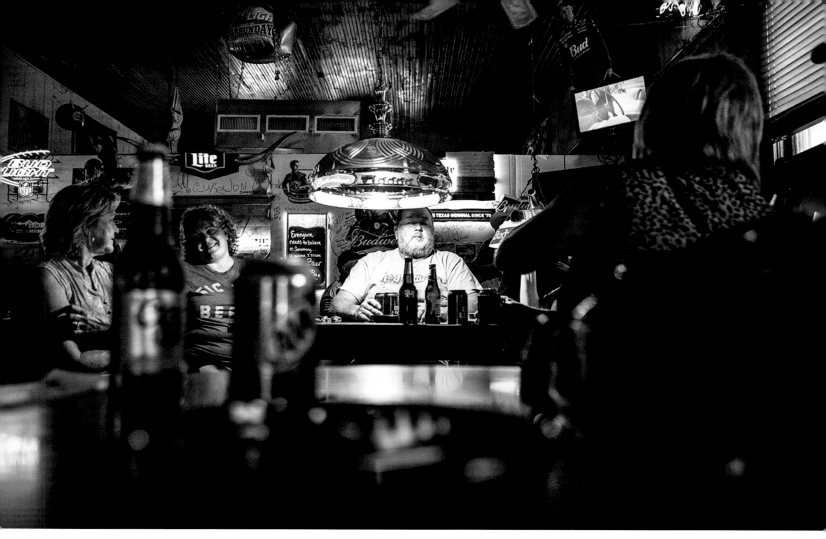

birds were the reason Mynars Bar survived. "She'd take eggs to town and sell them to make the bar payments. Her egg money saved the bar."

Actually, both of them will tell you that the true hero of Mynars was their father, John and Rosie's son, Felix Mynar. Felix was only ten when John died, but he'd absorbed a lot from his old man and began proving his mettle at a young age. Hard work was going to be part of his life, so he figured the best thing to do was to just meet it head on. In springtime he'd help plant the family's farm crops, then he'd go with a friend to Cali-

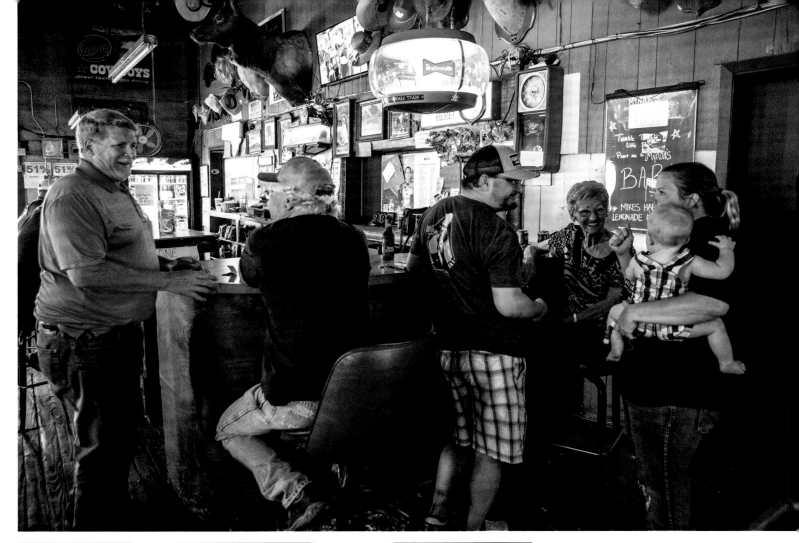

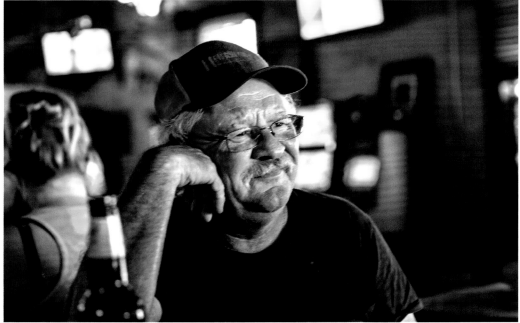

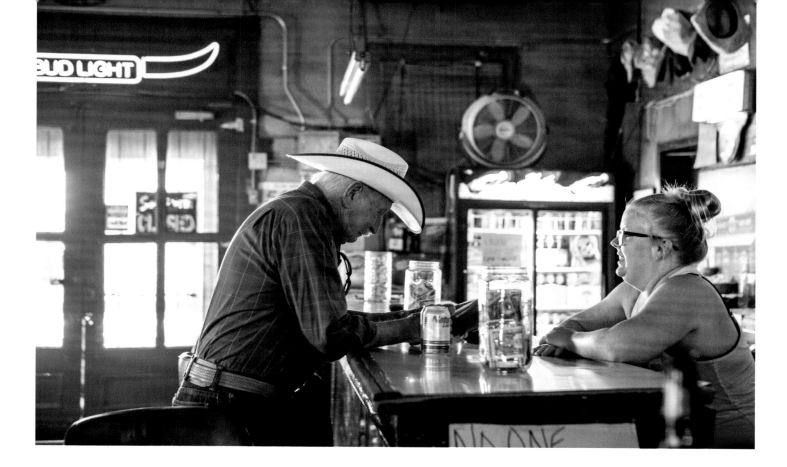

fornia to work on a dairy farm. In the fall, they'd return to West in time to harvest the crops.

Felix also took an interest in his mother's bar and learned pretty quickly just about everything he needed to know about running it. Eventually, he took it over for Rosie, outright buying the place in 1977. He'd get up at five, tend to the farm, and then work at the bar till midnight, six nights a week. But every Sunday after church, he'd spend the day at home with his wife, Haddie, his kids, a pot of guinea soup, and whoever stopped by for supper.

"Daddy always said, 'If you can't make it in six days, you can't make it in seven,'" Linda says, explaining why Felix closed the bar on Sundays.

Day after day, year after year, Felix kept the family business running, spending as much time serving beer and telling stories on one side of the bar as he did playing dominoes and telling stories on the other side. All the while, another generation of the family was taking an interest in the bar. At first, Rick admits, his attraction was purely financial. "Back in the day, we lived out there on a farm, and on top of the hill there was a friend of mine. We called him 'Junior.' We'd pick Junior up and come up here and we'd sweep the floor. I was probably ten. Daddy gave us fifty cents apiece. We were rolling."

With time, Rick came to appreciate how his family's bar had become an important gathering place in West, and, he tells

me with deep sincerity, he realized how important it was to keep the business going.

"When Ricky got old enough, he was always coming over here and helping Daddy," Linda says, picking up the story. "Daddy was getting tired toward the end. Ricky just took over more and more of the business. I was working in Waco as an office administrator for a doctor's office. I'd occasionally come over here and visit. But when Daddy got sick, I started working behind the bar."

Brother and sister bought Mynars in 2003, a year before Felix passed away.

* * *

When we all return to the barroom, the crowd has grown. It's even louder. I can't pick out which song is playing because so many animated conversations are taking

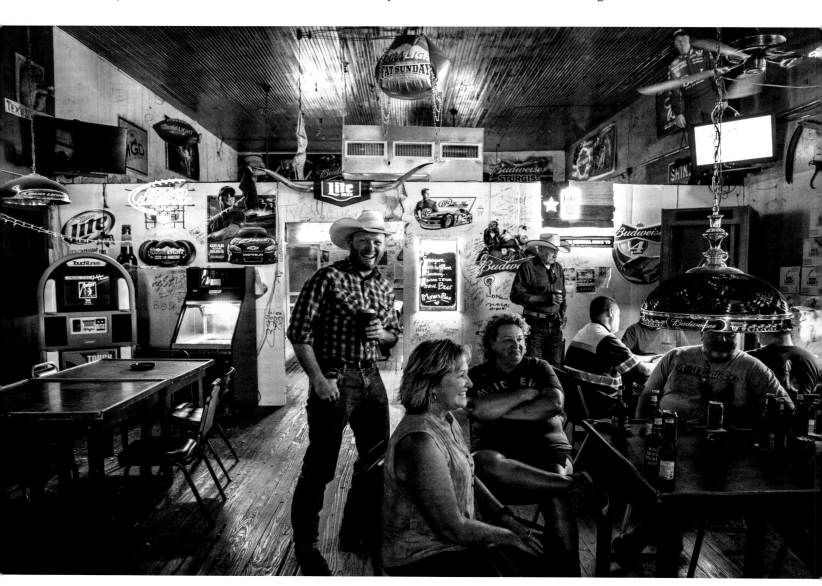

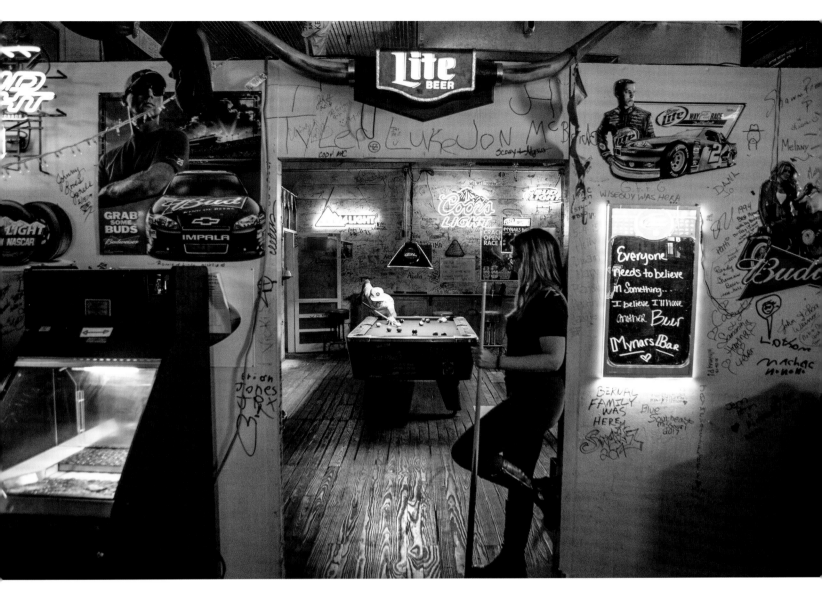

place over the top of the music. Some serious dominoes are being played in the back, and now and again an aggressive slam of a domino on the tabletop sends a sharp *clap* through the air.

Kirk finds me. We get a couple beers. He looks at his camera and says he's already taken hundreds of images. It's odd, we agree, that our last visit here was a quiet encounter in a corner bar that ignited the idea for

this book. Now we see the other life Mynars leads, one of a higher amplitude—like a Fourth of July family gathering. In fact, the scene before us is complete with young kids drinking sodas, eating chips, and amusing themselves while the adults drink beer, smoke cigarettes, and amuse themselves.

"It's all good until about seven o'clock. Then they got to go," Rick says of the children, who are, it must be said, well behaved.

"Now, about 5:30, I don't mind."

"That's the way it's always been. It's a good family bar," says Joe Mynar, whom I've just been introduced to. Joe's a cousin to Linda and Rick. He's a farmer and rancher. Like the kids sitting at the next table, he was well acquainted with Mynars at a young age. "I came in here when I was nine or ten years old. As time went on, I used to stand at the end of the bar with my buddy, when I was nineteen and twenty, and look at the table with Felix and all his buddies." Joe points across the room to a nearby table. "There were lots of people, but as time went by they dwindled down. I told my buddy that that was going to be us one day sitting at that table. And here we are."

These days, Joe knows the bar pretty well, like how if the screen door up front starts moving on its own, rain is on the way.

Rick nods and assures me, "When that screen door opens, in three days it's gonna rain."

Plus, Joe's seen more than one person ride through the bar on horseback, grab a beer, and head back out.

"Back in the day, they'd ride horses in here," Rick confirms.

And while Joe swears there ain't never been any shootouts in the bar, he's got a good story, one that happened back in the day when Felix ran the place, back when it can truly be said that times were different. "I can still see the West cop Tommy—a good friend, a good friend to all of us—come in this bar and it was closing time. And he said, 'Goddamn, what the fuck y'all think y'all doing? It's closing time! Midnight!' I can still see Joe, a buddy of ours, pull the gun out of Tommy's holster, walk outside with it, and shoot it three times up in the air. Felix

goes, 'What the fuck, Joe, are you doing?!' The cop goes, 'Y'all are crazy!' He got in his cop car, burned out, and took off. And that's the God's honest truth there. That's the God's honest truth. I can still see Joe grabbing that damn gun and going outside—pow, pow, pow! Them days are over."

Maybe that's for the best, I muse to myself while taking a seat at the bar. I try to untangle the exchange of news and gossip from the other customers. At one table there is talk of bikes, bikers, biker rallies, and biker bars. In the back four men with knobby, calloused hands play dominoes. In turns, others rotate in and out, keeping the table active most of the evening. Such games have been going on for decades.

"This is still Daddy's bar," Rick says. "He made this. We're just carrying on."

"Amen to that," says Linda.

Despite the urge, though, carrying on doesn't mean staying frozen in the past.

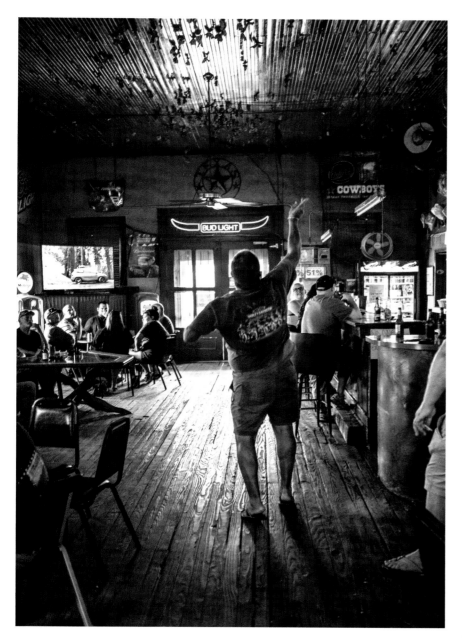

after many years of faithful service, the old Rowe jukebox was retired to Rick's garage.

When Rick sees the disappointment in my eyes at the loss of a real jukebox for a music streaming machine, he explains, "If it ever went down, we had no music because we can't get anyone to work on it. If the internet one goes down, we can get it fixed tomorrow."

Behind the bar, there's an old photograph of Felix and his favorite horse, Tony, that shows life around these parts during the mid-twentieth century. But perhaps the best measurement of time's passage in this place is the dark stripe that runs the full length of the Formica bar top.

"Daddy could tell good stories," Linda explains. "He would stand behind the bar, rubbing his beer can on the bar as he talked." He talked so long, so often, that he eventually wore away the surface of the bar. "People would stop by just to hear him tell stories. Today I can stand there, put my hand on the bar, and he's there." Then, giving me another moment of her smile, she adds softly. "It took him a long time."

Suddenly, there's a commotion behind us. Rick is getting the place riled up by demonstrating how to get a dollar bill to stick to the ceiling. Linda tells me the story of how some biker started the whole thing a long time ago. The trick involves folding a thumbtack and a quarter into the bill just right before letting it fly, but it's not easy. It takes about eight attempts, but Rick finally gets another one up there for good.

I'd actually heard that story before, back when Kirk and I first stumbled upon Mynars. That was back in the day, right about the same time we decided to do this book.

After Linda and Rick took over, they both agreed that adding televisions would be smart, although it was a big step for the place. Then, maybe four years ago, came the credit card machine, ending nearly a century-long Cash Only rule that went back to John and Rosie's grocery. Most recently,

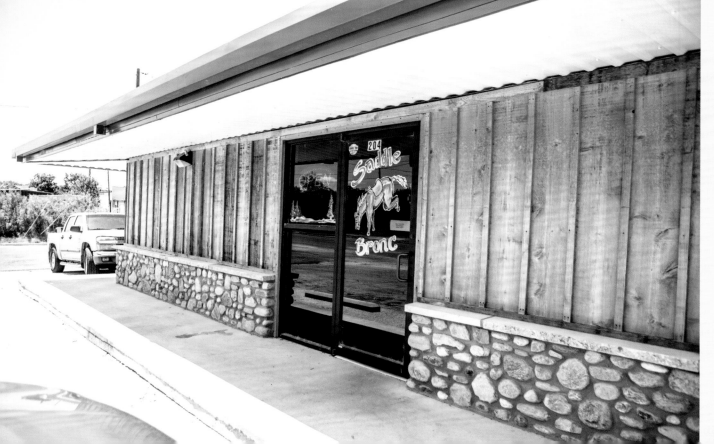

Just a Country Bar

Saddle Bronc, San Angelo

"Saddle Bronc is looking for a professional, positive, experienced bartender with excellent communication skills and skin thicker than a Bible page."

Shortly after I discovered those words written in a Facebook post, I found myself enjoying a mug of Dos Equis Lager at Saddle Bronc, at the corner of East Avenue L and Duggan in San Angelo. I just had to see the place for myself.

It's small inside but comfortable enough for a few of us to get our day drinking underway. The place has the feel of being carefully put together. It's neat, clean, organized. There are hand-crocheted coasters on the bar. And it's aptly named. There is bucking-horse, or "bronc," decor everywhere. Two stools over, some older guy with sun-kissed skin is wearing a cowboy hat with a brim so wide you could fit a couple

kittens on it. He keeps insisting that it's his birthday—that is, whenever he's not critiquing *every single commercial* that comes on the television behind the bar. But even when Fox News returns, his running commentary continues: It's the twenty-fifth anniversary of O. J. Simpson's double-murder trial ("He did it"); there's a story of the Vietnam War and Jane Fonda ("I stopped watching her movies in the 1970s"); and then there's Trump ("Best thing ever for America").

Alongside this entertaining customer with the big hat there is a man and woman bickering and carrying on as if they were, I presume, married. They too are watching the news. "You can't argue with a stupid person." I wasn't sure which one said that.

The afternoon lulls along. The old cowboy drifts away. The couple take their leave. Two new guys come in and order beers at the bar.

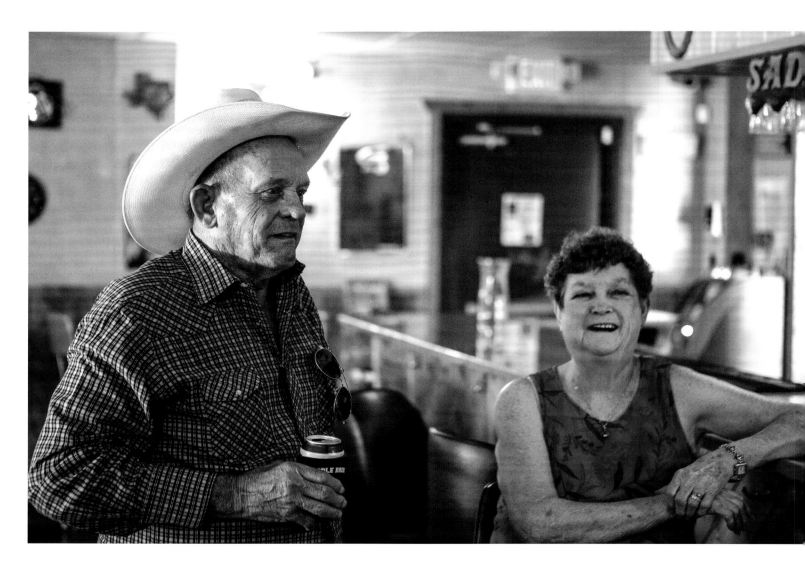

The only real sound comes from the TV, and that's just fine with everyone. There's no pressure to utter a word.

Still, after a time, I pipe up and introduce myself to the woman behind the bar, Ila Johnson, whose short curly hair gives her a no-nonsense look. She's one of the owners. Along with her husband, Bruce, Ila has been running Saddle Bronc since 2003.

She hesitates when I ask for her favorite memory from her tenure. After a moment, she looks past my shoulder and says, "When

we first moved in here, we were all sitting at this big ol' table, and then a couple of them got up on the tables and was dancing."

It's not *National Enquirer* material, but Ila is smiling wide at the memory.

We talk for a while. Only one other customer comes in during the next hour. Even though Ila would like more business, San Angelo's business district is growing away from Saddle Bronc and the city's south side. Most of the new development is nowhere near the corner of East Avenue L and Dug-

gan. "It's all on the other end of town, four or five miles from here, at the Coliseum," she says, and at this point, she wrinkles her nose, like a skunk just crossed her path. "They're trying to make downtown like Austin, where you can walk to all of them bars. I don't want people getting drunk in another bar and coming here. You have a lot of that happening in town."

Ila does turn out to be a no-nonsense kind of gal. Saddle Bronc, she says, is no place to get rowdy. Dives seem to have a reputation for being potential hazard zones for drinking, but she's established a code of conduct for her bar because it matters to her how her customers act. She just wishes she had more of them.

* * *

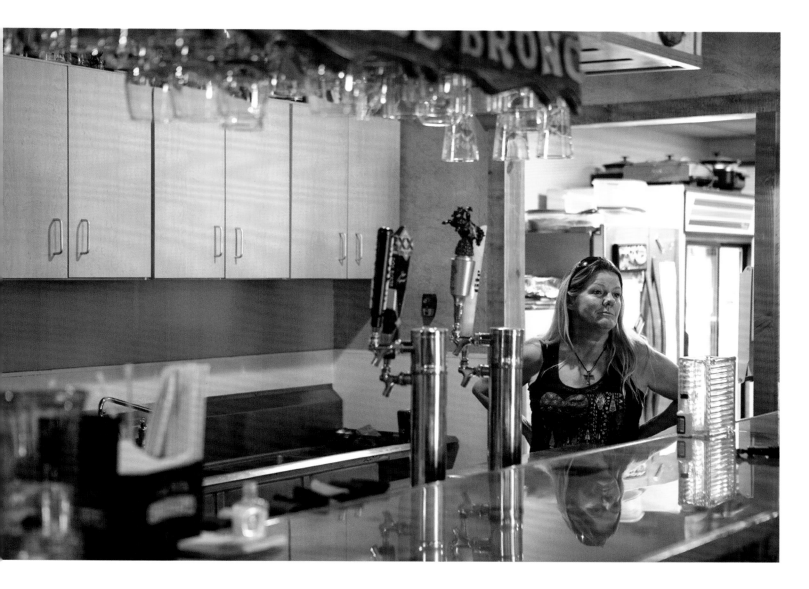

Saddle Bronc was worth a return visit, which happens about a month later with Kirk. It's empty inside, except for three fellas at the bar, and Waynetta, who typically works morning-afternoon shifts. Netta, as she's called, pours me a Dos Equis.

By the look of their clothes and their rough, dirty hands, the men are likely in construction. There may be only three of them, but with the help of the internet jukebox in the corner, they're filling the bar with their off-key bellowing, drowning out Jamey Johnson as they howl, "Hanging out in the bars with the drunks and the stars and a few good ole boys just like me!"

Netta seems amused. "They're good people. Some of them give Ila a hard time because she charges them a quarter every time they say the F-word. It's her bar, she wants it run her way." She points to a jar filled with change and dollar bills that's sitting on the Formica counter behind the bar, then back toward the three tenors. "She's got them for about fifteen dollars apiece."

One of them really likes the artist Jamey Johnson, who's now singing "Give me a six-string flat-top guitar/Put all you hillbillies in a honky-tonk bar" from his song "Redneck Side of Me."

Just as the song ends, Ila and Bruce arrive. She's in a red sleeveless top, and he looks like he's been wearing his cattleman hat since the day he was born. (Not that exact same hat the whole time, of course.)

Bruce is in construction, and they both own the dog-grooming business next door. Ila also owns an H&R Block franchise in nearby Ballinger. When I call her a three-business entrepreneur, she replies dryly, "Yeah, and I ain't rich off of none of them."

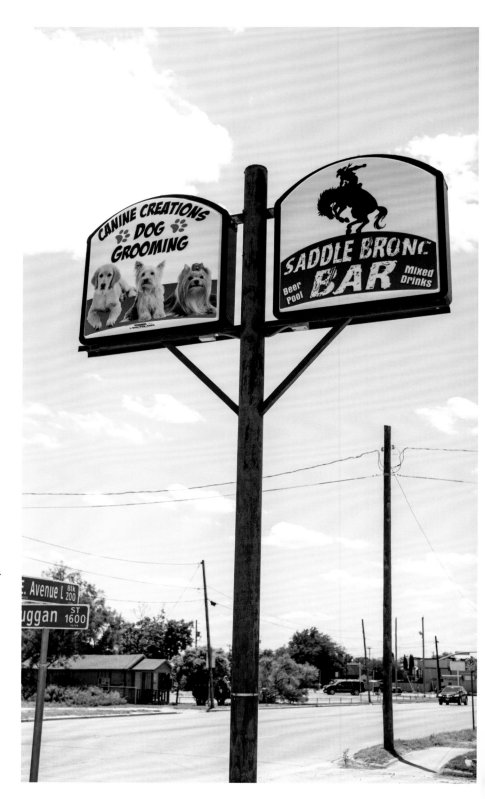

Before I forget, I pull out a copy of the Facebook post, the one about having "skin thicker than a Bible page," and read it to them. "That's from Amanda," Ila says. "She's one of our bartenders. I guess she should've left off that 'thick' thing—or ain't nobody gonna come in here."

Netta slides me another beer. "It's rough being a bartender," she says. "You don't know what you're going to hear. Sometimes you get polite people and sometimes you get vulgar, nasty people. When you cut somebody off, they get really mad and you can't get mad. If you get mad, it escalates the situation."

"The main thing is," Ila raps her nails on the top of the bar, "we don't let them get rowdy in here. There is no fightin' in here.

You let 'em know and you kick 'em out. Zero tolerance."

Bruce adds, "Most fights [at other bars] happen after midnight."

"Most of our customers leave at six," says Ila with a laugh. "They're mostly cowboys. Older. Retired people."

"It's just a country bar," says Bruce.

Ila tells me they bought it from a friend who had been running it as the Saddle Bronc since the early nineties.

They both had enjoyed drinking here for years before buying it, so they didn't feel the need to change the name. But a change was, indeed, soon to come. Bruce says that everything they did to take care of their new purchase "was like putting a Band-Aid on a bullet wound. You'd see daylight underneath the wall. The bathrooms were little.

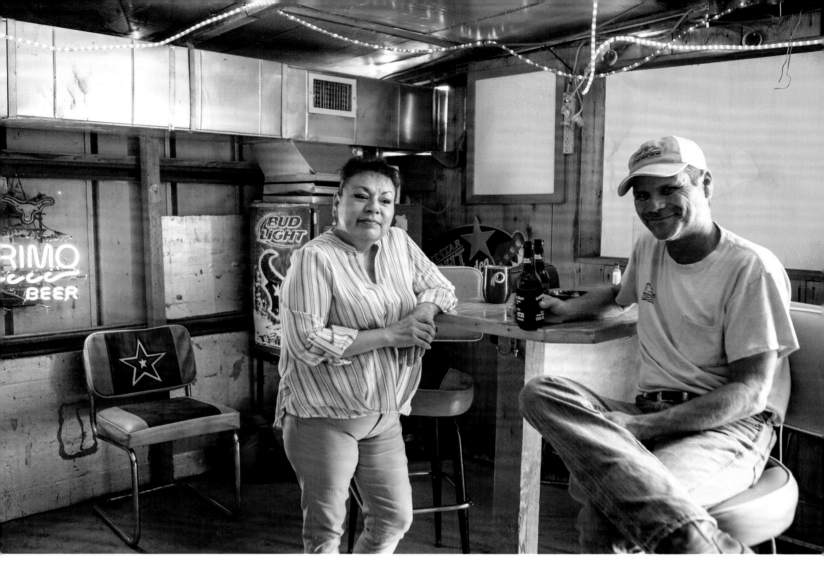

The floors were all rotted out. You'd fix one thing and another come along."

So they tore the whole thing down to its pier-and-beam foundation and started over with poured concrete. They moved the bar's contents to the empty space next door (now the dog groomer's), then went to work remaking the Saddle Bronc. Their son, Jeff, designed and executed the interior woodwork, including the birch plywood bar, the tables, and the wall finishes.

This new country bar has several personal touches. Jeff used a clear epoxy on a number of surfaces, including the bar top, where photographs chronicling the building's demolition and reconstruction are sealed under the clear coating. The memorial table (which doubles as the Sunday buffet table) has sealed beneath its surface the photographs of favorite patrons who've passed away. Playing cards dealt out in various poker hands were chosen for the tabletops.

Outside, Saddle Bronc's patio feels more like a clubhouse, a dedicated space with a sturdy roof, excellent heating and cooling, and the comfortable tables and chairs from the old bar. There's also a television and a buzzer to alert the bartender for service. And it's currently where the regular afternoon crowd of three has gathered.

"I been coming here since the early eighties," says Charlie, sipping on a bourbon and ginger ale. He says he's always worked in agriculture and remembers when all the developed land around here used to be pasture. Even though he lives about ten miles out of town, he comes in pretty much every afternoon. "The owners are very friendly. Lot of good people come in here."

Sitting next to him is Roxie, who's sweet but shy. She grew up in San Angelo and works at a dry cleaner's. "It's hot work," she says, lighting a cigarette. "It feels good to get here and get a cold beer. This is the only bar I drink in."

Across the table is Fred, who has snow-white hair and whiskers and works in livestock pharmaceuticals. "I've been coming here maybe ten years," he says. "It's a good little bar. The people, they're good. Ropers, builders, rodeo people. You never see a fight in here. Hardly an argument. Ila doesn't tolerate that shit, buddy. It's her way or the highway." When asked if anyone at the table ever came across Ila's bad side, Roxie laughs. "Do we have to answer that?"

I say, "Not if you know a good bar story."

Fred blurts out, "Ila danced on a table one night. She was wound real tight. Tight as a tick."

Roxie can't contain herself. "That ain't no lie. That's the truth."

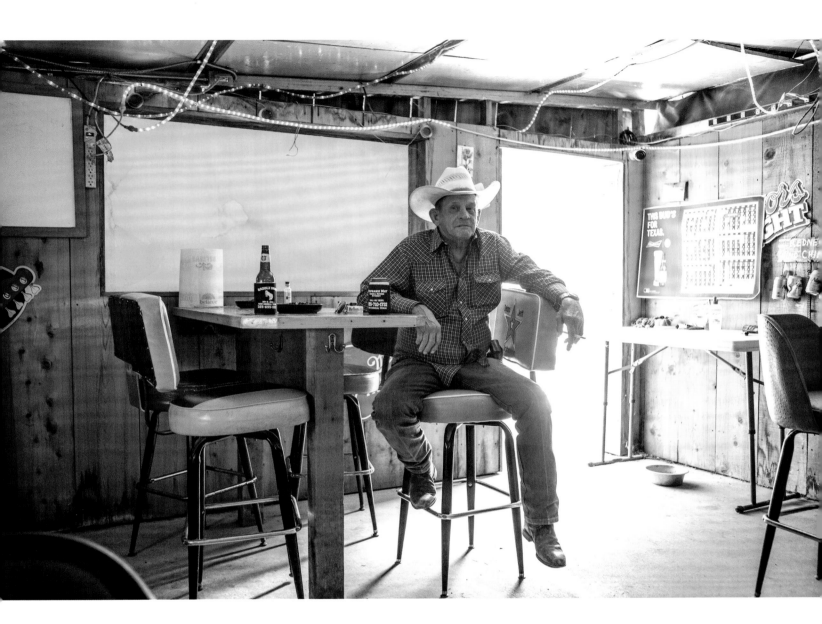

"Well, I had two strong men helping me up there," Ila protests. "I can't believe I got up there. I couldn't get off if I got up there today. I'd be up there forever."

* * *

Later, inside, Fred is about to leave but after saying good-bye to everyone, he pauses by my barstool and asks a couple questions

about the book Kirk and I are working on. He then nods approvingly and urges us to "Go to Shorty's in Port Aransas. You'll like it there."

I thank him for the tip and make a note of it.

Molly, who has taken over behind the bar, rings up a cold beer for Eddie, who's just arrived. Eddie drives a truck, hauling heavy equipment to Midland, Eagle Pass,

San Antonio. He calls Saddle Bronc his "home away from home," and he likes coming here because of that unwritten code of conduct. "Every once in a while, you'll get one that gets a little out of hand," he says of the customers, then sort of corrects himself with a smile. "It never gets out of hand. That's why I keep coming back here. There's no trouble here like at other bars. I ain't no fighter. There's some cussin,' but if you get caught you have to pay. But it's for a good cause."

In fact, the money collected from violating Ila's prohibition of the F-word is used for an annual dinner she buys for the regulars. Last year, they feasted on steak and shrimp.

"We've had pretty good times," Eddie says.

When I ask him to elaborate, to tell me a good story, he responds, "Ah, heck" (really, he did) and starts to laugh.

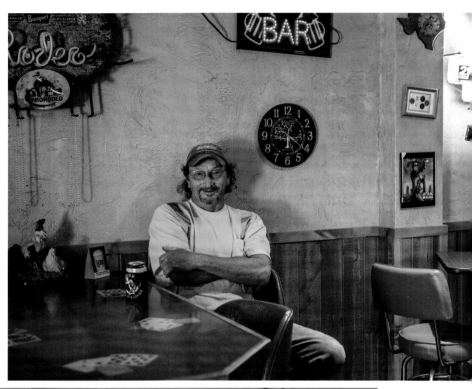

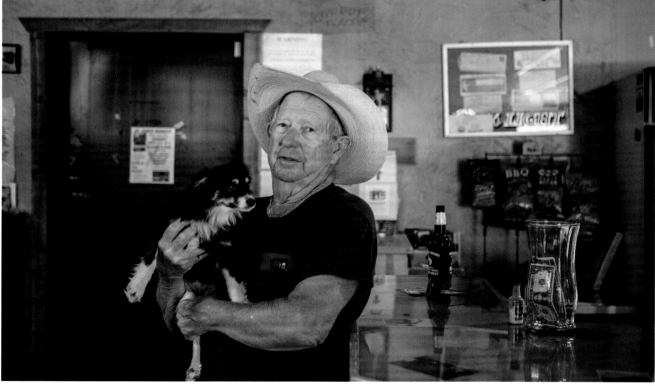

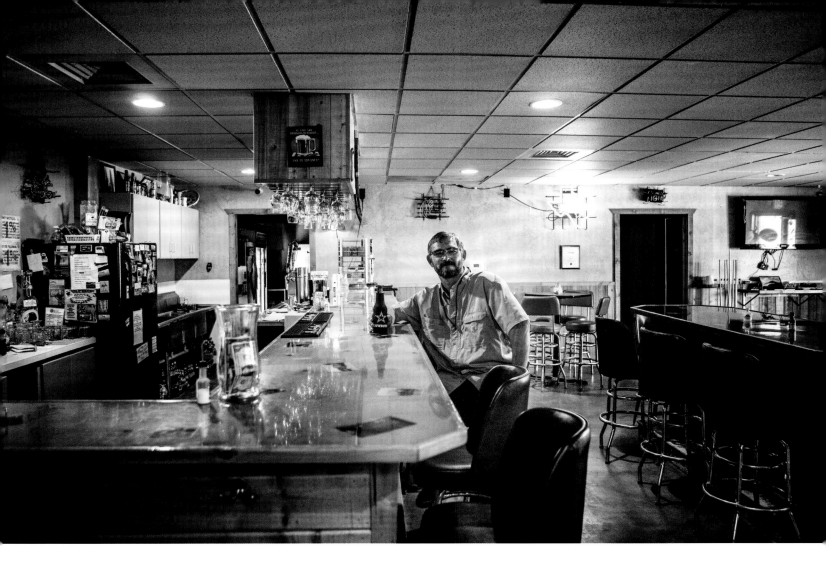

Molly lets him know that I've already heard of Ila dancing on the table.

And Eddie smiles wider because that was the story he wanted to tell but didn't know if he should risk it. "I'd be afraid to say it," he admits.

Sometimes, at a country bar, it's best to keep quiet.

When it comes time to pack up, two things strike me. First, Ila has a pretty firm hold on this place, which is why the regulars love it. And the other thing is that Saddle Bronc may be the purest form of the dive

bar we've visited so far: No kitchen. No live music. No karaoke. Opens at 8:00 a.m. And it's got a pool table.

But I have a hang-up about internet juke-boxes, and I can't help vocalizing it before we leave.

Ila tells me they used to own a CD-playing jukebox, but it was broken more than it worked. That old juke, it turns out, went to the great dive bar in the sky just a couple months earlier. I had just missed it.

As if to console my disappointment, Bruce says, "We do own the pool table."

Vices and Witches and Hurricanes, Oh My!

The Wizzard, Galveston

Owner Glynda Oglesby has a good reason why the Wizzard is not a neighborhood bar. "It's not a neighborhood bar because there are no neighbors," she says on a quiet night in August, having nothing else to do but take care of just one customer all night. "There is no neighborhood in downtown Galveston to speak of."

Glynda's cut of downtown, apparently, is not the place of street-corner gatherings or hanging out on the front steps of apartment buildings. It's not very pedestriany, in other words. The "dynamic" of the city grid has changed, she explains, because downtown Galveston is now made up of "so many condos that are second or third homes for people who don't live here." Of the people who do live close by Glynda shrugs, "Nobody comes out and drinks during the day. That's why I don't open the bar until four p.m."

The Wizzard lacks the regularity of regulars, but that's not to say that the same people don't return to the bar with some frequency. Quite the contrary, Glynda explains, "It's a 'coming-through' dive bar. When the condo owners and other periodic visitors come to town, they come by and catch up. They want to know what's going on, what's the dirt. And there are also the traveling people who don't want to be in a hotel bar, or a kid bar, as I refer to them. Sometimes they want to know what's new in town, and I'm sort of information central."

So the Wizzard does have its regulars, but they show up irregularly. So from day to day, or week to week, the same six or seven patrons *aren't* to be found sitting at the long, dark-wood bar, exchanging local gossip, agonizing over the Houston Texans being good but not great, grousing about the

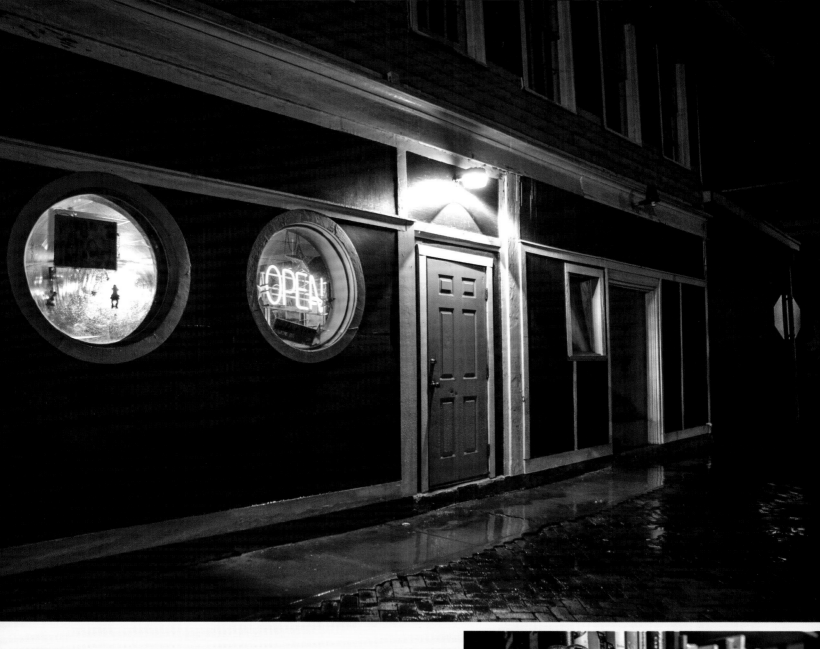

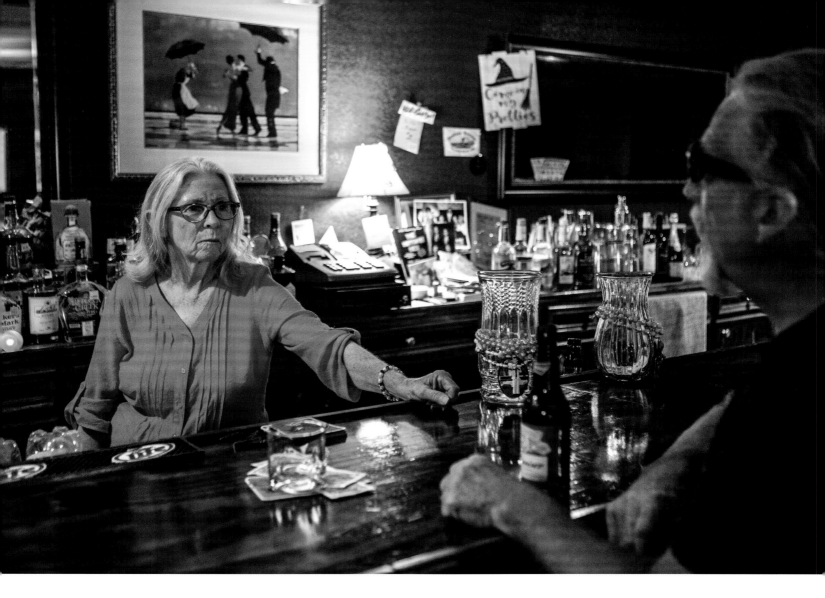

tourists that bring plenty of money to the city but have no appreciation for what the city truly is or, perhaps more important to Glynda, what the city truly once was.

Long ago Galveston was Las Vegas before there was Sin City. In the "Free State of Galveston" or the "Republic of Galveston Island," as Galvestonians liked to call their city from the late 1800s through the mid-twentieth century, there were illegal casinos and whorehouses, along with plenty of bootleg-

ging. And there were men, powerful men, behind all that vice.

Standing behind her bar, Glynda talks at length about this era of Galveston because in addition to being a "born on the island" Galvestonian, she's recognized as something of a local historian. When she recalls some of the more notorious activities that took place at the swanky Balinese Room, perhaps the nexus of notorious activities in post–World War II Galveston, she speaks proficiently,

like a history professor, even taking issue with certain locution.

"We don't use the word 'vice' down here, so if you don't want to look like you don't know what you're talking about, don't use that word," she says, never dropping her smile. "Just helping you out."

Whether or not felonious boozing, whoring, and gambling ought to be called vices, the city's nefarious history soon became just that: history. "The Texas Rangers came in and busted up the gambling in 1955 at the Balinese Room," Glynda says. "Everything started to get realigned in town. The old days have pretty much died off, so we don't have the storytellers that reminisce about their time. That's part of a lost conversation. They're still a few of us around that actually

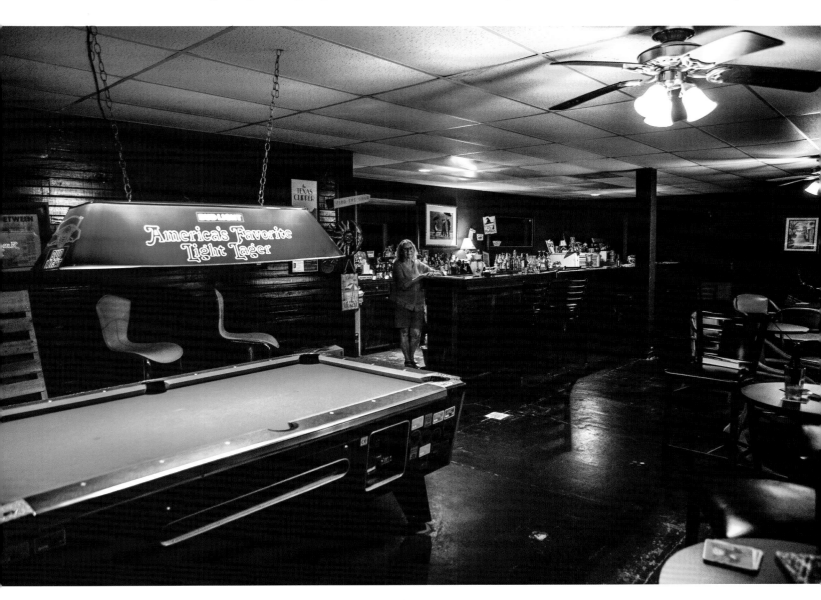

knew and met those people. We didn't live their stories, but we know what they had to say about their time in the city. I think that's why people come to bars like this. They want to know what this was about."

Glynda spreads her arms wide, indicating historical Galveston as a whole, including her bar and the building in which it resides, because they also fit neatly into the city's historical narrative. Back in the day, the second floor held both a brothel and a gambling parlor. At street level, the Circle News and Café, as the bar was called then, also played a not-so-insignificant role among Galveston's powerful men. Glynda produces a phone book from 1942 and turns to the page where the Circle is listed along with dozens of other beer joints. "It was sort of a neutral-zone bar between the bootleggers and gamblers on the beach and downtown. Sometimes things got out of alignment. The Circle was neutral territory for the businessmen to meet and have their talks, iron out their problems. There were no shenanigans in here. You came to resolve a problem. It was all business. We were not Chicago; there was no shooting out in the streets, but it got ironed out," she says.

There are no powerful men in the bar to iron out anything on this night. There are no irregular regulars either, so it's possible to sit and hear Glynda's stories for a couple hours and the front door never opens. Another round is poured. With the overhead lights lowered, it's dark inside. It's quiet. It's a good night to appreciate the surroundings, like the original circular windows that look out onto Church Street. There's a pool table, a large-screen television, and a Rowe AMI jukebox from the early 1990s.

There is also a full bookcase. Many of the books are about Texas and Galveston, and it's perfectly permissible for customers to sign their names in a spiral notebook and check one out. "You probably don't know too many bars that have a lending library," Glynda says proudly.

 * * *

A couple weeks later, when Kirk joins me at the Wizzard, it looks like it's going to be another quiet evening. On the television there is ongoing coverage of Imelda, a tropical storm that's targeting Galveston and dumping a ton of rain outside on the dark, empty street.

Glynda's expression quickly goes from easygoing to austere when a forecaster

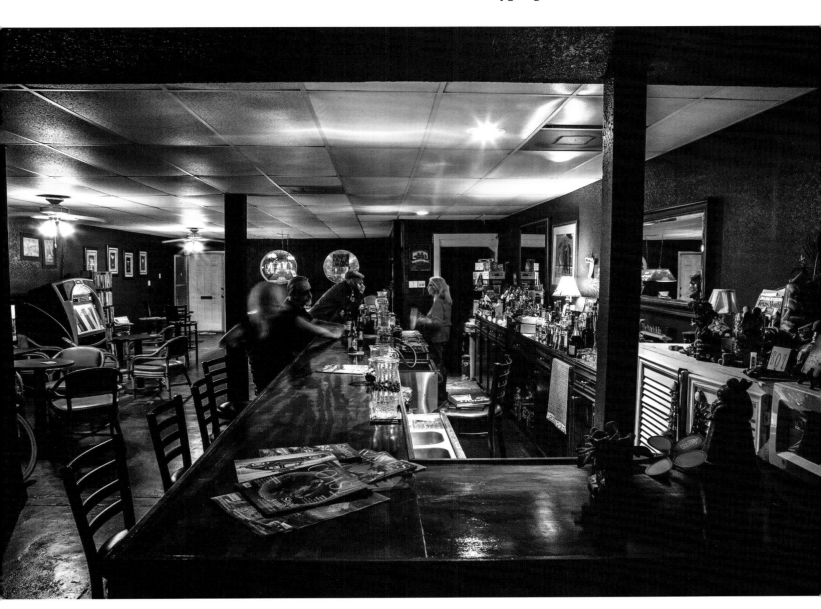

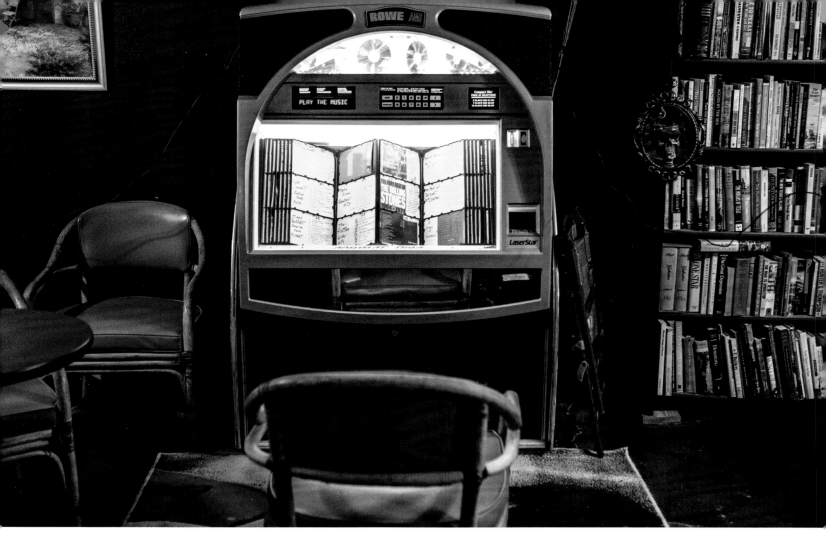

starts predicting more than a foot and a half of rain. She has plenty of memories of Hurricane Ike, which rammed through town in September 2008. That was twelve years into the Wizzard's run.

"Hurricane Ike gave us nine feet of water and four feet of ship-channel muck," Glynda says, glumly adding that just about everything inside was ruined. "There used to be a lot of nice music posters and paintings of old sailing ships, but none of that could be easily replaced. It's pretty heartbreaking. Once

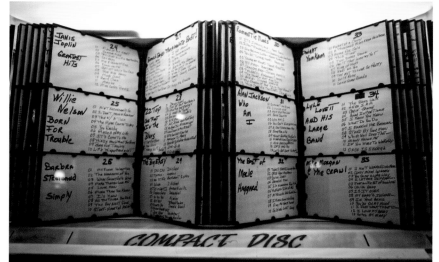

you get wiped out, the dream's gone. You can't replace those things. The history's not there."

Suddenly, the front door opens. In walk three people, one of whom has been here before. His name is Randy, a conservator of art, a restorer of art, and as Glynda points out, "He's a great artist in his own right."

Randy has brought with him a couple friends who aren't familiar with the Wizzard and one of its important dictates. So when they try to pay for their beers with a credit card, Glynda must politely tell them, "This is a cash-only bar."

"I wasn't anticipating that," says the man, a bit sheepishly.

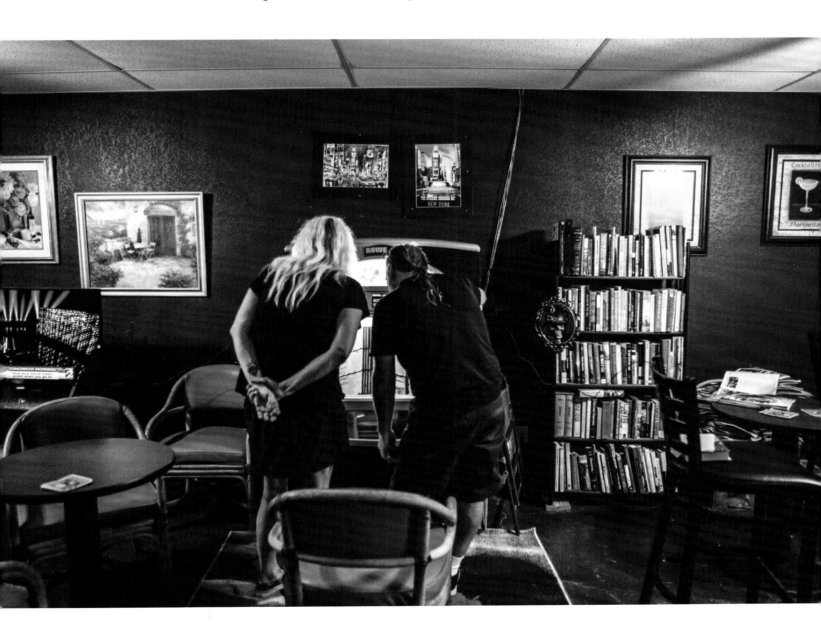

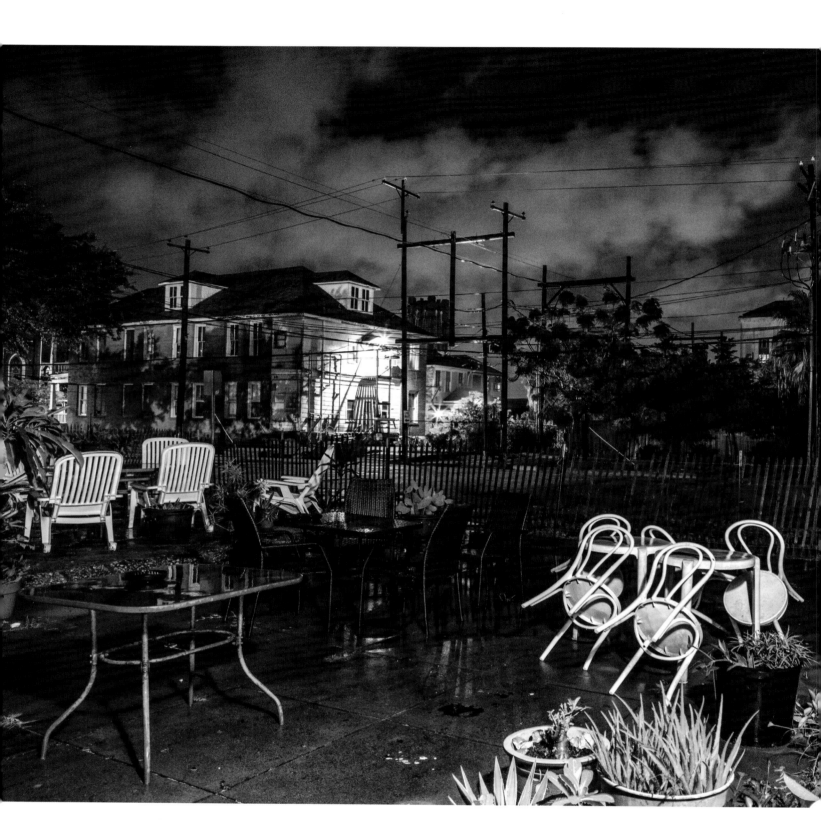

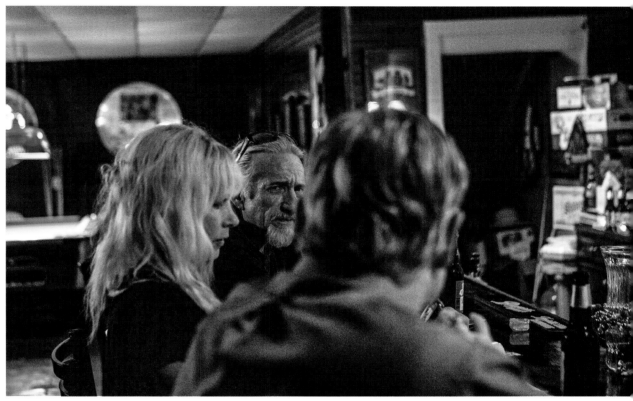

Glynda replies with good humor, "You're a grown-up, carry money," and then turns to the only customer who's taking notes and says, "Write that down."

After everything gets straightened out, Randy, a sixth-generation Galvestonian, explains that he frequently works out of town, which makes him one of the Wizzard's "coming-through" regulars. "This is where we come to get away from everyone. There's no nonsense in here. This is where you come to hide. Everybody's sane here. Everybody here wants to get away. That's why I always come here."

Randy remembers the bar from its pre-Ike days and says it was really jumping before the storm. "This place had a lot of people. Not a whole lot, but it could fill up; she'd have good business." He says it's now kind of coming back, but he still appreciates both its current low-key nature "and the jukebox." (We shake hands.)

With that, he slips away to get the music going with John Lee Hooker's "Lonesome Mood." The song's slow, grinding beat, along with Hooker's rich, signature voice, fills the Wizzard as the dark clouds continue storming outside.

* * *

There are black hats and broomsticks and several other illustrated references to witches to be found around the bar. Hanging on the wall inside a storage closet there's

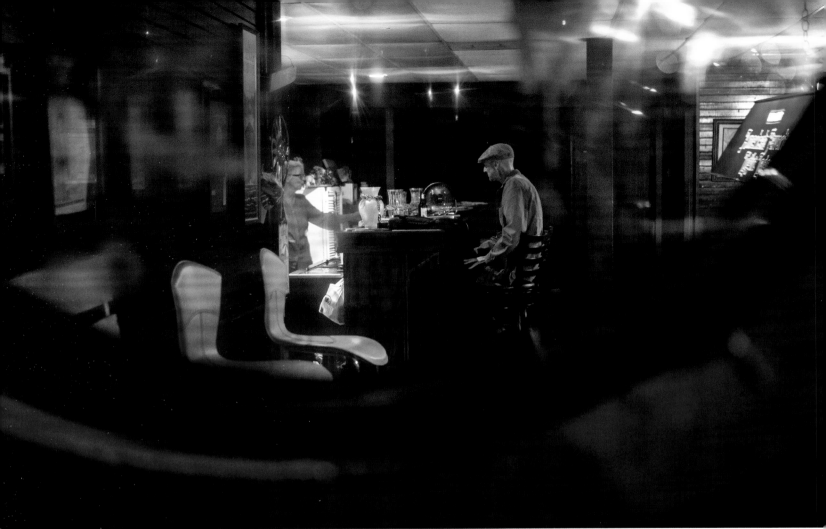

also a toy Tin Woodman, the silver-colored metal man from *The Wonderful Wizard of Oz*. The name "Glynda" is itself just one letter off from the name of the "Good Witch of the South" from the original Oz novels by L. Frank Baum. (In the 1939 movie version "Glinda" is the "Good Witch of the North.") But Glynda says not to read too deeply into any Oz connection and the name of her bar. She insists she wasn't really responsible for that theme. "That was the customers' doing. Before Ike, there was a lot of donated Wizard of Oz stuff because it's a natural thing

to assume with the name. There were a lot of posters of mystical, magical wizards on the walls too, but I can't go buy all that stuff again."

Why is it called the Wizzard? Glynda doesn't feel like telling that story tonight.

Cash is exchanged for drinks.

Randy plays ZZ Top's "Sharp Dressed Man" on the juke.

Outside, the rain keeps falling.

Eventually, Randy and his friends leave, but no one arrives to take their place.

Glynda thinks people don't go into bars like hers because they don't understand how interesting little businesses are. "I've had people come up to me outside and say, 'I've walked past this place for five years and I've been scared to go in.' And I say, 'Did you ever look in the windows? It's just an old lady.'"

Outside the clouds keep raining. In the morning, some of Galveston will be under two feet of water. And even though the bar will survive, for the rest of this night the door remains shut. There's nobody else to come and see the Wizzard.

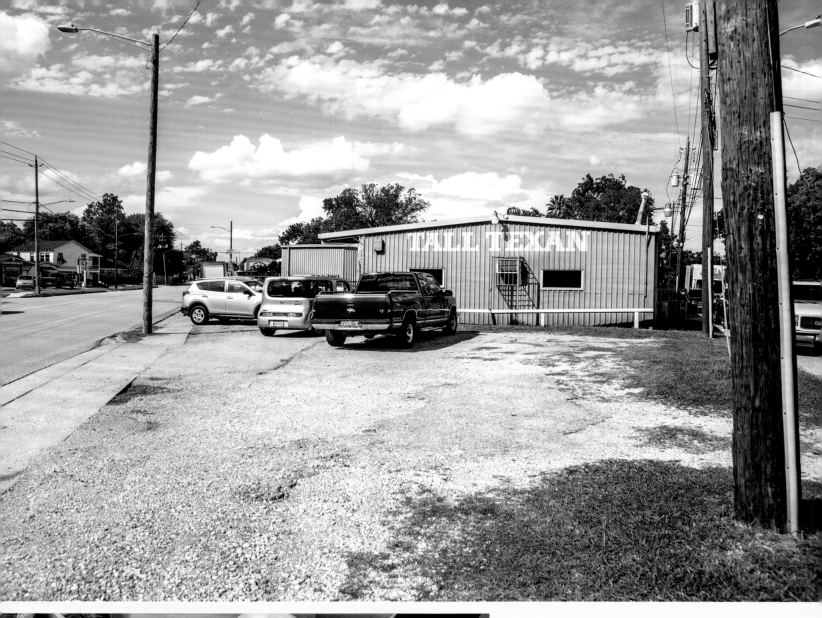

October Classic

Alice's Tall Texan, Houston

In about an hour, hundreds of thousands of television screens around Houston will be playing game three of the American League Championship Series between the hometown Astros and the New York Yankees. Although the game is being played in the Bronx, it's still the biggest event to watch in H-Town on this sunny October day. The city is primed for an Astros win—and Alice's Tall Texan is empty.

"It stinks because there's no one in here," laments Karen, who's wearing a blue Astros jersey and jean shorts and sitting at the Texan's Formica-topped bar. But she knows better. It won't be long before nearly every seat inside is occupied. She's just worried that Kirk and I are getting the wrong impression of the bar and that it'll reflect badly on Alice Ward, the owner for the past thirty-five years and Karen's dear friend.

But it's not that bad to have a place like this practically all to yourself. The front windows look out onto North Main Street and let in plenty of sunshine; there are old-school Christmas lights with big frosty bulbs over the bar; a wall-unit air conditioner blows strong; and "Jackson" by Johnny and June Carter Cash is playing over the speakers. The word "agreeable" immediately comes to mind.

To allay Karen's concern, I buy a round for the house. (Big spender, right?) The Tall Texan features beautiful 18-ounce schooners filled with either Lone Star or Shiner for three bucks a pop. Those are the only two beers on draft here, and they're served super-cold because the glass goblets are chilled in a refrigerator in the back room.

"The man I bought the place from had it like that," Alice says. There is an ease in her

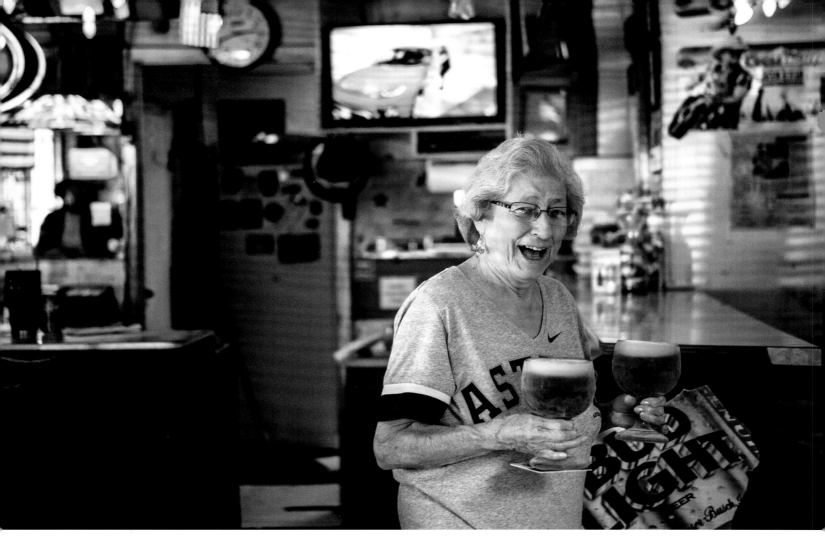

manner as she talks and sets two icy glasses in front of us. "I actually have three taps. I had Old Milwaukee, but it got hard to get. The beer companies still want me to put one in there, in the middle. I tell them I really don't have room in my cooler."

Decked out in a gray Astros jersey that compliments her short hair, Alice is approaching eighty, but her smiling eyes don't look like those of an octogenarian. Her dangling Texas-shaped earrings sport the team's yellow, orange, and red stripes. She likes to laugh, loves the 'Stros, and no doubt hauling around those heavy glasses of beer all day keeps her in pretty good shape.

Karen insists the Texan is habitually friendly and welcoming because Alice doesn't put up with any trouble. "She's a tough cookie."

"I just don't allow anybody to act up in here," Alice says, her smile never wavering. "It's always been pretty mellow. I don't think I've had too many altercations, although one time somebody ran in here with a machete. They was chasing someone. I had to call the cops to get him out of here."

This friendship began when Karen, who's in her early forties, was working at another bar, around 2011, and Alice was one of her customers. "We started going to Astros games together," Karen says. "We went to a game in Arlington once. We go in this sports bar, we're hanging out, and we're having a conversation with the bartenders, and we tell them that Alice owns the Tall Texan. And they Google it and they're like, 'That place looks like a dive bar.' And we're like, 'Yes! It is. Absolutely it is.' They acted like they'd never walk into a place like this."

That's their loss, am I right, Karen? Besides, any bar can become a "sports bar" if the TV is tuned to the big game, like it is at the Tall Texan. And before Houston's pitcher takes the mound and rubs his hand

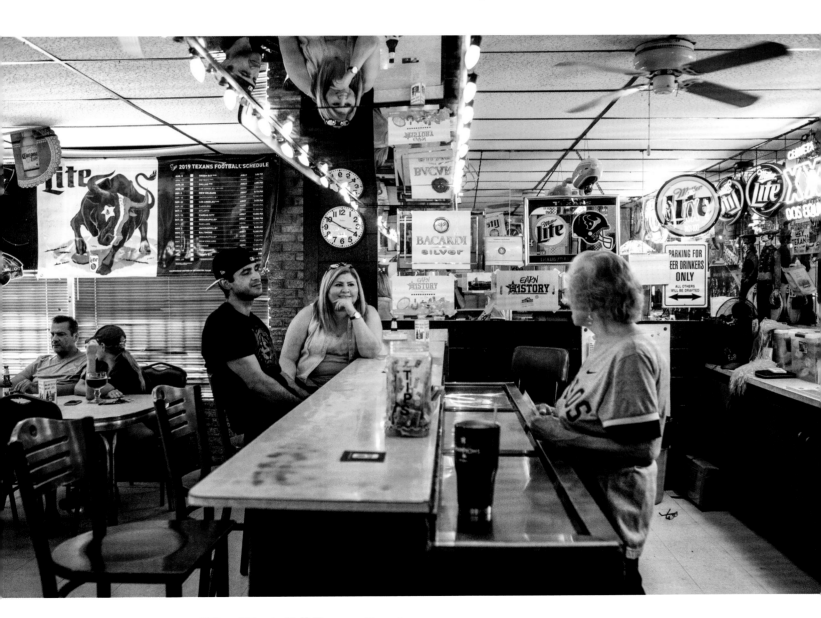

with dirt, the bar starts filling up—nearly everyone announces their entrance with the cheer "Go 'Stros!" Alice goes to work filling up those icy fishbowls with beer.

* * *

Alice isn't really sure how far back the bar dates. One customer thinks it opened in 1949, but a framed newspaper article on the wall states that it's "been around since Prohibition" (which ended in 1933). We do know that Alice started working here as a barmaid and manager in 1983 and bought the place in 1984.

Except for updating seasonal calendars for the Astros, Rockets, and Texans, she's preserved the same look of the place from before her tenure started, including keep-

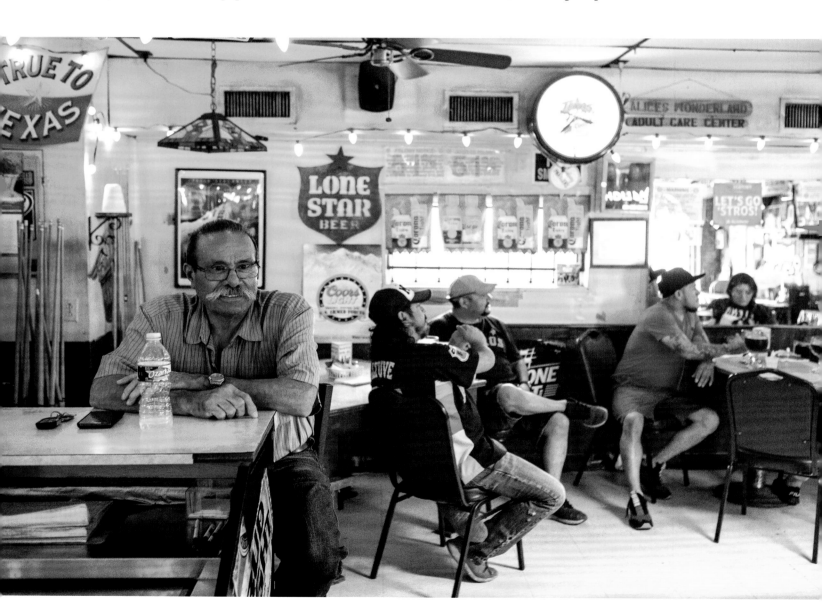

ing the stylish mirrors above the bar and the cowboy-themed wallpaper. She also saved the statue of a cowboy that stands on the back bar. "It was here when I got here. It looks like a tall Texan," she says while examining the art piece, finally determining that somebody named Ginger made it in 1979. The Tall Texan started as an icehouse, serving only beer and wine, and that's stayed the same too. "Never had liquor. I don't want a liquor license. Too much trouble," Alice says, although she points out that it's legal for customers to bring in their

own liquor bottles. It's called a "setup" and she's fine with that. In fact, she doesn't even drink beer or wine. "I drink mixed drinks. So I go to a bar that has mixed drinks if I feel like drinking." (If you happen to see her out, perhaps at Warren's Inn, buy her a vodka and tonic.)

Alice eventually did do one thing to update her bar. She—sigh—got rid of her CD jukebox for an internet model.

Alice sighs too when I whine that a place like hers deserves a real juke. "I know," she concedes. "The lady that had my jukebox before was named Rose. Her friend Bobby wanted to put [an internet jukebox] here and I said, 'I'm not gonna kick Rose out. If you and Rose can make a deal, that's between you and her.' So she made a deal with him, and that's how I got the internet. I don't recall when that happened, but Rose has been dead for a while. I figure about seven or eight years."

Ceida (pronounced *say-da*), one of Alice's bartenders who's dropped by, says some customers like the new jukebox because they can select songs using their phones. "They don't even have to get up," Ceida tells me. "You can download the app, you give a credit card, and they play it with their phone."

I guess that's progress. After all, it's been a terrible burden to have to walk across the room, perhaps twenty-five feet, in order to select some songs, but we just didn't know it before now. (By the way, Bon Jovi's "Living on a Prayer" is playing, and Karen whispers that another advantage of using your phone is that no one in the bar can tell who's choosing the music.)

With the place packed, there is a lot of optimism in the room. There is a lot of

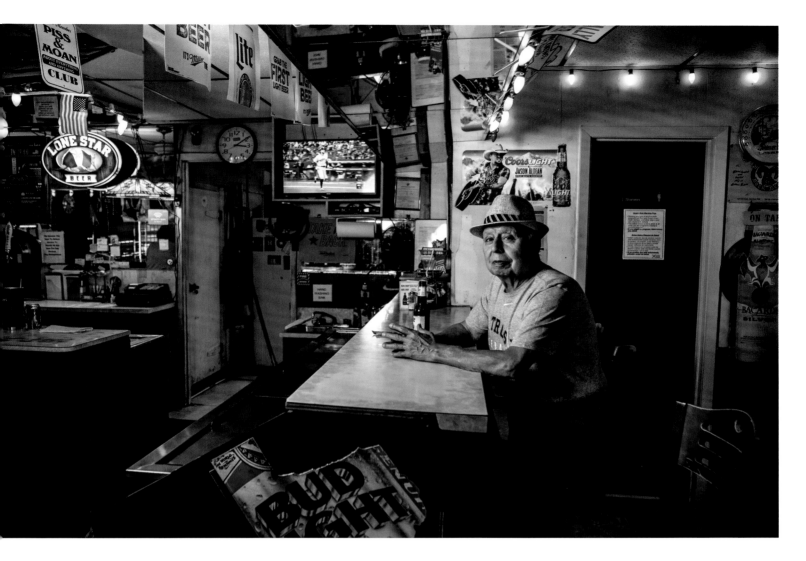

anticipation as the music is cut off and the game gets under way.

And from a couple dozen patrons there rose a lusty yell, 'cause in the top of the first inning José Altuve practically knocks the cover off the ball. He sends it to the stands for a solo home run, and the Texan is suddenly thrilled as Houston goes up by one.

"YEAH!"

"SWEET!"

"HERE WE GO!"

And now the bar is humming along with palpable energy. Strangers are bonding, becoming friends as well as fans. A few tables are pushed together right down the middle of the room. Alice doesn't sell food, but she sometimes puts out hot dogs or chips and salsa. People can bring in dinner if they want. There's kind of a living-room atmosphere, with folks eating and drinking family-style. The only rule is to clean up after yourself.

"YES!"

"WHOO!"

In Yankee Stadium the air is shattered by the blow from Astros right-fielder Josh Reddick, who just sent the ball to the second deck for another solo. The bar goes nuts, and Alice is pumped up too. At the end of the second, the score stands 0-2.

Kirk and I have been moseying around, trying to stay out of the way while talking with people, but it's pretty hard—nay, rude—to conduct interviews during the action. So I'm just going to be honest here.

After a while, we ordered a couple more goblets of beer and sat down to watch the game. I've actually liked the Astros from way back in the day—back when the team introduced the coolest, most colorful uniforms to the National League; back when Joe Niekro was throwing wicked knuckle balls (and doctoring the ball with emery boards and sandpaper); back when they played their home games in the Astrodome. Tonight it's good to be just another fan.

"Get him out!"

"Be ready, guys!"

"Pop-up. Easy pop-up. He's got it. All right!"

Now, get this: In the top half of the fourth inning, the Yankee pitcher served one up to Houston catcher Martin Maldonado, who blasted the ball to left field. "Yeah! Go! Get out! Get out!" came the cries, urging the ball to get over the fence for a home run. But one lone voice can be heard above the fracas: "Get it, get it, get it!" It was Alice! She'd been so busy pulling drafts that when she turned around she mistakenly started calling for the Yankee outfielder to catch the ball. "Get it! Get it! Get it!" When the ball landed on the warning track, the Texan crowd rejoiced as Maldonado headed for second base. It was only then that Alice realized what she'd done. "Oh, hell! That was the wrong one! I didn't know we were up to bat!"

The way this all played out in three or four seconds—the way the whole bar turned

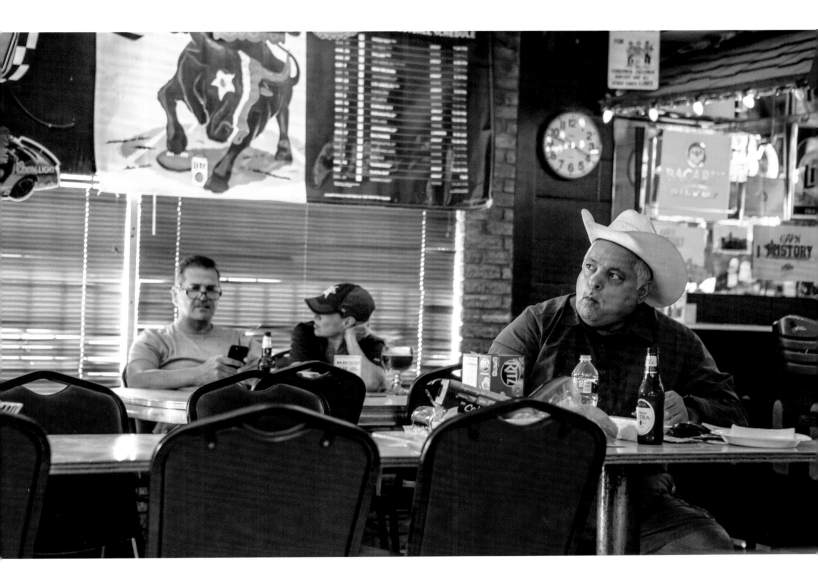

At times the bar gets quiet. The calm is sometimes broken by "Oh yeah!" if the Astros do something good and "Oh shit!" whenever the Yankees do. Alice leans her face into her palm and pounds the bar when the Astros go down scoreless in the fifth inning.

A young couple comes in and orders two beers. But they don't have cash, and that's a problem because Alice's Tall Texan is a cash-only establishment. The couple leaves.

Alice says that happens all the time, but she's not interested in accepting plastic or even putting in an ATM machine. "I guess because that's the way I like it," she tells me, keeping an eye on the game. "People make tabs and you have to collect credit cards, and if you're busy you have people standing around, trying to get waited on. In a cash bar you collect the money, give them change,

toward Alice in confusion—the moment she realized what she was doing—it may have been the funniest thing I've witnessed during our entire time on the road.

In between innings, I chat up the guy sitting next to me. His name is Santos and he's got a killer mustache. Santos worked maintenance for an oil company for fifteen years, then switched to doing interior work on high-rise buildings before retiring. He's been coming here longer than Alice. "This has been the same old Texan for a long time. It looks the same," he says. "I put the floor in, back in eighty-three, eighty-four, me and another guy. I fixed the front door for Alice. I do a little maintenance work for her every now and again."

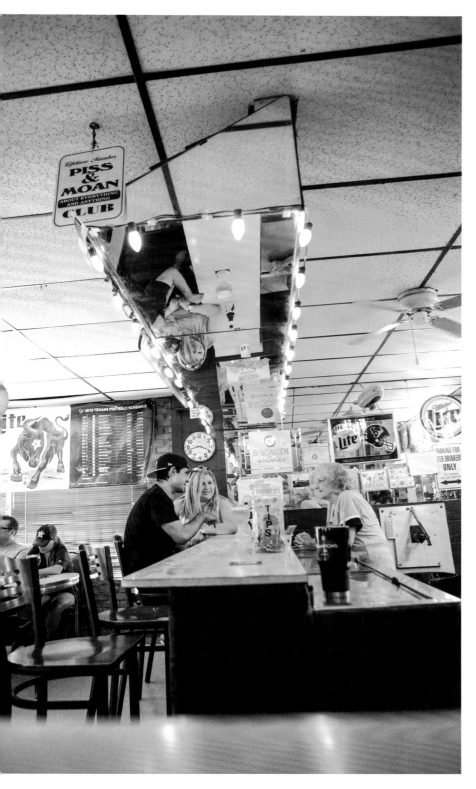

and move on to the next person. People have tried to get me to change, but nope. A lot of places have ATM machines that get broke into. No ATM here. There's an ATM across the street. Sometimes they go and get cash right away, sometimes they don't. But the next time they come back, they know it's a cash bar."

Clear enough. However, Alice remains curious about the couple who just left because she thinks the man looked a lot like her niece's son. "But I ain't sure," she says.

It's not long before the mysterious couple returns. "Now you have to figure out who he is," I say to Alice. Santos suggests asking him for his driver's license to get his name.

Alice saunters back to the bar. Because of the sounds of the game, we can't hear what's being said, but then she turns to us and smiles. He's family. Our little section bursts into a cheer and you would have thought the Astros had just hit another dinger.

Alice catches up on family news. We sip our beers and watch the game. Time passes agreeably.

"C'mon, get a hit!"

I don't need to detail the whole game, but the Astros won, 4–1. They eventually took the pennant and went to the World Series against the Washington Nationals, but lost the final game in Houston. And even though I wasn't there, I know that at the end of that game there was no joy at Alice's Tall Texan.

In fact, I'm sure it was pretty low at the bar for at least a week or two, during which time the cold schooners of Shiner and Lone Star surely fueled plenty of bitter conversations about what exactly went wrong. But in the right atmosphere, like what Alice provides, even the losses feel a little better.

You Can't Go Home Again

(In which the author must admit that he belongs to no bar)

Showdown, San Marcos

You know when you're dreaming about something, only it's really something else? That's how I feel when I'm drinking at Showdown.

If it's 10:20 in the morning and Pete's holding court at the corner of the bar, like what's happening right now in front of my eyes, then it seems like everything is A-OK. In fact, I see many familiar faces, like "Guitar Steve" (also called "Pecan Steve"), sitting by himself, just like always. And there's Adrian. You can't miss Adrian. He looks like a guy who works third shift at a company producing fan blades for aircraft. *The Price Is Right* is playing on TV. I'm enjoying a pint of Big Bark Amber Lager from Austin's Live Oak Brewing Company (which did not pay me to say that). This all feels normal.

And yet none of this normal because my hometown hangout used to be the Triple Crown, a small cinder-block bar located about a block and a half away from San Marcos's town square. The Crown was kind of famous for being a great live-music bar, but it opened at 8:00 a.m.—and that's dive time.

I often spent mornings there, working on assignments, sometimes taking business calls, occasionally meeting colleagues. The same group of guys (mostly guys) hung out there before noon. I bought them drinks. They bought me drinks. We traded hyper-local news and gossip. We reviewed the sports scores. Sometimes we talked about religion, sex, politics, and gun rights. Mostly we talked about nothing, at length, while we drank. We smoked cigarettes right at the bar (until a city ordinance chased us outside). We sometimes drank too much and acted a bit boorish. Some guys moved away,

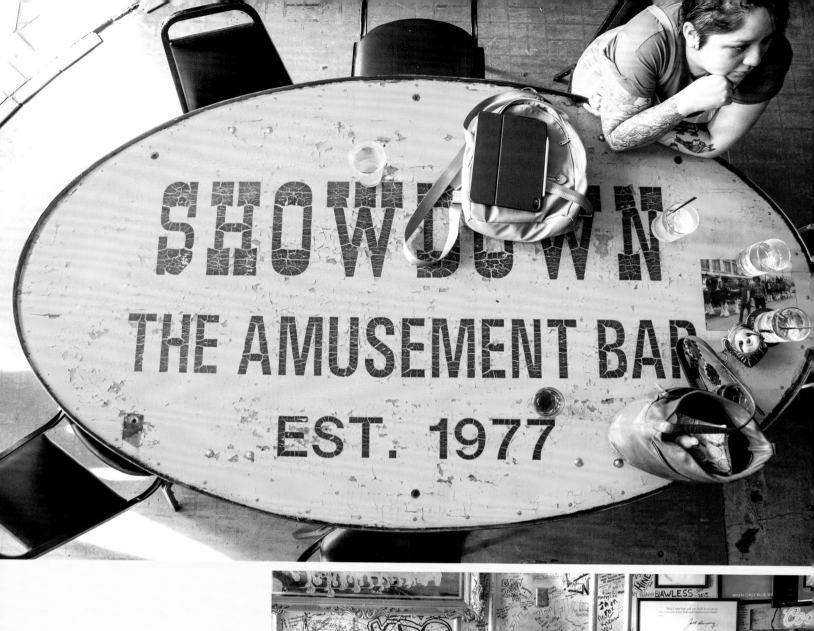
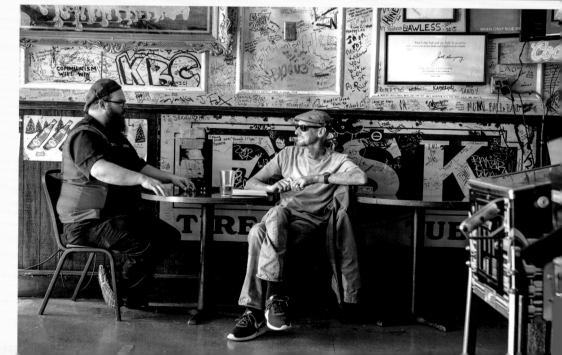

and some guys died. We welcomed new guys into the fold as long as they weren't dicks. We upheld the rules and protocols of the bar as if we owned the damned place.

Then one day at the end of 2015, after nineteen years, the Crown closed its doors forever. Back then it felt like being roped off from my own living room. But no one mourns the death of a dive. No one, that is, but the regulars, and I remember the last couple of weeks in business we kept asking each other, with disbelieving resignation, where to go next.

Many of us morning customers and a few of the bartenders ended up a block away at Showdown, a beige brick building with high archways for the front windows and a couple of tables on the sidewalk for the smokers. For some reason, though, after a couple visits I realized how much I hated change—in general—and just stopped going.

Four years later, I've returned to Showdown to see that many of the same guys are still here. Maybe that's why this morning feels a bit dreamlike.

Pete and Steve-O (not to be confused with "Guitar Steve") return from an outside smoke break, talking about candy cigarettes from childhood.

"Your mouth would glow with that powdered sugar."

"Remember that cigar bubble gum?"

"It was good-quality gum. Not like Big League Chew."

"Oh, no. It lasted a long time."

"I still like the grape."

It's the same old shit from the same old guys, and it feels like I never left the place. Pete anchors the bar's corner, just like he did at the Crown most mornings. With his

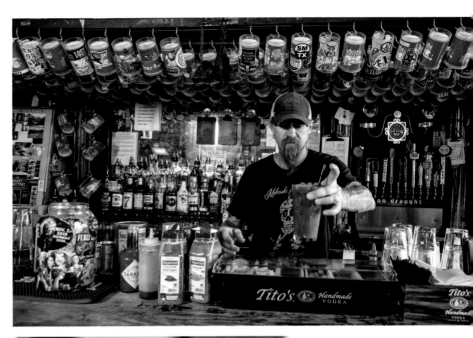

outsized beard and his gravelly voice, he ought to have a nickname like "Harley," but he's just Pete, and he mostly wants to watch the television, especially when *The Price Is Right* is on. Too much talk can get under his skin.

Steve-O is more of a talker. Slim with a short haircut, he'll chat easily about whatever topic comes up. Like me, Steve-O's

from Indiana, so we start talking about how Evansville just beat No. 1–ranked Kentucky in college basketball. Adrian and a couple other guys lean in, and suddenly it becomes a wider conversation.

As the clock gets closer to 10:50, Pete looks around and grouses that he's not going to bother explaining the game to any new people in the bar. Finally, he booms, "If you

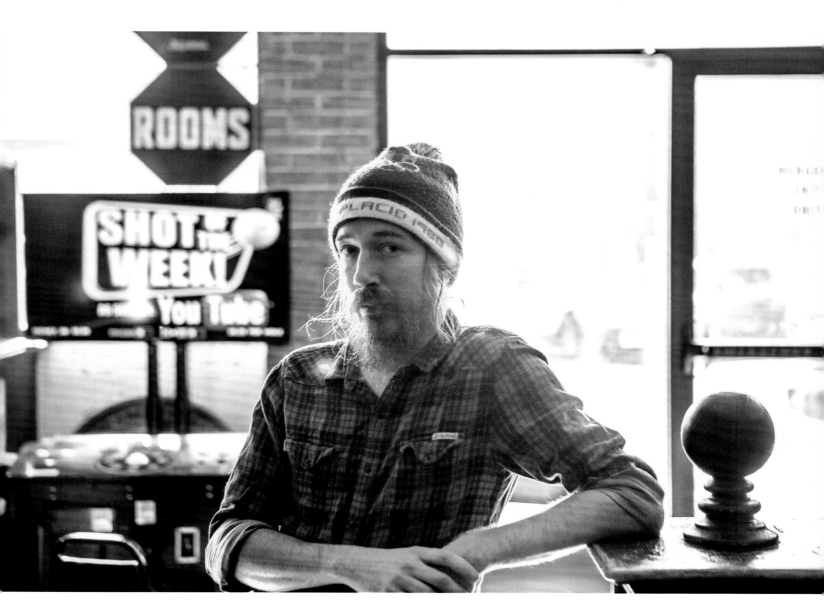

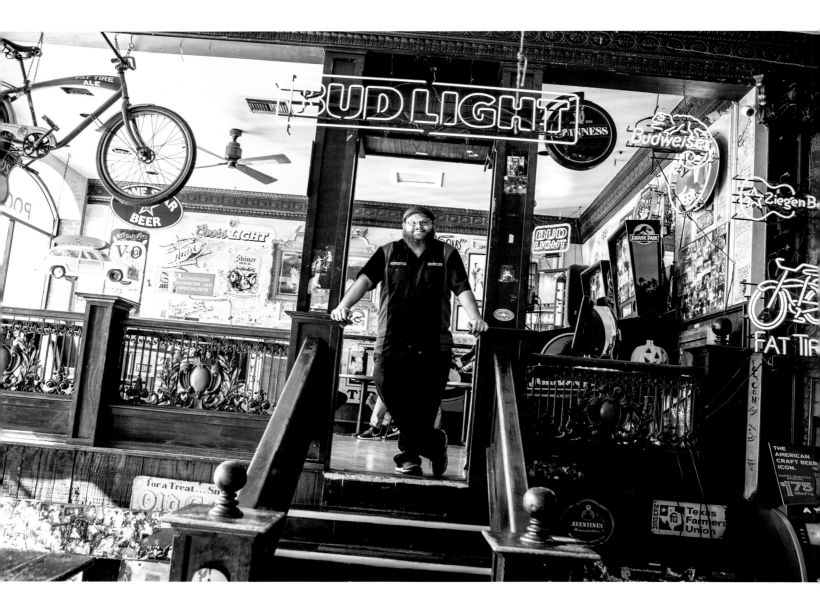

guys are playing, pay attention because I am not a patient man!"

The game is "Showcase Showdown," the last segment on every *Price Is Right*. Once a tradition at the Triple Crown, playing "Showcase Showdown" is taken seriously here, and Pete is the best at the game. I'm not bragging or nothing, but I used to be damn good too. I think it helps to watch the whole show beforehand in order to find a pattern

in the prices. Pete insists there's simply one thing to do: "Just pay attention!" Which is code for "Shut Up!"

Pete writes down the names of whoever is playing along. I'm sitting just to the right of him and must bid first. While I'm still tallying up my thoughts, Pete writes down his own bid and shouts, "Next!" I quickly make a guess. Pete is not a patient man. During the commercial break, while he adds

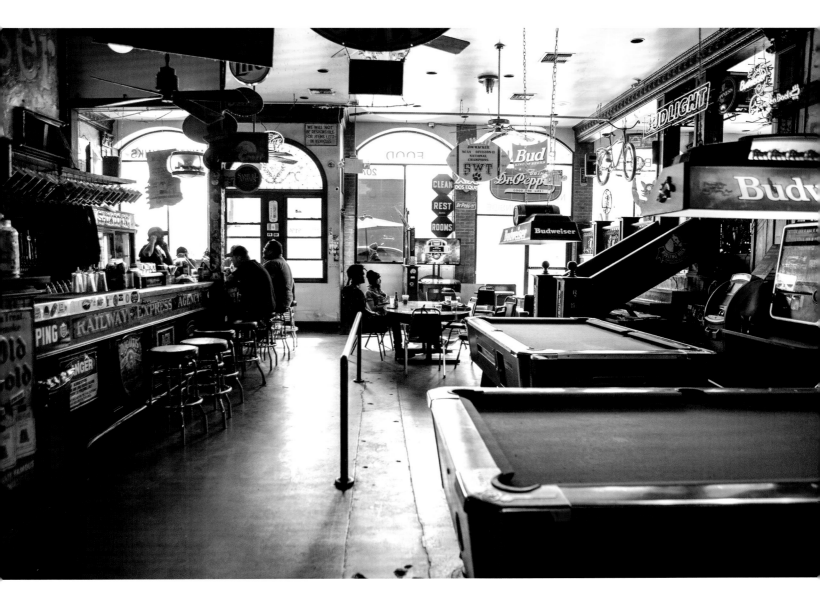

up everyone's totals, the rest of us engage in a robust discussion about which is worse, a colonoscopy or a prostate exam. There are well-reasoned arguments presented for each—but unfortunately, in the midst of such savory conversation the show returns and the official price totals are revealed. Pete wins.

And just like that, the TV's volume goes down, the music gets turned up. Drinks are purchased in celebration. Bartender Evie, who's sharp and funny and young, looks on as a bunch of us late-middle-aged men clap ourselves on the back and clink glasses like we'd just split the atom.

At the other end of the bar, near the tiniest of kitchens, I catch up with Michael, who introduced himself to me at the Triple Crown several years ago with this joke: "There was a husband and wife, and it was their

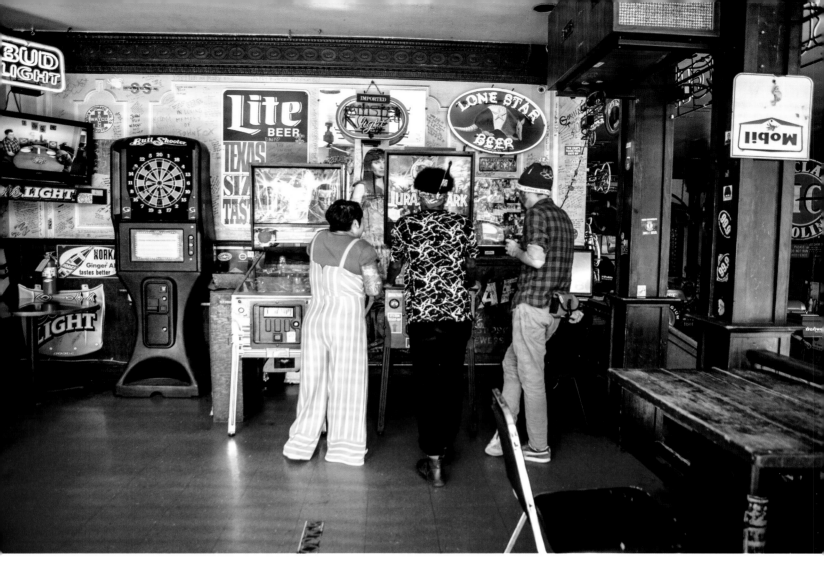

first Christmas together. The wife's mom is in town, she's staying over. And they're having Christmas dinner together. During the dinner, out of the blue, out of nowhere, the mother-in-law says, 'I've decided that I would like to be cremated.' And the husband rises from his chair and says, 'I'll go warm up the car.'"

He tells it again and I still think it's funny, so I buy him a shot of his favorite, Cuervo Gold. Michael taps the bottom of the shot glass to the bar before drinking up, just like he did when I first met him.

When he asks what I've been up to, I mention this book. He agrees that finding a comfortable place to drink away from home is important to certain types of people and that personal recommendations go a long way. We end up swapping stories about other dives and he mentions a place in Port Aransas. "It's called Shorty's," he says. "That was the first one I went to with my buddies when we were in Port A. I think you'd approve."

I thank him for the tip and tell him I might check it out some day.

* * *

If you reset your calendar to 1977, the year Showdown opened, you'll find Jimmy Carter was in the White House, *Star Wars* was released, Elvis died, the first episode of *Love Boat* aired on ABC, and Waylon Jennings (with Willie Nelson) released "Luckenbach, Texas." Which means that Showdown has quietly survived an excess of pop culture, seven presidents, and even a *Love Boat* reboot.

It has also outlasted countless nearby businesses. There are empty storefronts next door, where various shops used to be. Across the street, a gastropub replaced the

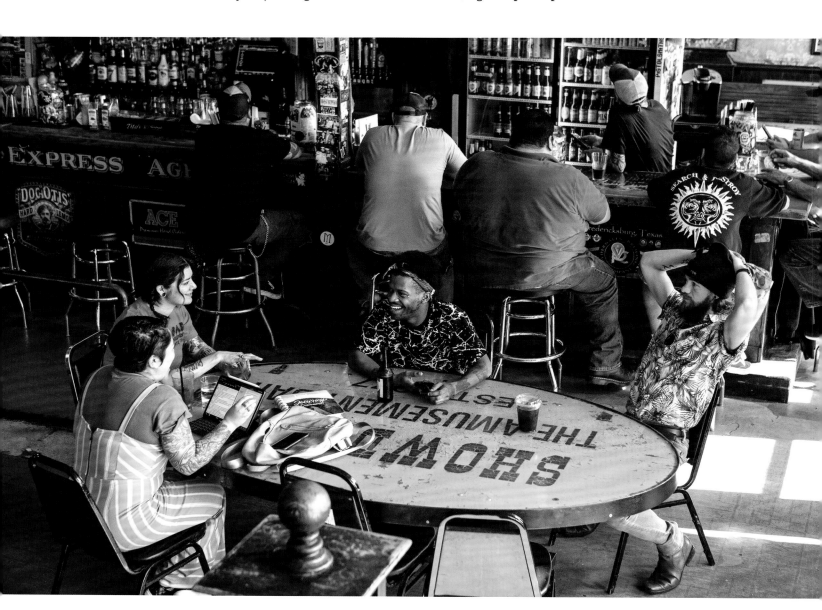

party-favor megastore many years ago. Up the way, my favorite mechanic's garage closed and was just demolished to the ground. *Perhaps*, I think to myself when I return to the bar the next morning, *I should give more credit to a place with Showdown's stamina.*

But just when I'm trying to get comfortable with the space, things take a nasty turn. Televised congressional impeachment hearings on the TV have preempted *The Price Is Right*, leaving a lot of us pouting in our beers. I head upstairs to talk to Andrew Fox, Showdown's manager, who wasn't around at its beginning but did get to work with Eddie Mack Edwards, the original general manager and president and a minor legend in San Marcos for launching a business that's now over forty years old. Andrew was working on a degree in astrophysics at Texas State University when he took a bartending job here. That was around Thanksgiving 2011. When Eddie Mack passed away

in 2015, Andrew accepted the management position.

"It's still Eddie Mack's bar. I really feel he created this community, and he created this bar," Andrew says. "It's a sanctuary. It's an honest bar. When the Triple Crown closed down, we were honored to take in its refugees." He seems especially sincere about that last point.

Downstairs, the guys have switched the TV to *Rudy*. It's a movie about a kid who never gave up on his dream. I find a seat

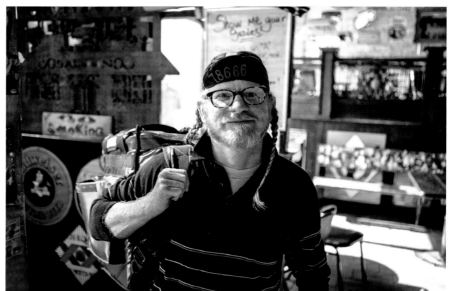

next to a man named Kevin, someone I used to see all the time at the Triple Crown. Apropos of nothing, he tells me that the owners of my old favorite bar actually took inspiration from Showdown when they opened. He says they wanted their place to have the same kind of vibe and the same kind of comradery among the customers.

We all sit and watch *Rudy* till the very end. It's during this mushy, oversentimentalized, terrific movie that I admit to myself that it's the people that make a bar feel like a dive, not the place. I miss the Triple Crown, but it's okay to move on. I think I'll keep coming back here.

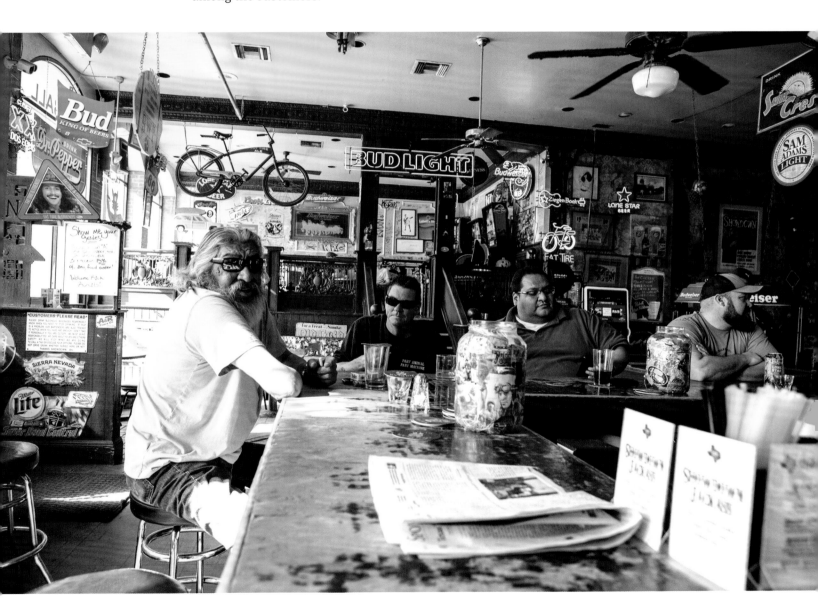

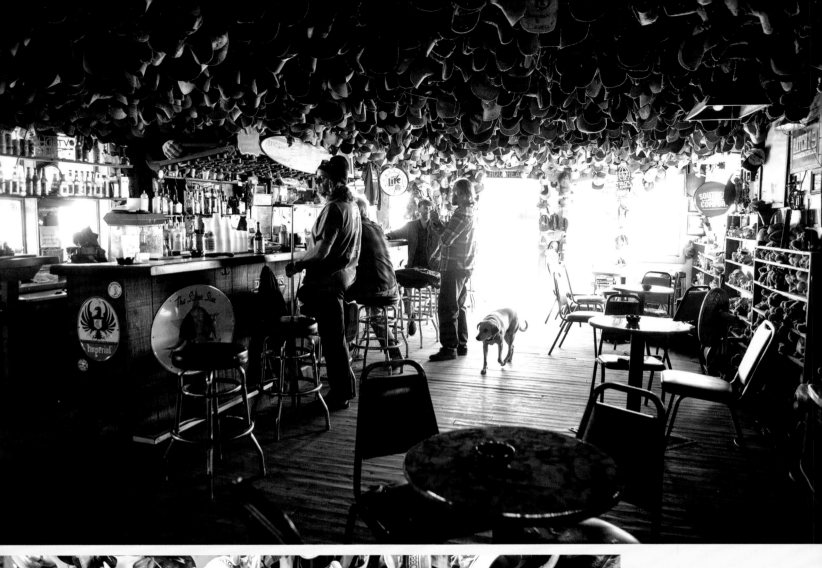

Drinks at the End of the World

Shorty's Place, Port Aransas

One brisk December afternoon on the drive to Port Aransas, I start getting the feeling that everyone in the world had been to Shorty's but me. Kirk already had, of course. He and his wife, Tracy, were screwing around on the Texas coast a few carefree years ago when they found themselves in Port A, and one day Kirk was out looking for a place to have a cold beer. So he went to Shorty's. He wanted, in his words, "to get away from the cutesy places that try to look cool." That was his first time. It was his idea to go back for the book.

But not his idea alone. Different people at different bars in different parts of Texas put the same idea—to visit Shorty's—in our heads time and time again. We talked to a lot of people about this book while working on it, which is why the nurse who draws blood at my oncologist's office once recom-mended Shorty's while sticking a needle in my arm. My sister-in-law, who owns property in Port A, has drunk there, and her kid, my sixteen-year-old nephew, once sent me a photo of Shorty's—just to troll me for having never been there. There are two types of people in Texas, those who have been to Shorty's and those who haven't yet. My intention was to change my membership status.

A few minutes after ferrying across Corpus Christi Bay to Mustang Island, we were in Port A and standing on Tarpon Street. Here I was, feeling like the last one to the party, and there it was, at the end of a row of low-slung businesses, a whitewashed beach shack that, to be honest, kind of looked like it had been to hell and back. Shorty's sign proclaimed "Oldest & Friendliest."

A couple of seagulls were flopping around the cars parked outside. I could smell the distinct maritime aroma of the nearby coast, but I couldn't quite see it. And I couldn't help noticing that someone planted a chain-link fence a few yards to the right of the bar's front patio, just about where Tarpon ended and Trout Street commenced. From the other side of that fence came the fierce, confident growls of construction equipment, demolishing the past to make way for the future. Over there was the beginning to a whole new world, and no one, we would soon learn, no one around here asked for it to come.

Inside, Shorty's is nothing fancy. There are hardwood floors scratched and scored by the march of time; the bar's lumber looks like it's been around almost as long as the

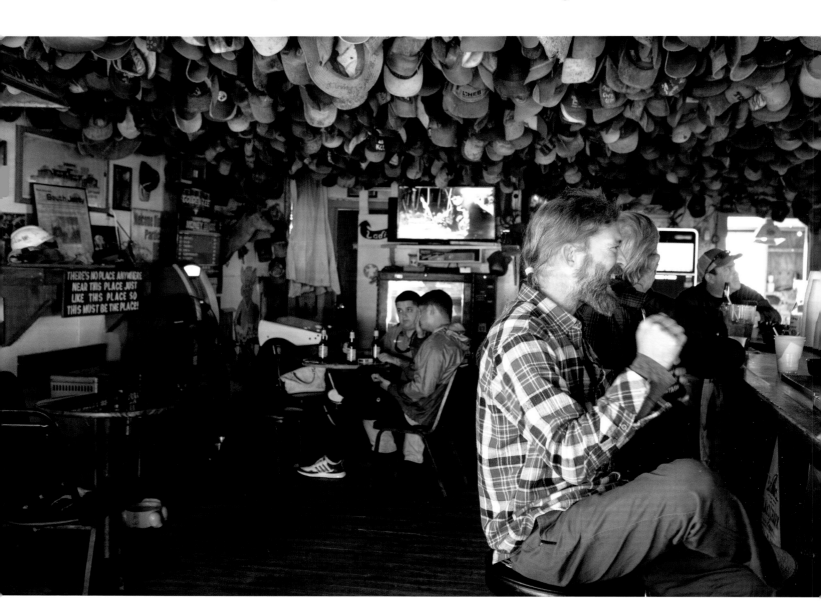

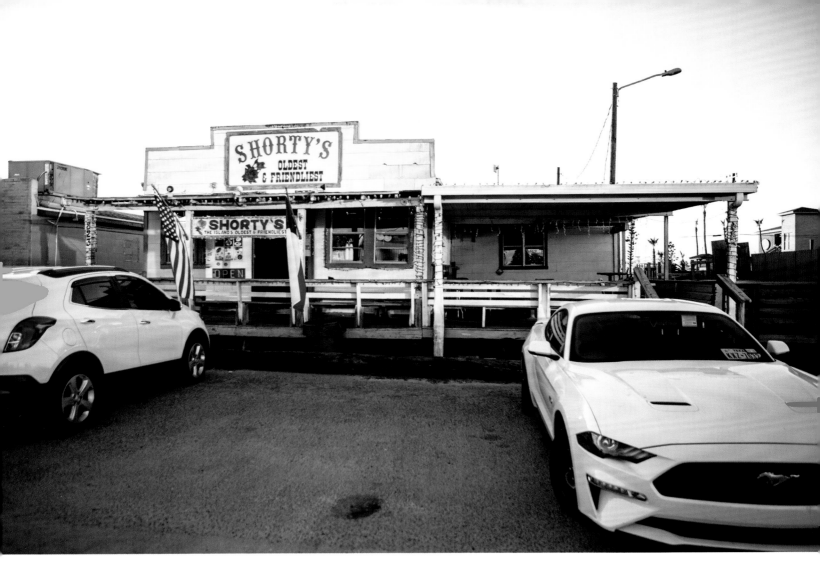

floors. A couple walls and some trim are painted sky blue. Just past the front door sit three bookshelves filled with pigs—stuffed, ceramic, plastic, wood, stone, pink, orange, white, some dressed like people, at least one had wings. Toward the far corner I can see one of those fake fireplaces that produces real heat and a fake jukebox that plays real music (currently, "Deacon Blues" by Steely Dan). An imitation rusted suit of armor stands guard near the cigarette machine. Two pool tables take up most of the back room. Several round four-tops and their chairs crowd beside the pigs up front.

Shorty's feels cozy, but with plenty of open windows and both the front and back doors open to the elements, the whole thing also gets regularly windswept. It's vintage beachy.

The hats. There's no getting around discussing the hats because they hang everywhere from the ceiling like barnacles on a fishing boat. Thousands of them, mostly baseball caps but not all, and many

of them have obviously been dangling there for decades. It's not a particularly attractive look. It feels claustrophobic standing beneath them while ordering that first drink.

About the only space that doesn't have hats overhead is behind the bar, where Kim, among the friendliest, most effusive bartenders we've come across, grabs us a couple cold Lone Stars. The space above her, however, is filled with hundreds of foam beer Koozies that are used by the regulars, so it's not much of an upgrade. Still, Kim tells us immediately, "I love this place. The patrons that come here, the tourists, everyone—they're just wonderful. People walk through here like it's a museum, just to see it once." Here she motions toward the hats hanging above us. "It's on their bucket list. It's a destination."

A beautiful golden brown dog, who's been calmly wandering from bar stool to bar stool, finally greets me with a friendly wag of her tail. Her owner, Kirt, who's every bit as companionable, says her name is Nai'a. We get to talking about stuff, like the old jukebox that had stickers on it warning that if you played "Hotel California" or anything by Jimmy Buffett, you'd get kicked out. "People would get pissed hearing those songs all the time. I think they put those stickers on to keep the bottles from flying. Now they got the electric thing up there," he says of the current internet music machine, with a smirk that I fully understand.

By the time we're done with our beers, he'd told me that he'd ended up in Port A after graduating from high school. "When I knew I was not going to get a football scholarship, I hauled ass down here to be a surfer."

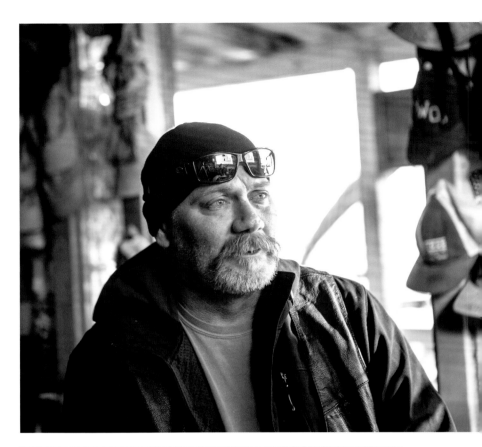

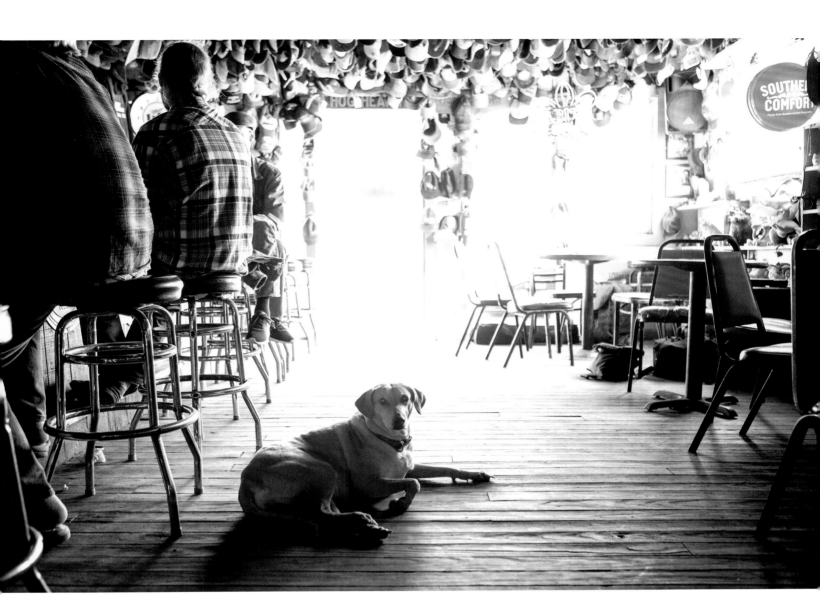

He's lived around the island for twenty years, give or take. He still surfs and does landscaping. His hair is pulled back. He exudes a certain quality of belonging, of being comfortable wherever he just so happens to be. "I'm known as a redneck surfer," he says, casually noting that Shorty's tends to attract bikers as well as rednecks and surfers. There are also a shitload of first-timers, like me, dropping around and asking all sorts of questions about the place.

Kirt says that he's been coming here since before he could see over the bar and has done some work for the owners in the past. "I was a trash boy. And I used to help with the Pig Parties," he says. "I've chopped the pig more than once."

If one has "chopped the pig" in Port A, it means that one has completed a certain rite of passage at Shorty's annual pig roast

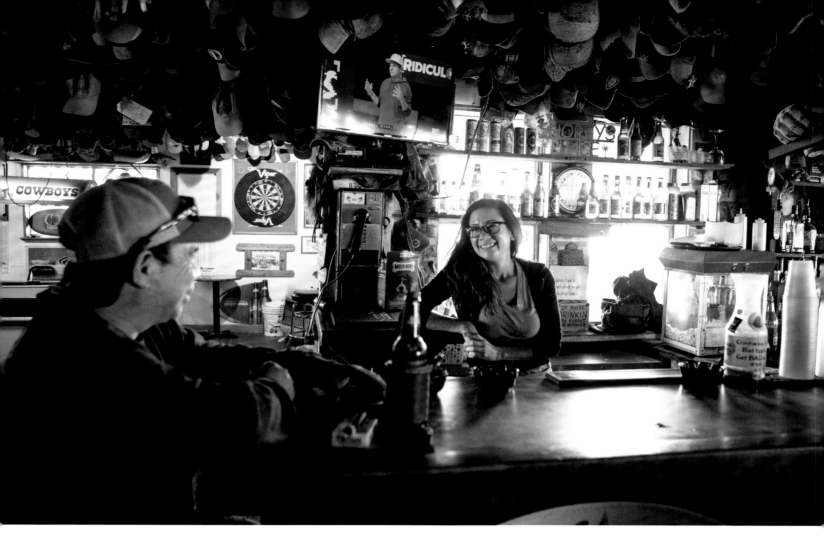

in October. (The expression is actually quite self-explanatory when you learn that detail.) In a way, I get the impression that Kirt looks upon his experiences at the bar similarly to how others grow up embracing the community of a church or scouting or 4-H. The only real difference is that at Shorty's, you can always get a drink.

He says there have even been sleepovers. "I can't remember how many times we slept on the pool tables," Kirt tells me, speaking of nights from long ago that were spent here with friends. "In winter, if no one's here, they used to shut this place down at eleven

at night. We'd stick around and secretly party until whenevs. Everyone paid for their drinks, of course. In the morning, everyone would clean the floors and such and then go on their way. But I'm sure Miss Rose would whoop my ass if she ever heard that."

Eventually, I would get a fuller picture of Miss Rose, who is no longer with us, but I had already learned that she was the daughter of original owners Mac and Gladys Fowler. (Gladys didn't like her name, so she went by the nickname "Shorty.") Shorty's Place opened in 1946 in this building,

which was formerly a mercantile store. At the start there were more pool tables than today because it operated more like a billiard hall that served beer and wine than a bar. After Shorty's death in 1978, her daughter, Rose Smithey, took over and ran it until she passed away in 2011.

Kirt points down the bar to a couple chairs in the corner. "I remember Miss Rose. That was her corner seat. She always sat there and had a couple glasses of sangria. Miss Rose's thing was pigs. That's why you see them all over here. The Pig Party came from that."

The guy sitting next to Kirt is named Bill. He used to work here but doesn't anymore. "I was working at another bar," he says, "when Miss Rose came in and said she was looking for a bartender. It was a good job—until I got fired. I got fired because of her [rela-

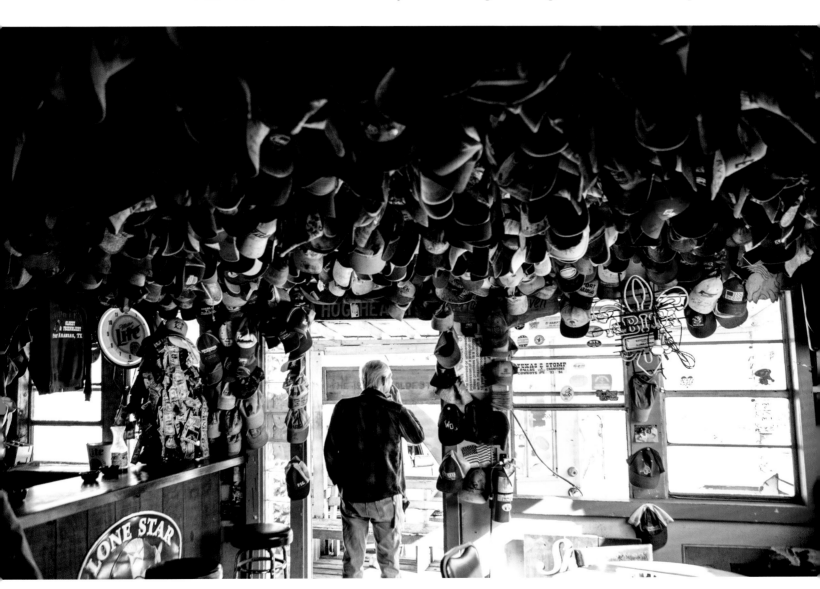

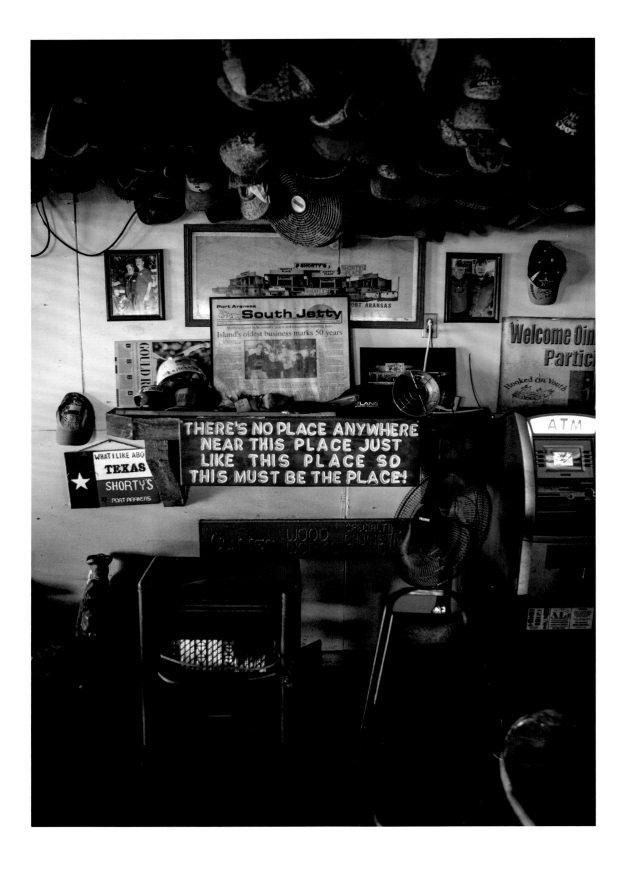

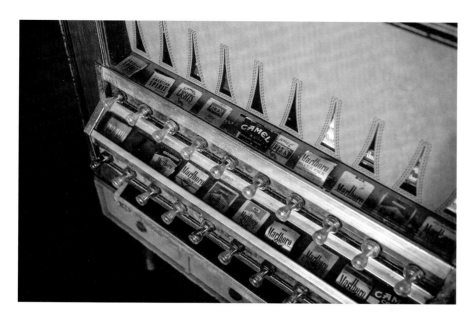

tive]. He came in one night, got behind the bar, started taking money out of the cash register. I called Miss Rose up and said, 'I'm gonna put your [relative] in jail.' She came down here and fired me. So I started heading for the door and she said, 'Where ya' going?' I said, 'I'm leaving. You fired me.' She said, 'I fired you because you were going to put my [relative] in jail. You're still welcome in here.' She bought me drinks the rest of the night."

The thing about good bar stories is that one typically leads to another, and they tend to get more dramatic in scale. There's an unwritten one-upmanship happening as Kirt and Bill try to define the bar's character to me through anecdotes, which somehow leads to Kirt telling a cautionary tale about a guy who once cleaned out his windshield-washer bucket on his car and filled it with rum and Coke. Running a hose through the dash, he enjoyed cocktails from a tap wherever he went. "There was one night, about eleven o'clock," Kirt continues, "he decided he could drive the car between

these two bars." Kirt points through the window to the bar next door. The space between the buildings seems hardly beyond the span of my outstretched arms. Kirt nods along with my sudden understanding. "He got it stuck. Had to kick out the windshield to get out, and had to have the car ripped out the next day. I saw it with my own eyes."

Not to be outdone, Bill points through the open front door, beyond the deck. "I saw a man tarred and feathered. Right out there. He was with one of the biker groups; I won't say who it is, but he obviously did something wrong," Bill says. "They took him out of the bar, took his bike away, and tarred and feathered him. Then they put him in the back of a truck, took him to the ferry, and told him to not come back."

Bill assures me that happened at least twenty years ago. Times have changed.

Kirt mentions the nearby construction and says some of the change is a bit disheartening. "I think they're gonna put up three-story townhouses. You won't be able to see the water anymore. You used to be able to see the ocean from here." The land between Shorty's front deck and the water used to be so undeveloped that this was once considered a dockside saloon. Now the bar sits next to a chain-link fence and the future is on the other side. Here, at this end of the world, things will never be quite the same.

"Port Aransas is not Port Aransas anymore," Bill says. After finishing his beer and tapping the ash of his cigarette into a black plastic ashtray, he suddenly remembers something important. "I got rid of my cancer yesterday."

* * *

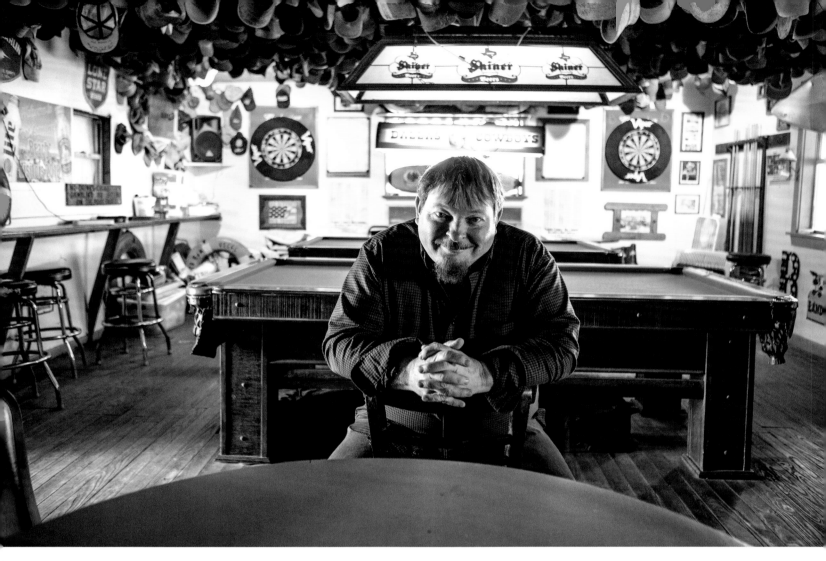

Shorty's stayed in the family after Miss Rose passed. Her daughter, Joy George, ran the bar for a brief time, but eventually she asked another bar owner, Edwin Myers, to take over operations, which he started doing in November 2012.

Edwin has a round, pleasantly determined face. He wears three key rings with about 100 keys for the various locks here and at his other properties. He jingles a bit when he sits to join me at a table near the front door. At first, we talk about a bar in New Orleans that he recently visited called

Erin Rose (it sounds like one to check out some day). But then we get around to talking about the pressure on his shoulders in looking after Shorty's. "This was a unique place. It's the second-oldest continuously run business in town. I feel like I'm a caretaker. I want to make sure this survives. You can see they're tearing down old Port Aransas and wanting to build new Port Aransas," he says, pointing past the chain-link fence.

Edwin hasn't made too many changes, although he did get this former beer joint a liquor license in 2013. The hats stayed, even

though some regulars lobbied to get rid of them. He says they had started going up in the 1970s and no one knows how many are up there today. Customers can tack up a hat anywhere; it's customary to sign and date it. It's simply a way to leave a little bit of themselves behind.

Some people have been known to tuck money inside their hat brim and later will tell friends to find it and buy themselves a drink—but you shouldn't even think about rifling through those hats on your own. That's a quick way to never see the inside of Shorty's again. If someone asks Edwin about a specific hat, he helps them find it. But they're so important to the bar's identity that he's been thinking of getting them insured.

And they've proven to be vulnerable in the past. Over the years, Port Aransas has experienced its share of major storms, including Harvey, a category 4 hurricane that slugged the coast in August 2017, flooding Mustang Island and slapping the shit out of Shorty's. "Harvey came and washed the hats and left me the bill," Edwin jokes.

"Everything was a mess," he continues, with a bit more weariness, while showing me his phone with photos of the damage. "We had to put the roof back together. The rain came in through the top. Debris washed up from the shore, sea grass wedged its way in. The mud was particularly tricky. It became hard as clay so I had to rehydrate it

in order to get it out. It took months for the floor to dry."

Harvey also damaged the walk-in cooler and knocked a mural of painted mustangs off the wall, exposing a window that no one even remembered being there. Harvey had barely left the area before Edwin and a group of locals, a lot of them musicians, fired up the generator, got the roof back on, and engaged with the rest of the damage.

"It's a pretty tough old building," Edwin says. "It wasn't built to modern code, but it was built pretty strong. They knew hurricanes were coming."

Shorty's reopened eight days after Harvey.

"It was the last business closed and the first to open," confirmed a man named Brian as he took a seat at our table. Brian is Shorty's great-grandson; he started bartending here in 1991, making him the fourth generation of the family to work at Shorty's. He showed me a Pearl Lager Beer baseball cap, the first to ever go up on the walls. "It belonged to Miss Shorty, who didn't particularly like it. She stuck it on the wall sometime before 1977. After she passed, someone asked if they could put their hat up as well. Then it became a thing."

When our conversation returns to Harvey, Brian says that after the storm Shorty's became the main place on the island for many residents to begin the long process of getting back to normal. "It's where people found each other," he says. "It was where people connected in order to get their lives back together."

After that, Shorty's became even better known, which didn't really surprise Brian. He's well aware of the bar's far-flung acclaim. "Everywhere I've worn my [Shorty's] shirt, from here to Saudi Arabia, people recognize it," he says. "Maybe," he speculates, "Port A is a universal meeting point, an access point. I think it's been described that way before. I've heard a couple times of people being separated somewhere else in the world and reuniting in Port Aransas at Shorty's."

* * *

Suddenly, it seems, the evening light outside has faded. The air is chilled. The deeper night is coming. Kirk and I grab a table near the pig shelves. He sums up our afternoon by observing, "Everyone said 'Hi' to us in here today." And that's the perfect way to describe Shorty's to somebody else. I may have to use that in this book.

After a while, when our bottles have long been empty, we talk about hitting the road for home. Kirk needs to process his shots, and I've got to write this damn thing. It turns out that I am not the last one to get to Shorty's, and more people should know about this place.

"You had enough there, my friend?" asks Kirk, rising to leave.

"I have."

Coda

Of Cocktails and COVID-19

We finished all the research, writing, and photography for this book months before coronavirus upturned the world in early 2020. After Texas began locking down, we wondered a couple of things, like would this book ever get published and would any of our bars survive.

If you're reading this, that answers the first question. As for the bars, well, almost all of them are still with us. While many of the state's businesses began the process of cautiously reopening, eleven of our featured spots welcomed back their regulars—albeit with some stiff restrictions in place—which proved again how resilient dive bars can be.

But the pandemic had extinguished one of our shining dive lights, this time in Houston. Alice's Tall Texan is no longer *the* place to enjoy a ball game and a schooner of Lone Star. Although Alice Ward had to close her place, some nights you can find her at Warren's Inn, letting someone else do the heavy lifting.

Then, in August of 2021, word reached us from Galveston that Glynda Oglesby, the historian, librarian, and owner of the Wizzard, had retired—at least from the bar business. Her tenure spanned 25 years—and it was a cash-only bar until the very end. Now, the old neighborhood joint on Church Street, the one with circular windows, is called the Alibi. It remains to be determined what became of the Rowe AMI jukebox.

As for the surviving ten bars, there has been staff turnover. Sales are down. No doubt some regulars will never return to their favorite watering holes, sometimes for very sad reasons. But these ten dives continue to endure with the idea of adding decades, not just years, to their legacies.

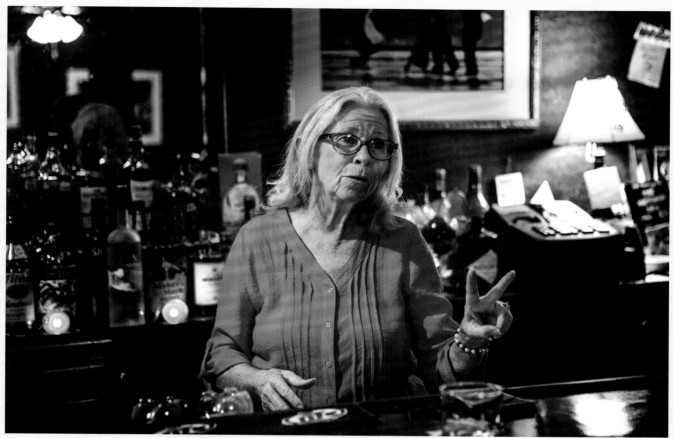

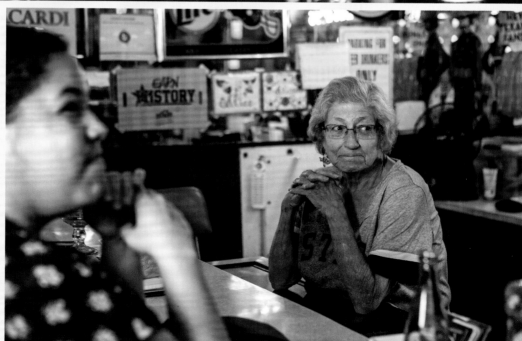

Glynda Oglesby (above) has retired The Wizzard of Galveston, and Alice Ward is no longer helming Alice's Tall Texan in Houston.

And so, while our original intention was to spotlight the uniqueness and, yes, the durability of Texas dive bars, we realized later that what happened was that we recorded the period of time immediately preceding one of the most dramatic shifts of human behavior in world history. Some traditional forms of social interaction, such as going out to a bar, may never again entirely resemble what is found within the pages of this book.

It's impossible to know what the conditions will be when you read this, so for future historians, if what you just saw here doesn't register any familiarity, we can confirm that there once was a time when sitting together—you know, really sitting together—was an everyday public occurrence. We used to shake hands a lot, with strangers too, and touch someone's shoulder while leaning in close to tell a good story. We'd slap a new friend on the back after hearing a good joke. Sometimes we'd even buy a total stranger a drink at the bar. Then we'd clink our glasses together and say, "Here's to your health."

<div align="right">

—Anthony & Kirk
August 2, 2021

</div>

Acknowledgments

This book's inception truly did come about because of our trip to Mynars Bar in West. But the only reason we had the opportunity to visit that bar was because we were coming back from "real" work for *The Tasting Panel* magazine, which gave us a monthly column for about ten years with a directive to simply explore Texas alcohol culture. Thank you, Meridith May and David Gadd, for enduring all those stories about Texas dives.

We want to thank our wives, Michele Richards Head and Tracy Weddle McGoldrick, for not only wishing us well whenever we'd hit the road for more "research," but also for occasionally bending their elbows at a bar and enjoying a drink or two with us. We understand you never bought our excuse that we were "writing a book about dive bars," but we love you for playing along just the same.

Check out Jesse Dayton's music. Despite not featuring any live music in this book, we both feel fortunate for living amid so much talent. (Texas' music scene was hit just as hard as its bars were.) Jesse's vibe struck a chord with us. We're grateful he had time to pen the foreword.

We met some pretty cool people during this grand tour of Texas. Our heartfelt gratitude goes out to all the owners, managers, bartenders, and friends who trusted that our inquiries into their lives and livelihoods were sincere. Our wish is that they continue to lubricate the Lone Star State in good times and in bad.

Thom Lemmons, editor in chief of Texas A&M University Press, encouraged the cre-

ation of this book one afternoon over beers and lunch at Duddley's Draw in College Station. *You* said you'd take a look at the manuscript if we ever pulled it off—which kept us going as we covered well over 3,000 miles for our project.

Thank you to editor Alison Tartt for keeping the text on track. A toast to Pat Clabaugh, associate editor at Texas A&M University Press, who had a suspiciously calming vibe while she guided this project through the editorial gauntlet. The same goes to managing editor Katie Duelm, who brought the project home. And we owe a drink to Omega Clay, our book's designer.

We're proud to be part of The Texas Experience and owe much gratitude to Sarah and Mark Philpy for their ongoing support of Texas A&M University Press.

Anthony would like to personally thank the ladies and gentlemen he met so long ago at the long-gone Triple Crown of San Marcos. And big love especially goes to James Gibson, my morning bartender, my sounding board, my friend. James helped hand-build one of the finest jukeboxes on the planet with a touch-screen interface and about 14,000 ripped mp3s. "We customized the fuck out of that one, including the wooden cabinet," James once told me with true enthusiasm for his craftsmanship, which is how I knew we'd be friends. I invited him to build some steps off the side of my home's front deck and he invited me to his wedding. It just goes to show you that real and lasting friendships can begin in a dive bar.

Buddy Guy, please call the Goat.

To anyone else involved in the book who escaped our notice here, we have one word: Cheers!